Animals in Art

Published for the Trustees of the British Museum

by BRITISH MUSEUM PUBLICATIONS LIMITED

Animals in Art

Edited by Jessica Rawson

Coins are reproduced × 1½ except where indicated

Cover pictures and below: Details from an Egyptian papyrus containing a series of caricatures in which animals take the place of human beings. Front: a lion and a hartebeest playing a board-game. Back: a hyena and a cat herding geese. New Kingdom, *c*. 1500–1200 BC. Height 15·5 cm. (EA 10016/1)

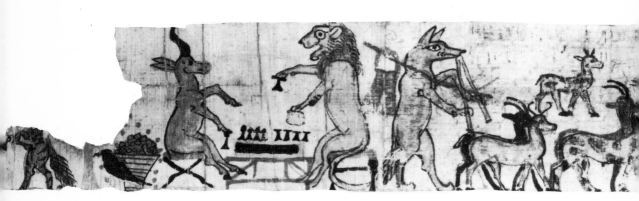

© *1977 The Trustees of the British Museum*

ISBN 0 7141 0081 1 cased
ISBN 0 7141 0082 X paper

Published by British Museum Publications Ltd, 6 Bedford Square, London WC1B 3RA

Designed by Roger Davies

Printed in Great Britain by Balding and Mansell Ltd, London and Wisbech

Contents

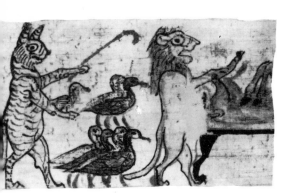

Acknowledgments

This book has been inspired by the British Museum exhibition 'Animals in Art', December 1977–February 1978. It covers a wider range of material than it was possible to include in the exhibition for some items were too delicate to display or too massive to move. The book thus serves as a companion to the exhibition and also stands in its own right as a discussion of the subject, illustrated by the material in the British Museum and the British Library.

We are all indebted to the trustee of the World Wildlife Fund who first suggested to the former Director, Sir John Pope-Hennessy, that the Museum should mount the exhibition. The exploration of the subject has led us to study the whole range of the Museum collections. The materials are extremely diverse and include sculpture and drawings, pottery, bronzes, masks and gems. In a project of this size my thanks are due in one form or another to most of the staff of the Museum and to many members of the British Library. The British Library Board have generously lent manuscripts to the exhibition and their staff have contributed to this book.

I must record first of all my debt to the Director of the Museum, Dr David Wilson, and the Keepers of all the Departments who have given me invaluable support throughout. I would like above all to thank my colleagues in the departments who have given so much time, thought, and enthusiasm to work on the book and the exhibition. In this book all the captions have been written by members of the Departments as have considerable sections of the main text: Alexandrina Logan-Smith (Egyptian Antiquities); Malcolm McLeod (Ethnography, Africa, Ashanti); Elizabeth Carmichael and Penny Bateman (Ethnography, Middle and South America) Brian Durrans (Ethnography, Asia); Jonathan King (Ethnography, north-west America); John Mack (Ethnography, Africa) John Picton (Ethnography, Africa); Dorota Starzecka (Ethnography, Oceania); Joe Cribb (Coins and Medals); Donald Bailey (Greek and Roman Antiquities); Judith Rudoe (Medieval and Later Antiquities); Michael Rogers (Oriental Antiquities, Islam); Lawrence Smith (Oriental Antiquities, Japan); Roderick Whitfield (Oriental Antiquities, China); Wladimir Zwalf and Robert Cran (Oriental Antiquities, India); Gillian Wilson (Prehistoric and Romano-British Antiquities); Paul Hulton and Martin Kisch (Prints and Drawings); Terence Mitchell (Western Asiatic Antiquities). I must likewise express my thanks for the help of members of the British Library for similar contributions: Janet Backhouse, Ann Payne, Thomas Pattie, J. P. Losty, Rex Smith and Philip Waley.

For this exhibition we have had to impose on the goodwill of our colleagues in the British Museum (Natural History) for identification of the animals, a task which has been far from easy. The greatest burden has fallen on Dr Juliet Clutton-Brock but I must also thank Dr E. N. Arnold, Dr P. H. Greenwood, Mrs P. H. Napier, Dr D. W. Snow and Dr P. J. P. Whitehead.

Last but not least I would like to thank Jean Rankine who has worked on the exhibition throughout and without whom the project would have foundered long ago. As in all these ventures the Design Office, the Conservation Department, the Photographic Service and British Museum Publications Ltd have given immeasurable assistance, and I would like to thank in particular Celia Clear, Peter Hayman, John Dalesman and Linda Stoddart who have put so much effort into making this book and the exhibition a success.

JESSICA RAWSON

Animals have been the subject of art from the time that man started to draw, engrave and carve. They have been and are almost as important to men as man himself. In many societies and at many periods animals have been the most prominent subject of art. But this art shows much more varied attitudes to animals than those we today at first expect. In modern urbanised society we look on most animals from a distance. This distance is not bridged by the great extent of our modern scientific knowledge. The different species of animals are known and defined. Zoos, natural history museums, conservation programmes are widespread. These are all a consequence of an objective scientific understanding of animals, of a knowledge of their interdependence and their importance to the ecology of the globe from which we too are inseparable. We know that the preservation of the different species is important, but this knowledge lacks the urgency created by the close dependence of earlier men on the animals they hunted and herded. From these much closer relationships derive very different attitudes and interpretations which remain recorded in art.

Nowhere can the changing views of animals as expressed in the visual arts be better examined than in the collections of the British Museum. Animals in stone and bronze, painted on pottery or sketched in watercolours from all cultures and all periods can be studied together. This book has been arranged so as to examine these different views by theme rather than by chronology or culture.

Animals represented as hunted or domesticated are described in the first two chapters, for in these activities are seen the most important relationships of men and animals. Yet even here the paintings and sculptures of animals are not always, or even generally, simple records. Instead the frequent use of animals in art as visual metaphors is at once apparent. The strength of lions hunted by kings is a metaphor for the might of the ruler. Less explicit, but still an important element, the affectionate play of two dogs reflects the social qualities that man prizes.

In the next two chapters, 'Animals in Thought and Religion', and 'Signs and Emblems', the metaphorical intent of the representation of animals described is much more general. In place of the animals which stand for the qualities or attitudes of men, different creatures are used to represent the forces of the natural, spiritual and political worlds. On the bronzes of Benin, for example, the legitimate but ferocious power of the king is represented by the leopard, and the illegitimate power of the witch by the birds of the night. On coins animals are symbols of monarchs and states.

In the chapter on 'Stories and Fables' the actual process of the creation or the development of a metaphor can be observed. The animals described in Biblical stories or Greek myths, for example the winged horse Pegasos, have been taken by later generations to stand for particular qualities and attributes. In the animal fables, both Oriental and European, animals literally stand in place of men. They are given satirical or critical roles which in some instances might have been dangerous to attribute to men directly. At the same time such stories make general points about human foibles.

The many levels of the use of animals in a metaphorical sense are well illustrated by the satirical papyrus from Egypt (*page iv*). Here a hartebeest and a lion take the place of men at a board-game. Humour is obvious, but so

too is tension, for the hartebeest is the prey of the lion. This is one of a series of scenes showing animals in the place of men, particularly in herding domesticated animals. Again there is ironical humour as a cat, dog and hyena herd goats and geese. They perform their roles, and are represented as men would be in their tomb paintings doing the same things. This metaphor, the use of animals to represent both men and important aspects of their universe, is a thread which links all the first five chapters.

The last two sections of the book are to be contrasted with the first part. Here the form of the representation rather than the significance is important. In the section on ornament, selection has been necessary, and the chapter concentrates principally on abstraction and interlace. This provides added contrast with the last chapter which describes the growth of objective studies of animals. In the art of the classical world and particularly in Renaissance and post-Renaissance Europe, realistic representation of animals has flourished. Animals have been portrayed as interesting in themselves and not for their more complex associations. To this context belong too the animals illustrated in the great western paintings either as incidental features, or as the main subject matter. These cannot be illustrated from the collections of the Museum, but they are directly related to the drawings discussed in the last chapter.

However, although these objective studies of animals are accepted as the norm today, the metaphorical force of animals still remains. We talk about the lion as the king of beasts and accept the analogy with royal power. The dog stands for faithfulness and the hawk for those with sharp eyes. Today we may respect animals in their own right, but both in language and in art this metaphorical use is of abiding importance.

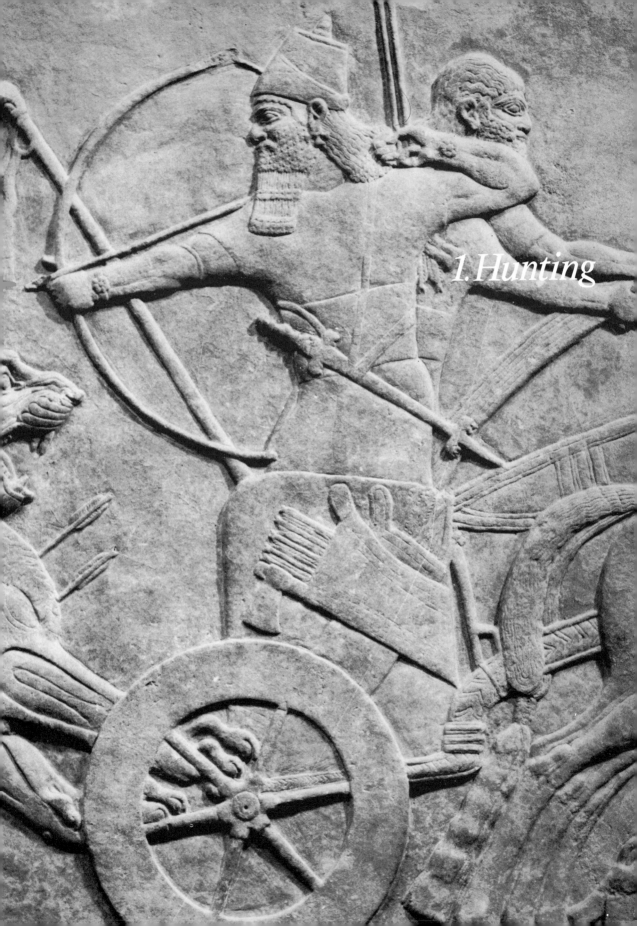

1. Hunting

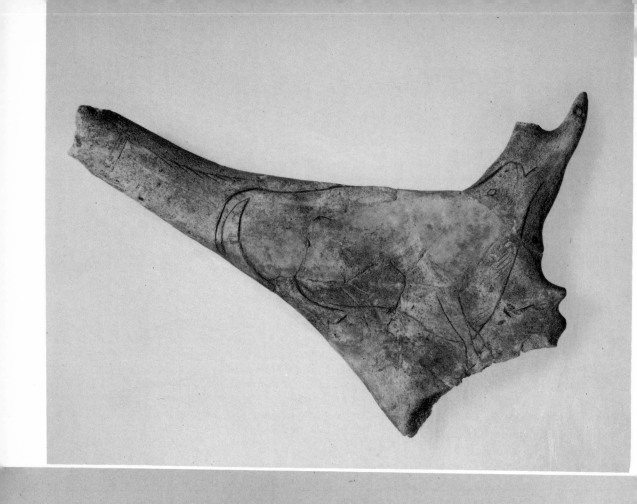
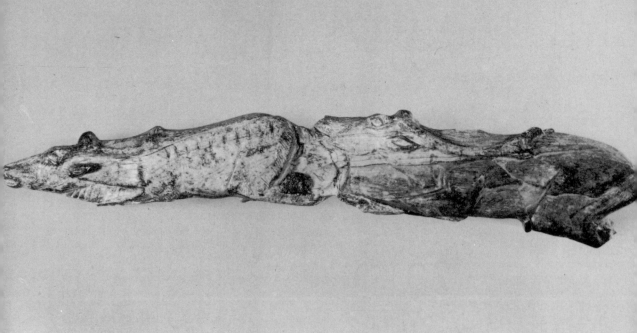

To live man has had to hunt. Hunting was a fundamental way of life, not a sport or diversion. Yet even this basic relationship between men and animals gave rise to complex and ambiguous attitudes. These can be examined most easily, not through what has been written about animals, but in the art and ornament made by men, whether in the paleolithic period more than ten thousand years ago or in the nineteenth century. What we find are not simple studies of animals pursued and captured, but rather a view of the world in which the hunt is an allegory of aspects of life.

The very earliest representations of animals were made in Spain, France, Italy, central and eastern Europe during the period of the paleolithic known as the Aurignacian culture, 30,000–27,000 BC. This same part of the world saw the greatest flowering of paleolithic art in the Magdalenian culture, *c.* 10,000 BC. The most dramatic and famous examples from the latter culture are the great cave paintings of southern France and Spain. At the same time animals were engraved in horn, bone or stone (1) or, more rarely, were carved in three dimensions (2). Although these carvings lack the scale and mystery provided by the cave setting, these smaller studies of animals convey a vivid impression of form and movement. Indeed the carving of the reindeer shows a rare sense of the struggle of the creatures swimming against the flow of water.

These bone carvings have not usually been found in stratified excavations and are therefore difficult to date with great precision, but they are part of an exceptionally highly developed art, which was peculiar to this region. Both the cave paintings and large scale rock-carvings show an evolution of style. Strangely isolated though this artistic phenomenon is, it is exceptionally important in the history of man's interest in animals.

It is even more intriguing that a study of the organisation and placing of animals on different parts of the walls of the more elaborate caves has made it possible for us to see that the men who painted these animals had a complex attitude to their subject. The sequences of animals painted in any one cave do not make up simple hunting scenes. Instead the different animals seem from the frequency of their appearance, and their position, to have had some sort of ranking in men's mind. The animals which were most commonly portrayed were the horse, the bison, and the aurochs or wild ox. Moreover, it has been shown that, in the caves which have been systematically examined so far, they always occupy a central position. The deer, the ibex and the mammoth form the next most prominent group. These appear in positions other than the central one but are often nearby. Three other species, the rhinoceros, lion and bear, are found only in the deepest part of the caves. This ordering is taken one stage further in that the central images, those of horse and bison, are found in association with abstract symbols which are wide and broad and which are assumed to represent the female. The next group, the deer and ibex, are found with the narrow abstract signs thought to represent the male. Some system of categorisation was clearly at work. Paleolithic art is remarkable both for the representation of the form and movement of the animals as they were observed, and for the way in which men at that time placed animals in a hierarchy.

The Australian Aborigines, the Bushmen of the Kalahari and the Eskimos retain, in highly specialised forms, the hunting way of life of paleolithic man.

fragment from palmate antler, with an incised figure of a wounded bison. Found at Laugerie-Basse cave, Les Eyzies, France. Paleolithic, Magdalenian culture, *c.* 10,500 BC. Length 24·3 cm.

2
Handle of a spear-thrower carved from mammoth ivory in the shape of two reindeer. Found at Montastruc, Bruniquel, France. Paleolithic, Magdalenian culture, *c.* 10,500 BC. Length 20·7 cm.

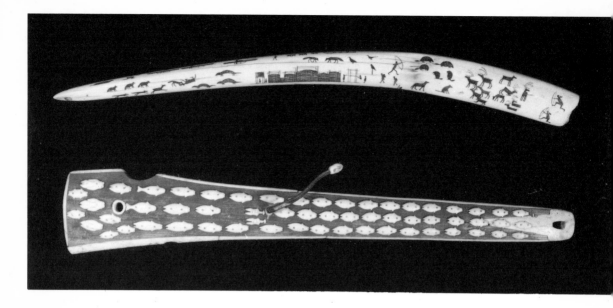

3a
Walrus tusk incised and
painted with scenes of hunting
from kayaks and umiaks,
showing birds, wolves, arctic
foxes, caribou (reindeer) and
beavers. Western Eskimo,
Alaska, 19th century. Length
53·5 cm.

3b
A wooden spear-thrower
decorated with appliqué ivory
figures in the form of seals.
Angmagssalik Eskimo,
Greenland, 20th century.
Length 53 cm.

Detail from **3a**.

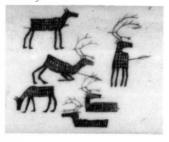

It has always been tempting to compare the art of the Eskimos, in particular,
with that of much earlier hunters. In a limited way they share a similar
economy and similar tools, such as the spear-thrower. Some animals are
common in the cold world of both, notably the caribou or reindeer.
Tempting though this comparison is, it obscures the most important
contrast between them. In their time the paleolithic men in France or Spain
belonged to some of the most successful societies of their era. They lived in
what were probably very favourable surroundings with adequate or
abundant resources. Eskimos are not unsuccessful in their own terms, but
they live at the other extreme, inhabiting the lands which settled men cannot
tame. They are spread thinly across the Arctic, so sparsely indeed that their
social organisation is loose and ill-defined. The resources of the Eskimos
appear minimal but are merely specialised. Like the men of the paleolithic
period, Eskimos use bone and ivory, but the content and form of their art is
very different. Repetition of small seals on the spear-thrower (3b) is
decorative and playful. Many small carvings of animals, mainly seals and
walrus, are equally simple and direct. Graphic details and a down-to-earth
approach are characteristic of the scenes of hunting engraved on a walrus
tusk (3a). Hunting is a matter of life and death but not a mystery. The beliefs
of the Eskimos have probably no connection whatsoever with those of the
paleolithic men in France, but are closely related to those of the peoples of
Siberia. Common to both is the use of shamans to intercede with the
extensive world of spirits. The animals hunted embody these spirits, but the
Eskimos seem to have a more intimate relationship with them than can have
been possible for the paleolithic men faced by the mammoth, bison, bear or
lion.

Paleolithic men and the Eskimos stand apart from the settled neolithic
communities or the later ancient civilisations because of their dependence on
hunting for their livelihood. Such hunters have had to live following the
animals. There was another group of peoples who were equally mobile, who

too followed the great herds of wild animals, and whose way of life can equally be contrasted with that of the settled kingdoms of Egypt, Greece or Western Asia. These were the nomadic peoples of south Russia and Central Asia who lived by hunting and herding. Although they were not simply hunters, wild animals clearly played a large part in life; stags, ibex and mountain goats figured prominently in their art. The small bronzes made by these different nomadic peoples represented animals almost exclusively and are therefore known as 'animal art'. Little is known about these nomads as they did not write and their art, which illustrates so well the animals on which they depended for survival, does not reflect all aspects of their society. They inhabited the vast areas of the Eurasian steppes from the end of the third millennium to the fall of the Roman Empire (see map below). Groups can be described but the relationship of one to another is unsure. Yet, as we shall see, their art shared common elements, and all the forms of this 'animal art' are more similar to one another than they are to the art of Babylon, Egypt or classical Greece.

The best known group, the Scythians, whose activities were recorded by Herodotus, were by no means the earliest. However, the care with which he described their way of life reinforces this sense of the gulf between the mobile hunters and the settled civilisations which he himself represented:

A people without fortified towns, living, as the Scythians do, in waggons which they take with them wherever they go, accustomed one and all to fight on horseback with bows and arrows, and dependent for their food not upon agriculture, but upon their cattle: how can such people fail to defeat the attempt of an invader not only to subdue them, but even to make contact with them.

The rich burials of the Scythians were also described by Herodotus. From these tombs, below great mounds or *kurgans*, spectacular work in gold has

Asia and Europe *c.* 2500 BC– AD 100, showing areas inhabited by nomadic peoples and the adjacent civilisations.

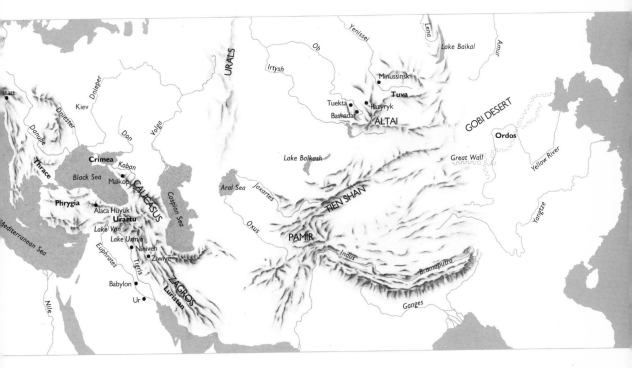

been retrieved similar to some pieces of the treasure from Ziwiye (4). The stylised crouching lions and birds' heads on this strip are characteristic not just of Scythian art, but of much nomadic art in general. Even in three dimensions a similar emphasis on outline or silhouette is striking. It is as though both wild animals, particularly stags or lions, and also the cattle and goats which the nomads herded, are seen standing against the sky. An ox from Alaca Hüyük (5) illustrates this quality. This creature, which probably decorated a standard, belongs to a time long before the Scythians were of interest to the Greeks. It is similar to other pole figures found in the tombs of warriors at Maikop in south Russia and suggests a people who had moved into Anatolia from the north and imposed their will on the settled peasants of the area. Again it is the art of the nomads and hunters and not that of the settled population.

One of the difficulties of understanding the life and attitudes and even the interrelationship of these nomadic hunters is the discontinuous nature of the remains. Groups of axes decorated with animals (6, 7, 8) are found in the area of Van and the Caucasus but are generally less common further east,

4
Fragment of a gold ornamental strip decorated in the Scythian style with lions flanking circles, and stylised addorsed eagles' heads at the border. From Ziwiye, north-west Iran, *c.* 7th century BC. This piece illustrates influences from the north in the area south of Lake Urmia in the 9th–7th centuries BC, when Indo-European speaking nomads from the northern steppes had imposed themselves on the indigenous peasant population. Width 3·2 cm.

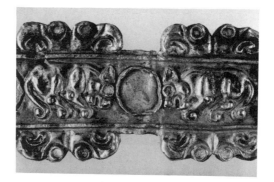

5
Silver ox with gold inlays on a copper stand. Probably from Alaca Hüyük. Anatolian, *c.* 2500 BC. Several animals including oxen and deer, evidently mounted on stands or poles, were discovered with other objects of gold, silver, and copper, in rich burials at Alaca Hüyük. A comparable burial has been found at Maikop in the Kuban area of the north Caucasus. Height 24 cm.

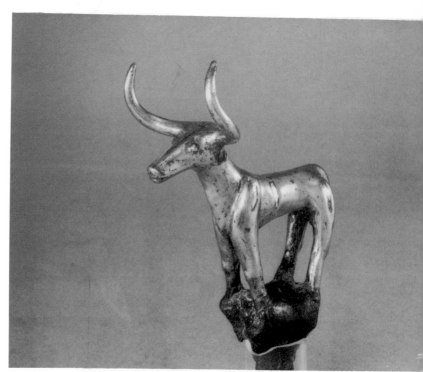

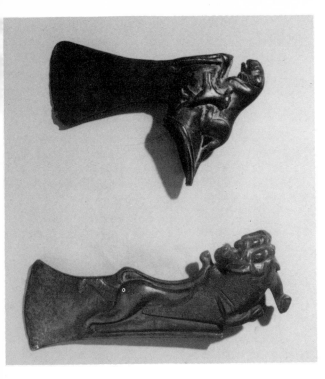

6a
Bronze axe-head with a
crouching lion attacked on
each side by dogs, on the shaft
socket. From Van, Anatolia,
c. 2500–2200 BC. Length 13·5 cm.

6b
Bronze axe-head decorated
with a lion whose body, shown
on both sides of the blade,
ends with his head and neck
turned back so that the shaft
passes through his gaping jaws.
From Hamadan, Iran,
c. 2000–1700 BC. Length 16·5 cm.

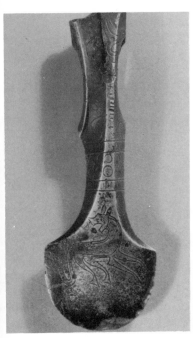

7
Bronze axe-head with incised
decoration of a stylised
quadruped, perhaps a lion.
Western Caucasus, 11th–8th
century BC. Length 16·5 cm.

8
Bronze adze-blade with an
incised horned animal and sun-
disk on both sides. Found near
Kertch, Crimea, North Pontic
culture, *c*. 1100–900 BC. The
horned animal on this adze has
traditionally been interpreted
as a bull, an animal associated
with the solar cult in Central
Europe. Length 14·2 cm.

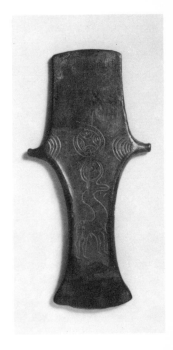

9

Six bronze knives from Siberia and the borders of China. *From left to right:*

a

decorated with stylised birds on handle and hilt, north-west China, 7th–3rd century BC. Length 27·6 cm.

b

with birds on the hilt, south Siberia, 7th–3rd century BC. Length 27 cm.

c

with a tiger on the pommel, north-east China, 10th–8th century BC. Length 26·5 cm.

d

with a horse's head enclosed within a double loop. China, 11th–10th century BC. Length 26·8 cm.

e

with a crouching tiger on the pommel, south Siberia, 8th–6th century BC. Length 18·7 cm.

f

with a bird's head, south Siberia, 10th–7th century BC. Length 18 cm.

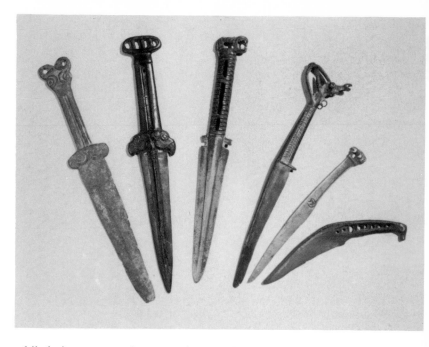

while knives seem to be more characteristic of the Far East (9). Both types are decorated with animals. On the axes lions are shown in several quite different guises. The earliest example shows a lion boldly modelled, crouching, alarmed by attacking dogs (6a), while on two later examples the skill of representation lies in the line rather than the solidity of the form (6b, 7). The knives in a similar way show, over a period of time, different approaches to the use of animal heads to decorate weapons. Two types of weapons are thus among the distinguishing features of widely separated groups whose ways of life had common elements.

After the eighth century the relationships became much closer. Two ornaments illustrate the contact: a goat from the Caucasus (10) and a sheep from the steppe borders of China (11) are remarkably similar. At this stage the transmission of ideas across the steppe seems to have been very swift. Even more extraordinary is the similarity between a pole top jingle from the Ordos area (12) and the same form from northern Italy (13). Intermediate examples have been found in Scythian burials. Small double-headed animal pendants are so unusual an idea that they must be related even when they are found as widely scattered as north-west Iran (14), the site of Hallstatt in Upper Austria (15) and in northern Italy (13b).

Europe both before and after the advent of the Celts appears to have had contact with, if not to have shared, the animal art of south Russia and Central Asia. Certainly the waggons which were an important feature of the lives of these nomadic peoples, and are found in burials as far apart as the Crimea and Pazyryk in the Altai mountains, are also found in Central Europe in the tombs of the Hallstatt culture, *c.* 700 BC. These common customs suggest that the peoples were in contact with each other or were related to one another. As we have seen, some animal ornament, such as the double-headed animal, was also shared by them. In a similar way small ibex

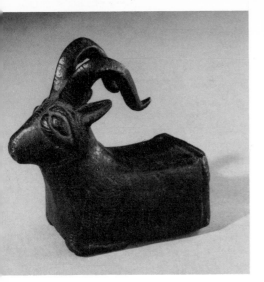

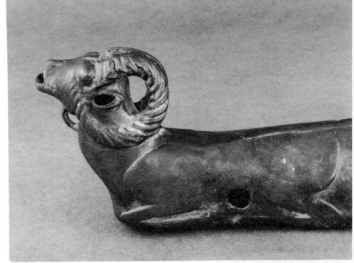

11

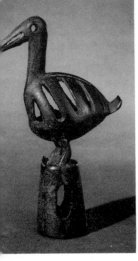

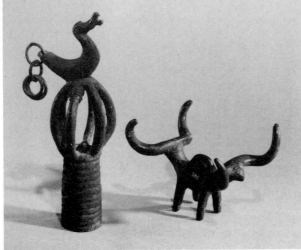

13

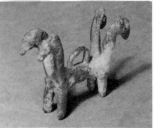

14

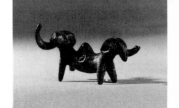

15

10
Forepart of a goat in bronze with a socket of square section in the rear for mounting, perhaps on the arm of a chair, or on a chariot pole. Possibly from the Caucasus, *c.* 1000–800 BC. Height 12 cm.

11
Bronze terminal in the shape of a ram. From the Ordos area, north-west China, 5th–3rd century BC. Length 19 cm.

12
Bronze jingle in the shape of a bird. From the Ordos area, north-west China, 6th–4th century BC. Height 13·3 cm.

13
Two bronzes from northern Italy, 8th–7th century BC:
a
staff-end with a bird above an open-work ball. Height 13·9 cm.
b
double-headed ox. Length 8·8 cm.

14
Bronze pendant in the form of two addorsed double-headed animals from north-west Iran, 9th–8th century BC. The creature represented in this composite form is possibly the Saiga antelope, *Saiga tatarica.* Height 5 cm.

15
Bronze double-headed figure of ram. Found in the cemetery at Hallstatt, Upper Austria, 8th–6th century BC. The ram occurs as a cult animal in Celtic societies. It is often represented together with severed human heads and is closely associated with the serpent, an attribute of the Celtic Horned God. Length 6·5 cm.

harness ornaments are found in Greece, Anatolia and also in south Siberia
and the Far East.

However, the peoples in Europe lived a more sedentary life and their art
reflects this element too. The ibex and lion were not so widely known in
Europe. Instead birds, particularly aquatic birds, took their place and were
part of a widespread sun-cult found in much of Europe. The birds on a flesh-
fork (16) from the extreme western tip of Europe, from Ireland, have been
identified as swans and ravens. The swan was associated with the sun-god in
his healing capacity, the raven with Celtic war and fertility goddesses, and
with the power of telling the future. Equally important in these cults were the
ram and the boar (15, 17). In later Celtic art the boar, which must have been
both hunted and domesticated, had a central place (17). The boar or pig was,
in Celtic mythology, a supernatural being with prognostic powers, and a
harbinger of death and disaster. It was believed that it had been introduced
into England and Wales by the gods and there were several legends telling of
divine swineherds. Certain joints of pork played an important role in feasts
and are also found in burials. On both the small figures and the coin (18) the
mane is extremely important, and the boar on the coin in particular is very
vividly represented.

Powerful though the boar was in its time, viewed in the perspective of the
art of the nomadic hunters as an extended group, it was a relatively rare
motif. The lion was much more characteristic of the art of the region as a
whole. In Russia it survived as late as the invasions of the Slavs, albeit in a
rather distorted form, on harness and saddle decoration (19). The slightly
curved shape of the silver lion from Kanef, with its curled claws, is

16
Bronze flesh fork with
ornamental swans and ravens.
Found in Dunaverny Bog,
County Antrim, Ireland. *c.* 800
BC. Length 56·5 cm.

17
Bronze figures of two boars
and one canid. Found at
Hounslow, Middlesex,
England. 1st century BC–1st
century AD. The boar was the
most important Celtic cult
animal. Originally the larger
boar would have had an
openwork crest. The figures
were perhaps mounted, for
example on a helmet. Length
left to right 6·4, 7·1, 4·9 cm.

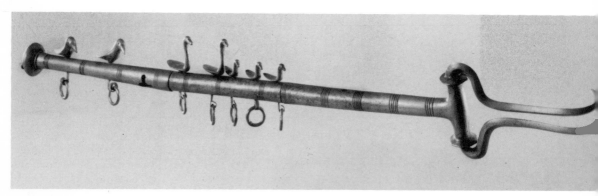

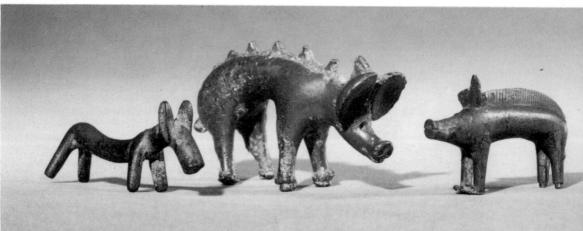

reminiscent of such Scythian lions as those on the gold band from Ziwiye.

Even more important than the lion alone are scenes of a lion attacking a bull or a stag, which make up the theme known as 'animals in combat'. These are not animals hunted by man but animals hunting one another. Artifacts decorated with such scenes have been particularly associated with the peoples who created the 'animal art' just described. A belt plaque (20) from the Ordos area north-west of China, following as it does examples from further west, is typical of the interest which this theme had for the nomadic peoples of Russia and Central Asia. It is possible that it had a special significance for them because as they hunted animals they saw animals preying on one another. On the other hand, not only is this theme found in the Far East, in the Altai mountains, and among the Scythians, but, as we shall see, many examples come from the islands of the Aegean where lions killing bulls and stags are less likely to have been seen. This theme of the lion killing a lesser but strong beast appears to have a significance which is parallel to the representations of the kings of the great settled civilisations killing lions as a symbol of their authority and power.

The source of this motif is the art of Mesopotamia in the third millennium BC. In Western Asia it was one of a number of combat scenes which also included 'bull-men' tackling lions. Both scenes are seen on a musical instrument from the Royal Cemetery at Ur (21). In ancient Mesopotamia the combats between two animals and those between men or bull-men and animals were certainly related artistic ideas. Above the scene of the lion attacking the bull both the 'bull-man' with two leopards and the panel with a pair of bulls illustrate the paired or 'heraldic' formula in which such animal

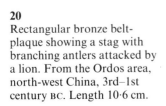

18
Silver coin of the Coritani (Leicestershire), *c.* 10 BC. The silver coinage of Celtic Britain is not directly derived from Continental prototypes, and therefore shows a greater diversity of subjects. Nonetheless most of the types are drawn from the normal range of Celtic art. This boar is one of the earliest treatments of this common Celtic subject on a British coin. Diameter 15 mm. Reproduced × 2.

19
One of a pair of silver animals, possibly representing lions, originally mounted on a saddle. From a hoard found at Martinovka, Kanef district, Kiev, south Russia. Slav workmanship, 7th century AD. Length 8·4 cm.

20
Rectangular bronze belt-plaque showing a stag with branching antlers attacked by a lion. From the Ordos area, north-west China, 3rd–1st century BC. Length 10·6 cm.

9

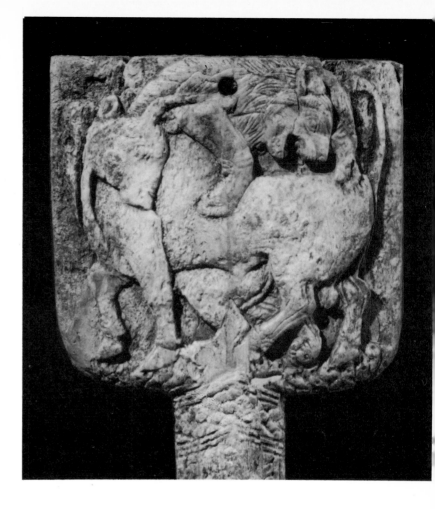

21
Detail of shell decoration on a wooden lyre from the Royal Cemetery at Ur. Sumerian, *c.* 2500 BC. Shown on the lower three of four panels are, (above) two bulls rearing up against shrubs, (centre) a bull-man holding two leopards, and (below) a lion attacking a bull. Height approx. 10 cm.

22
Detail from an ivory mirror-handle showing a lion killing a bull. Found in a tomb in Enkomi in Cyprus, *c.* 1200–1100 BC. Height 20·5 cm.

combats often occur. Thus sometimes, as in this example, there is a single lion killing a bull; in other compositions it is balanced by another making up a pair.

The scenes of lions attacking bulls and biting them at the neck appear carved in realistic detail on Cretan sealstones, *c.* 1450 BC. The motif was introduced into Crete along with the 'heraldically' opposed animals to be discussed in more detail later (see page 73). The intertwined bodies of a lion and bull on an ivory mirror handle from Cyprus (22) show the theme worked into a very satisfying composition, not unlike the example on the lyre. This theme must have reached the Aegean from Mesopotamia. The ivories from Cyprus, of which there are a group in the British Museum, are more lively than some later examples. The painting on an archaic vase of the eighth or seventh century BC (23) is spare and stilted. An ivory found at Ravenna, however, shows a more sophisticated version (24). The increasing interest in realistic representation transformed the treatment of this subject. This can be seen by comparing two Greek coins only a hundred and fifty years or so apart in date (25a, b). While in the West the animals became increasingly naturalistic, in the Far East the subject was obscured by the emphasis on decorative details. An openwork plaque from the Ordos (26) shows a tiger with not one but four ibexes. Two of the ibexes have undergone a strange

23
Detail of a leopard killing a stag, from a painted clay jug found at Aegina. Made in one of the Cycladic Islands, Greece, *c.* 700–650 BC.

24
Ivory handle of an iron knife (some of the iron remaining) in the form of a tigress and her cub attacking a goat. Said to have been found at Ravenna. Possibly late first millennium BC. The goat can be identified as the Barbary 'sheep', *Ammotragus lervia*, which is found only in Africa. This piece may well therefore have been made in the Mediterranean area rather than further east. Length 10·2 cm.

25a
Silver coin of Acanthus in the Chalcidice Peninsular in north Greece, showing in archaic style a lion attacking a bull, *c.* 490 BC. The area where this coin was minted in Thrace is adjacent to the region inhabited by the Scythians. Diameter 27 mm.

25b
Silver coin of Tarsus, in Asia Minor. Issued by Mazaeus, Persian satrap of Cilicia, *c.* 350 BC. The design of this coin, showing a lion attacking a stag, was copied from the issues of the City of Citium in Cyprus after Mazaeus annexed Cyprus to Cilicia. Diameter 24 mm.

26
Bronze plaque representing a tiger surrounded by four ibex or deer heads. From the Ordos area, north-west China, 3rd–1st century BC. Length 8 cm.

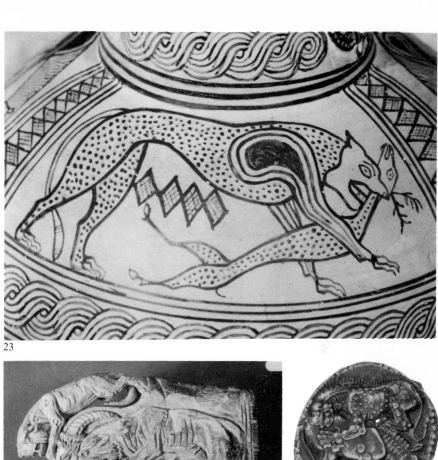

23

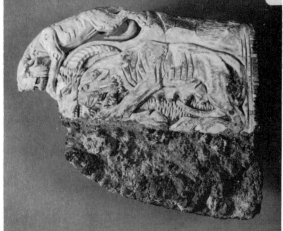

24

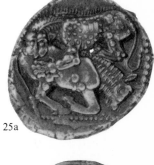

25a

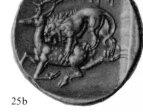

25b

26

27
A lioness attacking a hind.
Ottoman Turkey, second half
of the 16th century. Except
that the animals are
represented with their backs to
the tree, the scene is almost a
repetition of the celebrated
mosaic in the Umayyad bath at
Khirbat al-Mafjar, AD 740,
near Jericho.
Cut paper glued to a backing
sheet, with tempera details.
Paper-cuts appear to have been
developed in Ottoman Turkey
before making their way to
Europe. 18·8 × 12 cm.

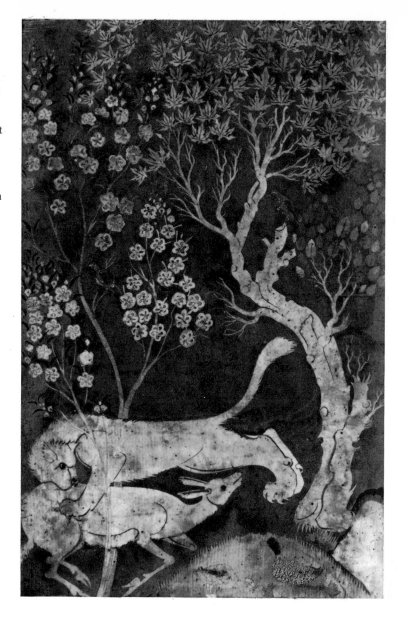

mutation so that their horns have become their necks. The interplay of plain surface and striations, eyes and ears, has dissolved the subject matter into a pattern. Long after the nomads had disappeared, the theme remained to reappear in mosaics, in Byzantine silks and in later miniature painting (27). Interestingly, in the Ottoman miniature, the creatures are still confined to a narrow rectangular area as they are in so many of the early pieces described.

While it is almost impossible to discover the meaning of this theme repeated across the Mediterranean, central and eastern Asia, the significance of the scenes of kings killing lions is immediate and direct. All aspects of these representations of hunts tell of their symbolic value. The very fact that

many lion hunts are shown as parts of spectacular palace architecture (28), or on coins or seals, demonstrates that they were intended to expound and reinforce the might of the king. During the Eighteenth Dynasty in Egypt (*c.* 1567–1320 BC) objects in the form of scarabs were inscribed with the triumphs of the king to proclaim his might to a large audience. Such a ceremonial scarab was issued in large numbers by Amenophis III (*c.* 1417–1379 BC) to commemorate his hunting achievements. It bears the following inscription:

May the Horus live, the Strong Bull appearing in truth, Lord of the South and North, who establishes the laws and pacifies the Two Lands, the Golden Horus great in bravery, who smites the Asiatics, King of Upper and Lower Egypt Neb-Maat-Re, son of Re, Amenophis, ruler of Thebes, given life, and the king's wife Tiy, given life: Between the first and tenth year of his reign His Majesty bagged with his own arrows a total of 102 fierce lions.

The most famous illustrations of lion hunts are the bas-reliefs from the Assyrian palaces of the ninth to seventh century BC showing the kings Ashurnasirpal II (883–859 BC) and Ashurbanipal (668–627 BC) confronting and killing lions. These are carefully balanced compositions in which each performer has his role. The king and his huntsmen are composed and calm; the lions vigorous and swift, yet causing no panic, no fear, for the king is always victorious (28). In the words of one of these kings this assertion of royal power is thus proclaimed:

I am Ashurbanipal, king of the universe, king of Assyria. In my royal sport I seized a lion of the plain by its tail, and at the command of Ninurta and Nergal, the gods my helpers, I smashed its skull with my own mace.

Not only do the words, and the different modes of representation of the men and the lions, show that this is part of a dramatic, staged presentation of the

28
Gypsum bas-relief showing Ashurnasirpal II, king of Assyria 883–859 BC, hunting lions from his chariot. From Nimrud (ancient Kalhu), neo-Assyrian period, 9th century BC. Height 88 cm.

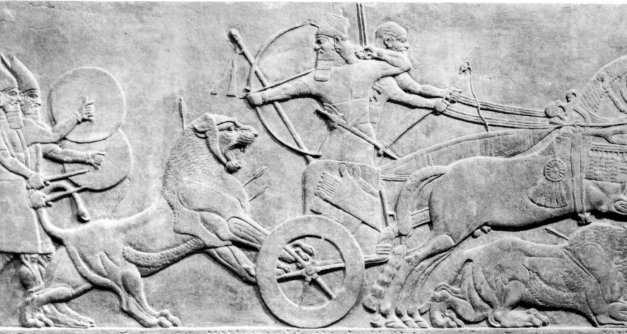

king's power, but also the details of the scenes show how it was to be contrived. Among these bas-reliefs, in which the king is shown undertaking deeds of unbelievable bravery, are also ones which show lions ignominiously caged in wooden crates to be let out for the king to kill ceremonially. Symbolically the power of the king is equal to the power of the lion and like the lion he will triumph over his enemies. This theme was taken from Assyrian and Babylonian art into that of the Achaemenid kings in Iran. Cylinder seals of Darius and later monarchs show kings shooting at lions from their chariots, or holding them upside-down by their tails. In the same detail the hunting scenes on Gupta coins, in India, of the fourth to sixth century AD, demonstrate the power of the king (29). One inscription on the coin of King Chandragupta II (AD 380–414) is as telling as, if more poetic than, the words of Ashurbanipal: 'The moon among kings, brave as a lion whose fame is far spread, invincible on earth, conquers heaven.'

In later centuries this same symbolism was carried further west to Anatolia and later Byzantium. The small gold mount from Asia Minor, made at the same time as the Gupta coin, is a more lyrical treatment of the ancient theme (30). In the heavy border, which is common to so much Mediterranean work in precious metals in the fourth century, it anticipates the beaded borders of the roundels on the silks of Sassanian Persia and China which were to enclose the same motif. A fragment of Byzantine silk shows the lion hunt in a very similar style, but this time it is paired in the form common to the 'heraldic' formula derived originally from Mesopotamia (31).

Although the scenes of a king or lord hunting a lion or other beasts of prey can be singled out as directly symbolic, there are very few hunting scenes which are without such overtones. The documents of some ancient civilisations show that hunting was concerned with the rituals of the state, or was governed by rules which related to the power of the king. For example, during the Han dynasty (206 BC–AD 220) in China the hunting parks of the emperors are described in long poems as pleasure grounds of extraordinary natural beauty. At the same time the historical works of the Han period contain the following entry in the *Treatise of Ritual*:

On the day of the Autumn's beginning, with the completion of the suburban ceremony, serenity and martial vigour began to flourish. Animal victims are slaughtered at the suburban eastern gate so that they may be offered in the temples of the imperial tombs. In this ceremony the Emperor rides in a war chariot drawn by white horses with deep red manes. He himself holds a crossbow in his hands with which he shoots the sacrificial victims.

Although not all hunts had such an obviously ritual character, the common people were not free to hunt in the royal parks, a rule which is familiar even today. We accept the idea of poaching as hunting on someone else's land, and recognise the restrictions in hunting some creatures, such as pheasants, at particular times of year, and the prohibitions on the hunting of others, like the swan and the sturgeon. In all the hunting scenes that follow, restrictions, rules, and ritual implications lie behind what are generally decorative and attractive compositions.

The earliest is on a slate palette from Predynastic Egypt, *c.* 3100 BC (32). It

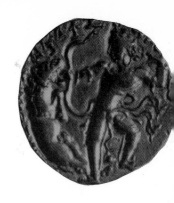

29
Gold coin of King Chandragupta II, AD 380–414. Gupta dynasty of India. Gupta coins frequently show hunting scenes which glorify the might of their kings. Diameter 21 mm. Reproduced × 2.

32
Slate palette, Egyptian, Predynastic Period, before 3100 BC. Carved on one side in raised relief is the scene of a hunt, which includes in addition to deer, gazelle, hare, fox and ostrich, a hartebeest, *Alcelaphus buselaphus*, now extinct in Egypt. The central cavity may have been used to grind material to make eye-paint for the decoration of a god's statue. (The upper right fragment is a cast of the original now in the Louvre.) Length 66·6 cm.

30
Gold ornament showing a lion
hunt. From Asia Minor, Early
Christian, 4th century AD.
Width 5·1 cm.

31
Silk fragment decorated with a
symmetrically doubled hunting
scene. Byzantine, 8th–9th
century AD. 21·5 × 23·5 cm.

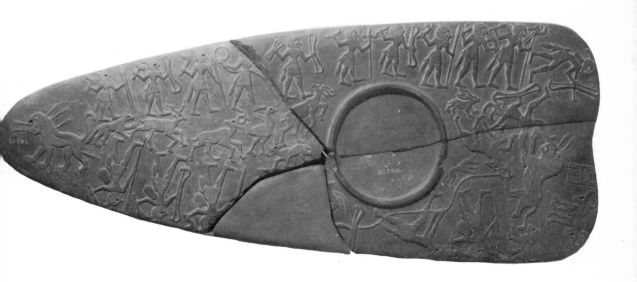

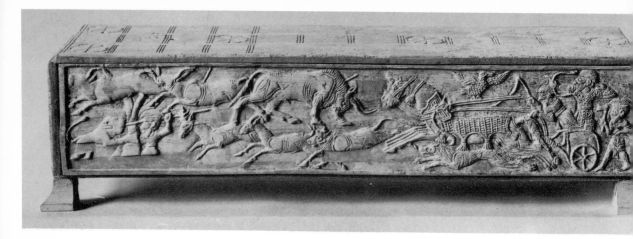

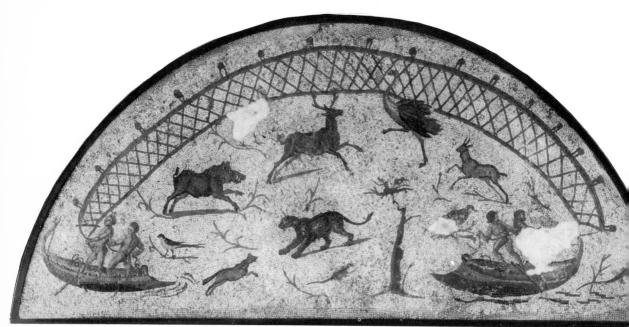

is crowded with activity, and the animals and men mingle in several
directions. The palette was made at a time when there were two
confederations holding Upper and Lower Egypt respectively. Two capitals
were established, one at Buto in the Delta and the other at Hierakonpolis in
Upper Egypt. This was a period of continuous political upheaval. The
palette, which shows the hunting of two lions and other animals, may refer
thus symbolically to the political struggles. The fact that palettes were used
for grinding minerals to make eye-paint for a statue of a god suggests that
they had a ceremonial or votive purpose.

Unlike the confused organisation and strange proportions of the animals
on the palette, the Mycenaean hunting scene seems more closely organised
(33). However, this is partly because the artist was lucky in his format. The
narrow rectangular space contained the animals and the chariot, thereby
building up the tension of the scene. As this type of box was used for a game
which was also known in ancient Egypt, the inspiration for the scene may

3

Man hunting goats, ass and cattle from a chariot. Relief from the side of a carved ivory gaming-box. Found in a tomb of the Mycenaean period at Enkomi in Cyprus. 1200–1050 BC. Length 29·8 cm.

have been Egyptian. However, both the formula of the pursuit of animals from a chariot and the disposition of the creature have more in common with the later scenes from Assyria.

Hunting scenes were popular throughout the classical world and, as with both the two early examples just described, one of their interests was to show as many different animals as possible. On a hunting mosaic from north Africa the hunting net is used to bind the group of animals together (34). This same net recurs again, as much an artistic device as part of the hunting equipment, on a later glass humpen from Bohemia (see colour plate I). The hunting mosaics had provided a series of decorative motifs which could be copied directly onto gold and silver. The fourth-century gold mount from Asia Minor already mentioned combines the late antique naturalism of such a hunting scene with an abstract ornamental background derived from oriental art. Although from a Christian context, the running animals on the sixth-century silver spoons from the Cyprus treasure (35) are likewise taken from larger hunting compositions, but here are used simply as decoration. Hunting mosaics represented the pleasure of hunting as a sport, but they may also have alluded to the pagan allegory of man's triumph over danger, which was transferred into the Christian repertoire as the triumph of good over evil.

Later medieval hunting scenes retained other symbolic elements. The importance of illustrations of monarchs killing strong beasts still remained. The thirteenth-century tile roundel (36), part of a mosaic pavement, showing a youth on horseback spearing a lion, is one of a series of roundels with such combat scenes. It was drawn by a highly competent artist with great strength and vigour. A medal by Pisanello (37), two hundred years later, shows further advances in the portrayal of living creatures. Pisanello did not invent the art of the medal, but it was he who used it to such effect that it became an independent form in its own right. Commemorative medals of this sort were intended to glorify the many competing princes of Renaissance Italy. Here the medal flatters Alphonso V, King of Aragon, Naples and Sicily, showing him as a young boy killing a boar.

In these later works we have left the grandiose compositions of the ancient

34

Fantasy hunt on a mosaic floor decoration, showing men using a weighted fishing net, from two boats, to catch various land animals, including a boar, a stag, an ostrich, a leopard, a gazelle and a lizard. A jackal is also shown, and two birds; a lizard escapes. From Utica, in Tunisia. Roman, 4th century AD. Length 339 cm.

35

Three silver spoons with griffin, stag, and horse in relief on the bowl. From the Cyprus Treasure, Early Christian c. 600 AD. While other pieces in the same treasure are ornamented with specifically Christian motifs, these beasts are copied straight from hunting mosaics. Length 26 cm.

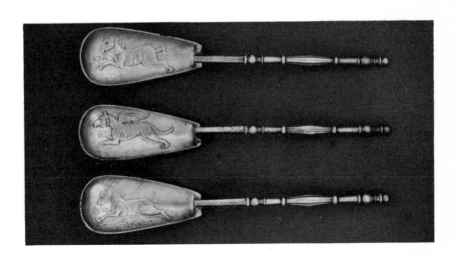

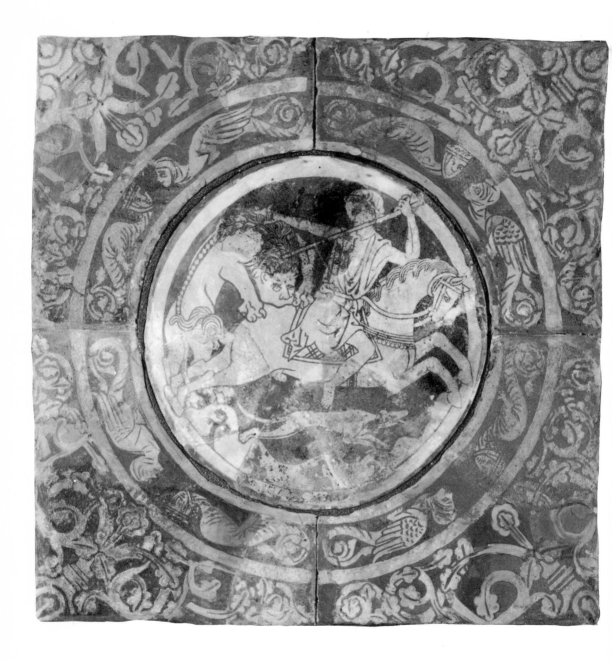

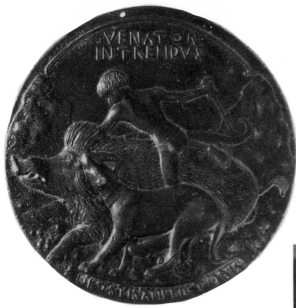

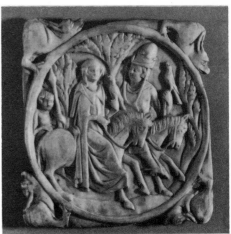

37
Reverse of a bronze portrait medal of Alphonse V, King of Aragon, Naples, and Sicily, by Antonio Pisano (Pisanello) of Verona (*c.* 1390–1449 AD), showing the king killing a wild boar, whose ears are held by two hounds. Width 11 cm.

36
Roundel with lion attacking mounted youth from earthenware tile mosaic pavement. From site of Chertsey Abbey, Surrey, late 13th century AD. Width of square frame 40·6 cm.

38
Ivory mirror-back with a hawking scene. French, 14th century AD. Hawks were carried on the gloved fist before being released, but falcons were trained to a lure – a pair of birds' wings, sometimes baited with meat. Height 10 cm.

and classical world for the more detailed scenes of late medieval and Renaissance Europe. The French mirror-back expresses this personal intimacy in its most lyrical form (38). Both the animal at the corners and the subject matter are exquisitely treated. In this context the use of the falcon as a symbol of a lover seems the more appropriate. Falcons symbolise lovers in many languages, as in *Romeo and Juliet* (II, ii): 'O for a falconer's voice. To have this tassel gentle back' (tassel = terzel, male falcon). But one of the most famous poems in which the falcon is thus used is by Der von Kürenberg, the earliest named German lyric poet, writing in the mid-twelfth century:

I trained myself a falcon, for a year and more. I tamed him to do as I wanted, I adorned his plumage with gold. Yet he rose up high and flew to other lands.
 Since then I have seen this falcon flying freely, bearing silken jesses on his feet, and his plumage gleaming with scarlet and gold. May God heed the wishes of all lovers and unite them.

Romance apart, falconry was a serious matter, and like all medieval

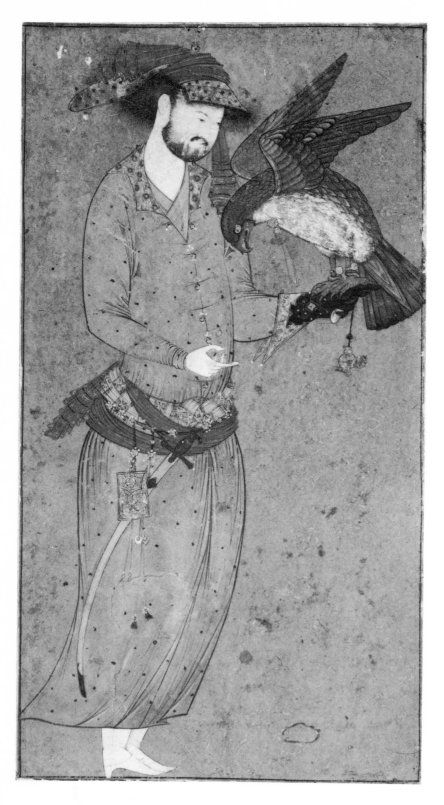

39
Court falconer with a falcon
on his wrist. Safawid Persia,
AD 1580. So prized were
falcons in the Islamic world
that the 15th-century
successors of Tamerlane at
Samarkand and Herat would
exchange Turcoman horses, or
their own lions and leopards,
with the Ming emperors of
China for gerfalcons from the
Sea of Manchuria. This
consuming passion shows itself
in this drawing, where the
careful observation of the bird,
a tradition drawn from the
naturalistic painting of 15th-
century Herat, contrasts
strikingly with the stylised
pear-shaped figure of the
falconer.
Tempera and ink on paper.
14·8 × 8·2 cm.

40
The emperor 'Akbar on
horseback, hunting. India,
Mughal school, late 17th–18th
century AD. Under the emperor
'Akbar (AD 1556–1606) the
foreign Mughal dynasty
became firmly established in
India. His active patronage
helped to create a new school
of painting of which this later
example shows him hunting
the black buck, *Antilope
cervicapra*.
Gouache on paper. 23·7 ×
14·9 cm.

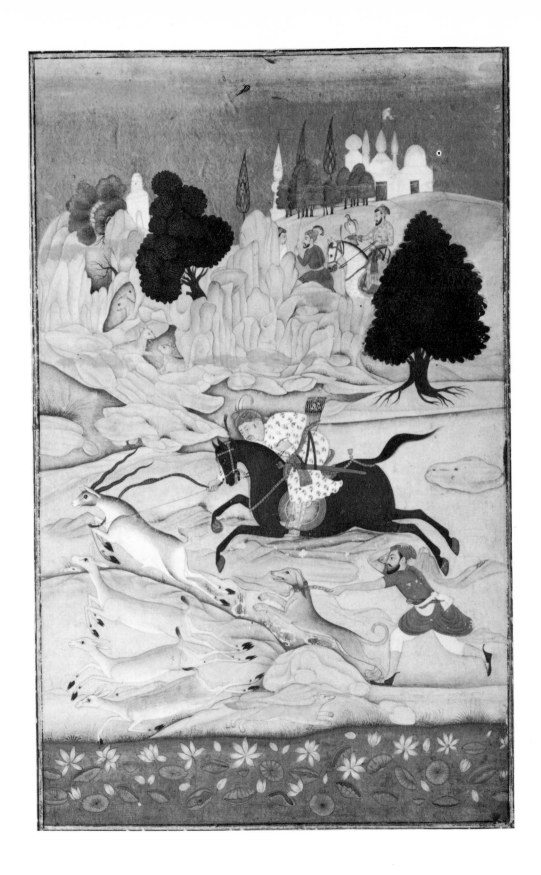

hunting was defined by complicated rules. According to the *Boke of St Albans* of AD 1456 a man was entitled to own different species of bird from gerfalcon for a king to musket or male sparrowhawk for a priest's clerk. Falconry was equally if not more popular in the Islamic world (39). The kings of Safawid Persia, and also the Seljuks, Mamelukes and Ottomans, all sought precious birds, and had court falconers such as this one to take care of them. From the courts of Islam the Emperor Frederick II of Hohenstaufen, Holy Roman Emperor (AD 1220–50), drew his information for his famous treatise on falconry *De arte venandi cum avibus* (*On the Art of Hunting with Birds, an Analytical Inquiry into the Natural Phenomena manifest in Hawking*).

Frederick II was the epitome of the medieval king with an elaborate court, whose pleasure and might was expressed in ceremony, procession and the hunt. His court was more exotic than most. Not only was he the Hohenstaufen Emperor of Germany but through his mother he was King of Naples and Sicily with its Islamic heritage. The camels and dromedaries employed in his baggage train were the wonder of Italy, and in AD 1231 he startled Ravenna with his panthers, leopards and white falcons. Frederick's book on falconry is famous for his detailed knowledge of the practical problems of rearing and keeping birds, and also for his exposition of the scientific questions based both on the works of Aristotle and his own personal observations. Though his writings were revolutionary in this respect, his attitude to hawking as the proper pursuit of the noble and the king is in the full tradition of the ancient and medieval emphasis on a ranking of men and beasts in hunting.

The hunts of the medieval kings and Renaissance princes were thus an assertion of power and prestige by means of restrictive rules and splendid display. Such courtly hunting scenes embellish the margins of late medieval manuscripts. Equally attractive are the miniatures painted for the Mughal court in north India. The Mughals were the descendents of Tīmūr, or Tamerlane as he is known in the West, and through him the Mongols. Under Bābūr (AD 1526–30) they invaded north India taking with them the tradition and customs of Persia. The conquest of north India involved a long and prolonged series of campaigns. It was only under 'Akbar (AD 1556–1605), Bābūr's grandson, that Mughal rule became secure. Though 'Akbar was preoccupied with the campaigns of war through much of his life, he is illustrated here hunting (40). This miniature shows the emperor pursuing a blackbuck, but in fact the greatest importance was attached to the hunting of the tiger, the killing of which was ceremonially restricted to the emperor himself. Even with a lesser beast the purpose of the miniature was not merely to please or even to flatter but, as with the Assyrian reliefs, it was intended to glorify the emperor. Although the success of the king in killing the creature hunted is the common thread there has been an enormous change in artistic treatment, or at least that is the first impression. For this miniature seems to place animal and man on an equal footing; both are magnificent creatures. But the romantic landscape shows that this is an idealised portrait whose intention is not very different from the earlier bas-reliefs. In both hunting scenes man appears to take to himself the qualities of the beast he pursues.

2. Animals in the Service of Man

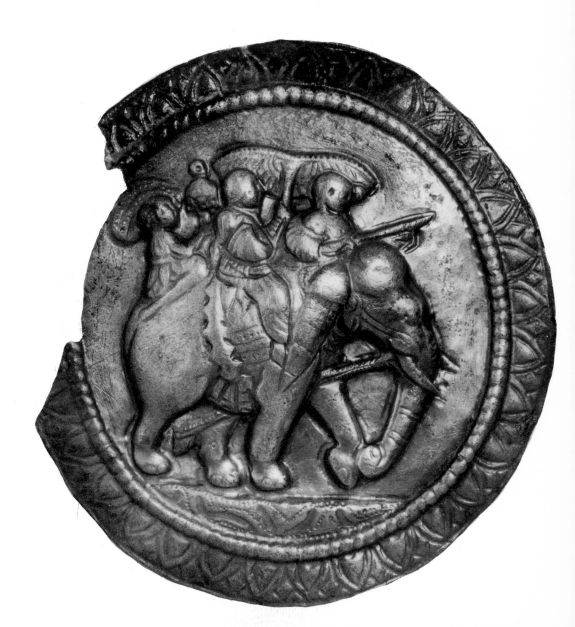

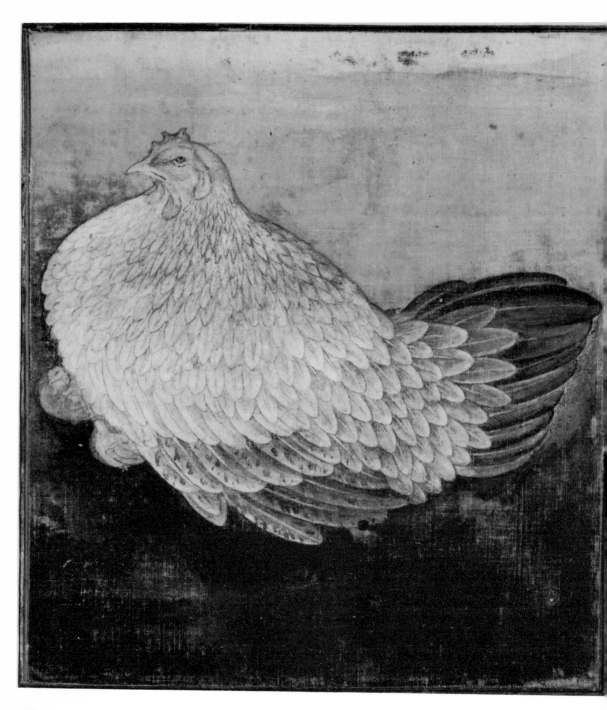

41
A hen and chicks. India,
Mughal school, period of
Jahāngīr (AD 1605–27).
Gouache on cotton. 19 ×
17·5 cm.

24

Animals hunted are animals seen from afar. Animals domesticated, used by man, can be studied more intimately for they are always close at hand. The painters at the Mughal court in north India in the sixteenth and seventeenth centuries had a keen eye for fine detail. They were contemporaries of the artists in Holland or Italy who produced equally appealing studies of animals. A hen, puffed out and protective over her chicks, has been painted with faithful and loving care, the fan of her feathers forming a pattern of subtly varied colours (41). From the Deccan comes a wholly contrasting miniature which catches with deceptive simplicity the attempt of an ox to evade his keeper (42); breaking into the painted frame of the picture, as though in flight above the cowering herdsman, the animal shows all his strength but the menace is tempered by an element of humour.

The proximity of domesticated animals to the men whose lives they share gives many of the paintings and sculptures in which they appear a timeless quality. For it is the elements of familiarity which are most successfully captured. A pair of Roman grey-hounds could easily be the much loved dogs of today (43). This effect is due not just to the realistic sculpture which was the artistic medium of the time, but to the close ties with man which gave the opportunity to observe these playful moments and the sympathy to record

umped ox (zebu). India,
ssibly Deccan, 18th
ntury AD.
ouache on paper. 13·8 ×
·5 cm.

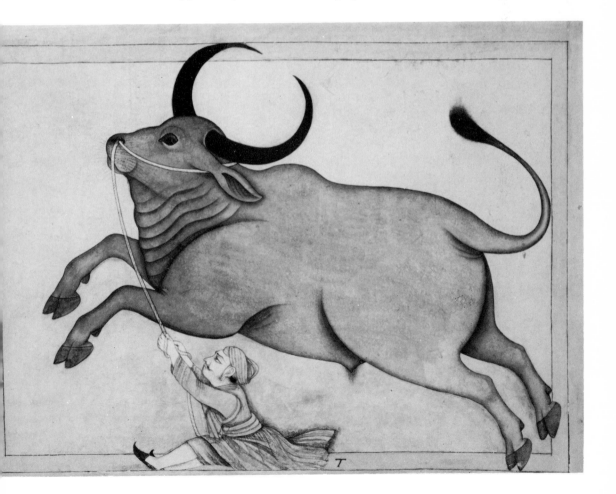

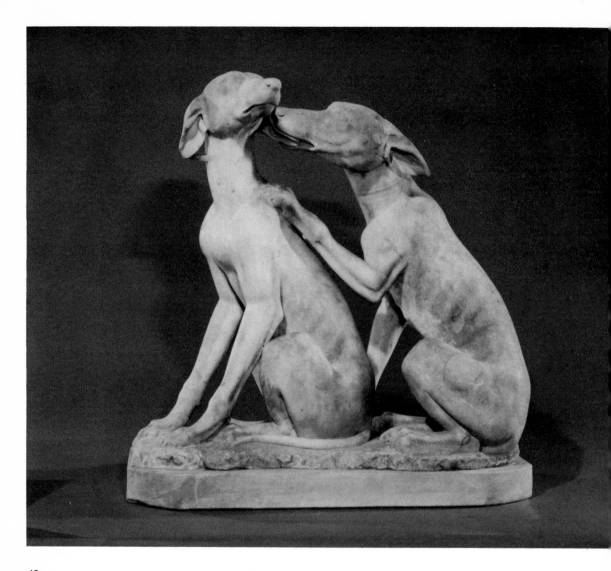

43
Two greyhounds, a dog and a
bitch, in marble. Found at
Monte Cagnolo, near the
ancient Lanuvium. Roman,
1st–2nd century AD. Height
65 cm.

them. In western civilisation the dog has always had a special place in man's
affection. He is commended for his faithful service and dedication to his
master. Such affection is not sustained in all cultures. In Islamic countries the
attitude to dogs has always been ambiguous: hounds are a special breed, and
formerly an emir was often put in charge of them as master of the hunt, but in
general they do not share the house and hearth in the same way as dogs do in
the West. Cats, on the other hand, have there been fully accepted in the
household (44); surprisingly there are in the countries of Islam, as in the
West, relatively few representations of them.

In both European and Islamic countries pigeons have been widely kept
(45). The most extravagant pigeon houses are the towers at Isfahan in Persia
and Diyarbekir in eastern Turkey built in the seventeenth and eighteenth
centuries. Their construction was a work of piety, for here, though not in all
Islamic countries, pigeons were looked on as sacred because their cooing was

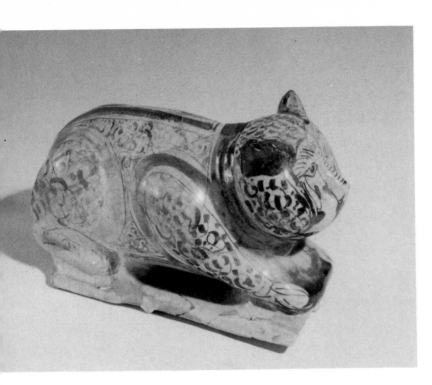

44
Hollow earthenware cat
painted with lustre details on
a semi-opaque white glaze.
Possibly from Rayy, Persia,
13th century AD. Apart from
the bestiaries (cf. the *Manāfi͑c
al-ḥayawān* of Ibn Baktishū͑c)
the sources ignore cats which
nonetheless were widely
domesticated in Islam.
Length 21 cm.

45
Steel fan-tail pigeon, inlay of
gold and garnets. Signed on
the back of the head by the
craftsman, Ḥājjī c͑Abbās. Zand
or Qājār, Persia, 18th–19th
century AD. Length 22 cm.

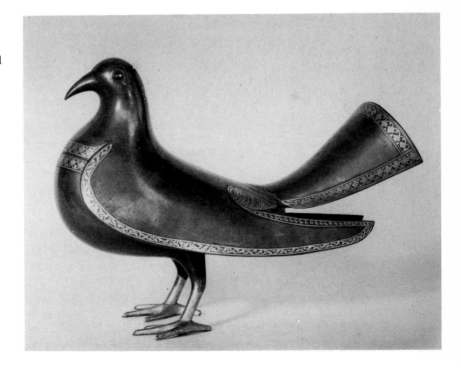

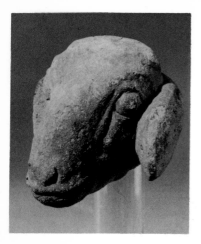

46
Head of a ewe in baked clay.
From Babylonia, Sumerian,
Late Prehistoric period, *c.* 2900
BC. The head is similar to the
present day Persian fat-tailed
sheep. Height 9·5 cm.

likened to *Huwa! Huwa!* (He! He! *that is* God). Long before this date carrie
pigeons were used by the Mamelukes in Egypt, and even earlier, in Fatimi
Egypt in the tenth to twelfth century AD, the pigeon was a favourite shape fo
water containers and incense burners.

These few examples alone show that in different places and times ther
have been various needs and preferences for the animals used. Climate
custom and even personal taste all have their role. What is always importan
in the portrayal of domestic animals is the degree of familiarity which ma
has had with the particular creature. Cats in Egypt were, for example, bot
domestic and sacred animals, and their portraits show precisely this. Cat
were sacred to the goddess Bastet (see p. 49) but they were also trained fo
hunting and kept as pets. The different roles are shown by nuances in th
form of representation.

Studies of domesticated animals are known from very early times. Thi
head of a sheep of the third millennium BC (46) has the same almos
sentimental character as the grey-hounds. It is again an animal living closel
with man. It comes from southern Iraq, the area where man firs
domesticated animals and established settled agriculture. The earliest settle
agricultural societies make convenient, almost stereotyped, contrast wit
those in which hunting is the main preoccupation. Remarkably, or perhap
understandably, the animals who came to share man's life were much les
elaborately portrayed than those which the hunters of the paleolithic perio
pursued, trapped and killed. In the short term much less was at stake; in th
long term man owes much to the sheep.

Sheep and goats were the first livestock animals to be domesticated. The
beginnings of domestication seem to have taken place in the uplands of Iraq
and Iran, but the practice spread rapidly to the rest of the Middle East. The
earliest evidence for the domestication of goats and sheep has been found a
sites on the western edge of the Iranian plateau, *c.* 8000 BC. Man had
probably tried to tame many different animals, but they had not all proved
possible to domesticate. Gazelle and deer, for example, are territorial animals
which are unlikely to breed if herded together and thus constrained by man
Only animals with a suitable social hierarchy, such as the sheep and the goat,
that can accommodate man's domination, can be readily domesticated.
These animals, moreover, have versatile eating habits which are compatible
with the cultivation of crops. While crops are growing they can be tethered
satisfactorily, and after the harvest is gathered they will graze across the
stubble.

The very elaborate civilisations based on agriculture, particularly in
Egypt, illustrate a special attitude to domesticated animals. Egypt as a fertile
land was created and defined by the Nile. Until very recent times the annual
inundation of the river in late summer deposited a layer of rich, black mud
over the fields. Intensive irrigation and deep ploughing were therefore
unnecessary. After the waters had subsided the ploughman with his oxen
turned over the earth (47). Herds of goats or sheep were driven over the fields
to trample in the seeds. In normal years the peasant had no fears for his crops
but sometimes the Nile failed to respond to the prayers of the king. The flood
was low or, worse still, delayed and the desert began to encroach on the thin
strip of cultivation bordering the river.

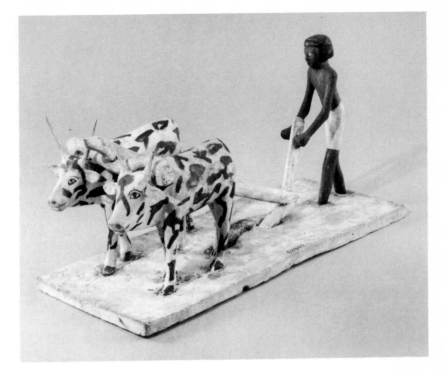

...inted wooden model of oxen ...oughing. Egyptian, Middle ...ingdom, *c.* 2000 BC. Models ...this type were included in ...e tombs of Middle Kingdom ...ficials. They illustrated the ...tivities of servants on an ...tate so that they might exist ...r the benefit of the official in ...e Afterworld. Height 28 cm.

From early times a highly complex administrative system was developed, involving the registration and assessment of land for tax. This was based on the surface area of each province and the recorded height of the inundation. Taxes were paid in kind and much of the produce went to 'the table of the ruler', but a proportion was stored regionally, so that rations might be issued if the crops failed.

Under Tuthmosis III (*c.* 1475 BC) taxes were levied in the form of grain, herds, fruits, agricultural produce and gold and silver. For the Old Kingdom (*c.* 2686–2181 BC) only two forms of taxation were known: periods of labour from those who held few or no possessions, and grain and livestock from those who owned estates.

While the Egyptians were unsuccessful in their attempts to domesticate desert animals like the antelope and the oryx, the breeding of cattle and poultry was already highly developed in the Old Kingdom. Such stock was assessed annually. In a scene from the tomb of Nebamun geese are being herded before scribes for inspection and census (48).

Officials like Khaemwese, the overseer of the cattle owned by the god Amun, were responsible for the breeding and assessment of all beasts in their charge (49). The great temples raised cattle and poultry not only for food but also for ritual purposes; they might be offered as sacrifices or as part of the meal presented to the god. Similarly an inspection of standing crops took place just before the harvest in May. Another scene from Nebamun's tomb shows an official standing by a field of ripening barley to check a boundary stone. He says: 'As the Great God who is in Heaven endures, the stela is correct' (50).

Dishonesty in agricultural matters was considered a severe crime. Chapter

125 of the *Book of the Dead* lists forty-two crimes which the dead man had to deny before he might be granted eternal life.

I have not lessened the supplies of food, I have not diminished the land measurement. I have not encroached on fields, I have not deprived the herds of their pastures, I have not built a dam on flowing water, I have not withheld cattle from the god's offerings.

In such a context the animals had become part of the organisation of the country.

Animals are regarded in this way in all societies, both ancient and modern, where they are an essential part of the economy. Man's relationship to the horse has been equally systematised but for quite different reasons. There are still complicated methods of training and rules for breeding. These are the consequence of the problems of breaking a horse and of the importance which men attach to particular qualities. They arise above all from man's admiration for the horse, which is prized and valued above most other animals. In India for example, in Vedic times *c.* 1200 BC, the horse was a symbol of royal authority, and its sacrifice consecrated the power of the king. This horse sacrifice was also performed by the Maurya emperors in the third century BC, but then fell into disuse, until it was restored to honour by the Gupta dynasty in the fourth to fifth century AD.

The ritual was probably introduced with the horse itself by the Indo-Iranian tribes who invaded India in the second millennium BC. Certainly the domestication of the horse took place much further north, possibly in the

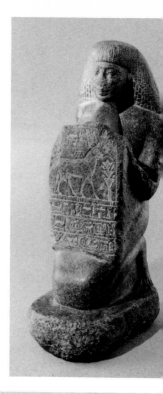

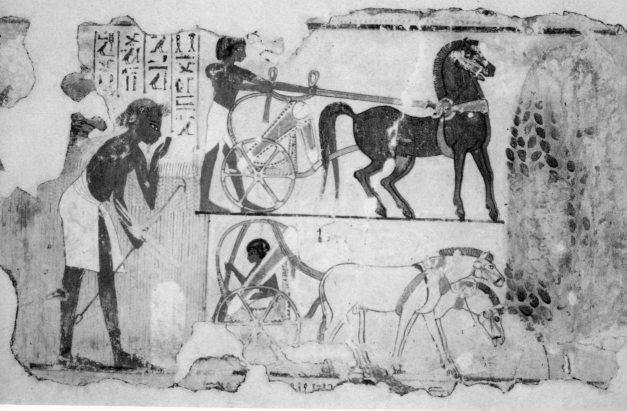

9

ranite statue of an official.
gyptian, Eighteenth Dynasty,
 1420 BC. The official kneels,
ith his arms raised in
doration. Carved on the stela
efore him is the figure of a
m, sacred to Amun, wearing
ie distinctive headdress of the
od with the sun-disk. The text
elow names the official as
haemwese, overseer of the
attle of Amun and scribe of
ie house of Menkheperure'
Tuthmosis IV). Height
4·5 cm.

0

omb painting showing two
hariots, one drawn by horses,
he other by mules. From
hebes, Egyptian, Eighteenth
Dynasty, c. 1400 BC. The horse
nd chariot were introduced
nto Egypt by invaders during
he Second Intermediate
eriod (1633–1567 BC) and
evolutionised fighting
echniques. On the left a man is
hown checking a boundary
tone. Height 58·5 cm.

8

omb painting showing the
ssessment of geese. From
hebes, Egyptian, Eighteenth
Dynasty, c. 1400 BC. Above,
everal scribes squatting on the
ground record the count made
by the attendants. Below to the
eft a scribe reports to the
wner whose figure is not
reserved. In the New
Kingdom paintings on the
omb walls served the same
urpose as the Middle
Kingdom wooden models.
Height 92 cm.

area of the Ukraine. Although the horse is a familiar animal today its early history is obscure; there were at least two species of wild horse, the Tarpan and the Przewalski, but there may have been others including the ancestors of the Arab breed. By c. 1700 BC domesticated horses were used throughout the Near and Middle East.

Horses were certainly ridden, but without stirrups. For this reason they could not be used effectively in war as the horseman had nothing to balance against when wielding a heavy weapon. Instead horses drew chariots for warfare and hunting. Earlier carts were drawn by mules, but in the second millennium much lighter forms of chariot were developed which can be seen in the Egyptian tomb painting (50) and a gaming box from Cyprus (33). In this area chariots had a high box and wheels with relatively few spokes. Similar but later and very solid versions are shown on the bas-reliefs of Ashurnasirpal killing a lion (28). A rather different type of chariot with a shallow box and many spoked wheels was taken eastwards from the area north of the Caucasus to China. As we have noted in the chapter on hunting, horse-drawn waggons and carts were an essential part of the lives of the nomadic peoples in Europe and Central Asia.

So far we have described chariots which are shown from the side to illustrate the pursuit of quarry and enemies. The artists were in this way recording the motion which was so much prized. Two later examples from the classical world show changing views. The naive charm of a terracotta model from Cyprus (51) puts the ponies first and men second. The chariot comes a very poor third. Indeed this vehicle has quite a slight structure compared with most of the war chariots we have described so far. In Greece (52) the situation was the same. Unlike the great battle chariots of the Assyrians, the chariot was not used as an integral part of the fighting force. Instead it brought the warriors to the scene of the fighting, where they then got down from their vehicle to fight on foot. On the vase the lightness of the chariot is clear, and, most important of all, the proud bearing and fine heads of the horses are emphasised. The black-figured technique of decorating Greek vases was an exceptionally effective way of recording the mane, eyes and muscles, and thus underlined the good breeding and high spirits of these beasts. As with the Cyprus model, the emphasis is on the horse rather than the speed and motion of the vehicle. Many different portrayals of chariots

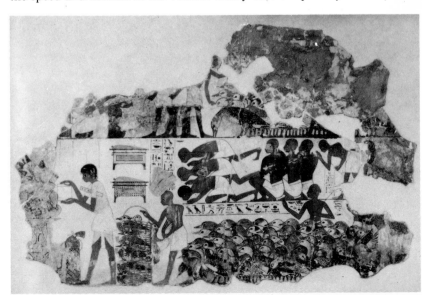

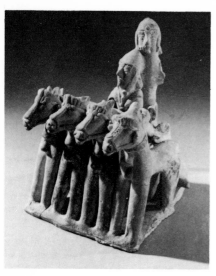

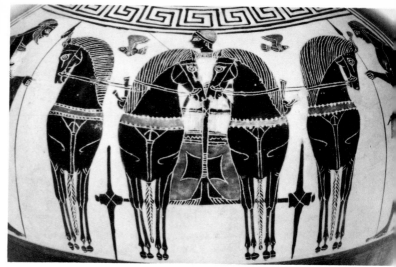

51
Hand-modelled terracotta group of a chariot pulled by four ponies or mules, with red, yellow and black coloured details. Two figures survive in the chariot (originally there were three), a driver and a warrior. Made in Cyprus and found at Tamassos. Mid-6th century BC. Height 20·7 cm.

52
A four-horse chariot shown on a black-figured jug. Found in Italy but made in Athens, decorated by the Amasis Painter. Greek, *c.* 540 BC. Height 21·2 cm.

and horses can be seen on Greek vases, but always the horse features more prominently than the chariot. A frontal view of the group was popular and had a long life, reappearing on Byzantine silks.

This emphasis on the horse may reflect a change in the way it was used. In the first millennium BC the horse became more widely used for riding. Mention is made of Assyrian cavalry in the ninth century BC. It was about this time that the nomadic inhabitants of Central Asia took to riding to a significant degree. The horses increased their range and their mobility and this struck fear into the heart of the settled lands of China, Western Asia and Europe. Bands of horsemen would descend on settlements, plunder and loot and retreat with speed. To combat this menace the Chinese and Greeks also became riders and cavalry came into use in these areas as well. In later centuries the mounted Arabs had the same advantages as the earlier Central Asian nomads, and speed on horseback was one of the foundations of their fortune.

Some of the magic and almost supernatural speed and skill of the nomadic horsemen is captured in a pair of slender Etruscan bronzes (53). They are sometimes said to represent Scythians. One archer is shown shooting backwards, the 'Parthian shot', a technique much used on the Central Asian steppe. The depiction of nomadic warriors in Etruscan bronze-work is probably of some significance. As we have already seen, the people who cast the bronzes in north Italy before the arrival of the Etruscans must have had close relations with the peoples of the north and east, and they must have been familiar with the eastern horsemen. Indeed there are so many features which Etruscan art shares with Western Asia and Egypt that trade alone can hardly explain the full connection. Perhaps the Etruscans included among them peoples of the east from Van or the Caucasus.

Nothing could point the contrast more clearly between the nomadic horsemen glimpsed at speed and the cavalry men of the classical world than a bronze horse (54). This Greek horse and rider are much more realistic in impression, if not in detail, than the Etruscan examples. The same stylistic

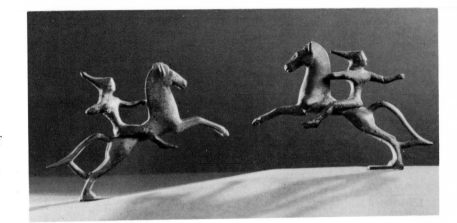

3
Cast bronze representations of two Scythian archers, or Amazons, mounted on horses. Etruscan, *c.* 500 BC. Such figures decorated the rims of large bronze vessels. Length 15 cm.

4
Warrior on horseback, cast in bronze. Found at Grumentum, in Lucania. Made in a Greek city in southern Italy, perhaps Taras, *c.* 550 BC. Length 27 cm.

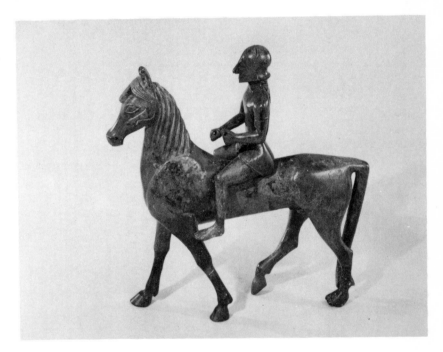

elements found on the horses on the black-figured vase are here reproduced in bronze; the emphasis is on the eye, the mane and the lines of the shoulders and the haunches. Grumentum in southern Italy, where the bronze was found, imported many items from mainland Greece, but this bronze was a product of an independent bronze-casting industry in Italy. It is the answer of the civilised world to the nomad threat: armour against arrows, and a good strong horse to meet the enemy on equal terms.

In the Far East the Chinese followed the nomadic tribes in the use of horses for riding. Constant pressure from the Hsiung-nu forced the Chinese to seek faster and stronger horses from further west. In the first century BC, embassies were sent to Ferghana, a dependency of Sogdiana which was a principality with its capital at Samarkand. By the second century AD the Chinese had gained access to a supply of western or 'dragon-horses'. From

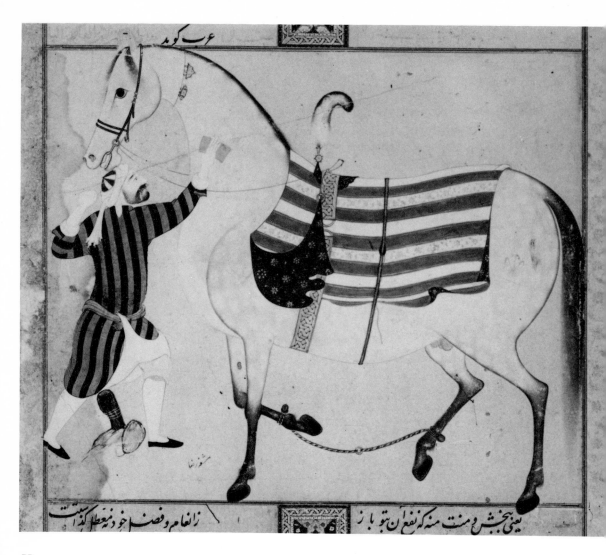

55
Grooming a stallion.
Miniature from a book of
verse. Safawid Persia, late 16th
century. Signed ʿShiqar Riḍā,
possibly one of the names of
the well-known painter, Aqā
Riḍā and datable to AD
1580–90. Above the miniature
is written ʿarab gūʾīd, roughly,
'said to be Arab'. Arab steeds
were highly esteemed in Persia
and Central Asia, and along
with Turcoman horses were
exported to China. Note the
brand on the horse's rump.
Tempera on paper. 20 ×
30·3 cm.

then on the Chinese regularly imported horses from the West, usually by
trading with the Turkic tribes on their borders. As this tribute and trade in
horses was of great importance the Chinese were often humbled by the
Turkic peoples into handing over large quantities of silk for relatively
inferior horses. As one famous poet Po Chü-i wrote in the ninth century AD:

Day after day silk is taken out of China and horses are brought in.
But the land is not suitable and there is nothing for the horses to eat.
Each year of every ten horses six or seven are maimed or die.
The woven silks cannot meet the demand and the women toil away.
(From the *Mountains of Yin-shan*)

Horses were of course first and foremost for the serious business of war, but
exotically coloured beasts and well-trained animals were prized as
curiosities. The Chinese were particularly fond of highly trained horses.

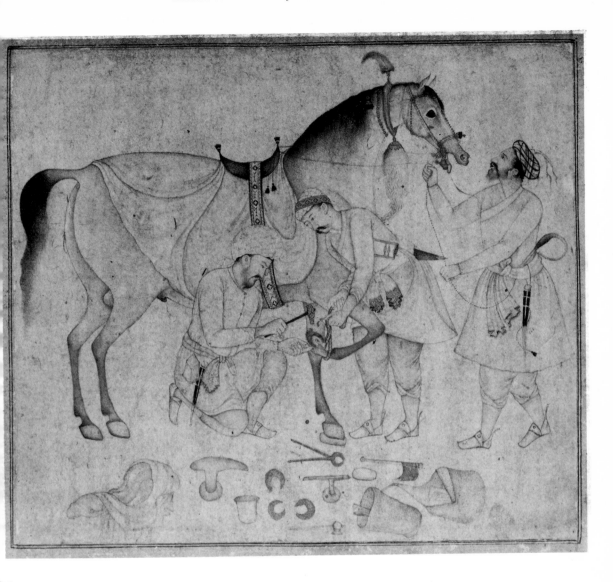

56
Stallion being shod. India,
Mughal school, *c.* AD 1600.
The shoe is presumably 'cold
fitted'. Farrier's tools and
horse shoes are shown below.
Tinted drawing on paper. 12·4
× 14·2 cm.

Horses were also used for the game of polo which was introduced to China
from Iran. Indeed the palace had its own polo field. Records show that a pair
of polo ponies were sent to China by the Central Asian city of Khotan in AD
717. Although the T'ang dynasty (AD 618–906) was the time when exotic
horses were most highly prized, and the stories about them were legendary,
the Chinese interest in imported horses never disappeared completely. The
genre of Persian horse-painting of which this miniature (55) is an example
may well have been inspired by a Chinese horse-painting. For a Ming
emperor had been so delighted by a horse with white feet sent to him by
a grandson of Tamerlane, the famous astronomer Ulugh Beg, from
Samarkand in AD 1419 or 1420, that he had a picture painted of it and sent
it back with the next Chinese embassy westwards.

 The horses so valued by the Chinese have their most attractive and
extraordinary points set out in lyrical poetry and evocative prose. A few

57
Bronze coin of the Pandya
kingdom in Ceylon *c.* AD 100.
As realism is so very
uncommon in Indian
numismatic art, this coin is
remarkable for its realistic
portrait of an elephant. Width
25 mm.

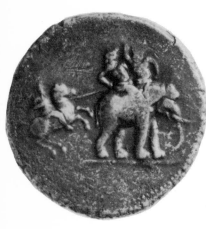

58
Silver coin of Alexander III,
the Great, kingdom of
Macedon. Issued at Babylon *c.*
325 BC. Alexander on
horseback attacking the Indian
king Poros on an elephant.
This is the earliest Greek coin
to show a representation of a
living king, and also the first to
commemorate so graphically
an historical event. Diameter
35 mm.

paintings have survived which also convey the same degree of interest. The
many earthenware figures, on the other hand, are rather ponderous and
solid. Only the 'flying horse' in bronze of Han dynasty date, second century
AD, recently excavated in China, illustrates the speed and beauty which the
Chinese so clearly admired in thoroughbred horses.

The Persian miniature, on the other hand, is a consummate study of a
horse of fine pedigree. The artist has conveyed the image of a horse of great
quality. This he has done not only by realistic detail, but by the balance of the
proportions of body. A fine head and legs are set against the solidity of the
body of this highly-bred creature; the dappled skin was probably a much
valued feature. The men of the countries of Islam had a great respect for the
horse, about which there was a large corpus of mythical tradition, describing
the winged horses of the angels, the horses of King Solomon, and the
Prophet's celestial steed.

This concern with horses was taken into India by the Mughal descendants
of Timūr, or Tamerlane, when they conquered northern India in the
sixteenth century. The Mughal painting is less a portrait of a pedigreed
creature and more a loving study of the technicalities of shoeing a horse set
out in exceptional detail (56). This is a composition in which man's work
with horses is explored in the space of the frame. The three men for the task
and the large array of tools are all as important as the horse itself.

We are accustomed to think of the horse and the ox as the main beasts of
burden, but in the East, in Arabia, Asia and India, the camel and the
elephant were more dominant. The camel was possibly domesticated in
Central Asia. At the same time or even slightly earlier the dromedary was
tamed and bred in Arabia from a different species of wild camel. In the silk
trade, by which China paid for horses in bales of silk, the camel played a
major part as transport. While camels were used in lands of great drought the
elephant was a creature for use in the monsoon tropics. Indeed in southern
India and Ceylon it was the principal beast of burden. Its importance was so
great that it was made the dynastic symbol of the Pandya Kingdom of
Ceylon (57).

In early historic India the elephant was no less important than the horse,
and so it was to remain. When hunting the king would avoid killing
elephants whose breeding was a royal prerogative. They were, however,
much sought after for their tusks which the Indian ivory worker carved with
great skill. The docile and intelligent elephant could be trained for work and
war. Indian armies were traditionally divided into corps of elephants,
cavalry, chariots and infantry, probably as long ago as Alexander the
Great's incursion, when at the battle of the Hydaspes in 326 BC the central
position of the enemy's elephants obliged him to attack from behind: in the
confusion the elephants did more harm to their own side than to the
Macedonians (58). Elephants carried archers as well as the *mahout* or driver
and were accompanied by horsemen and footguards. Armoured elephants
are also reported. Instructions for their use in war are given in a treatise said
to go back to Alexander's time. The care and training of elephants counted
as one of the accomplishments of a prince and formed the subject of technical
works in Indian literature which also included texts on the veterinary arts.

The elephant was used on coinage to symbolise strength and victory. It is

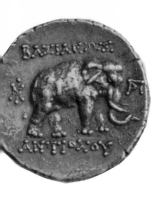

in this guise that it appears on a coin (59) of Antiochus III, King of Syria (246–227 BC), and nearly two thousand years later on a coin (60) of King Christian V of Denmark (AD 1670–99). King Antiochus III made an expedition against Bactria, now in Afghanistan; during the campaign he obtained a tribute of elephants from an Indian king, and this is commemorated on his coin. For Christian V the connection with elephants is more obscure. The coin refers to Christian's refoundation of the 'Order of the Elephant' in AD 1693. This was an exclusive order originating in the period of the Crusades when Europeans may have met with elephants in battle. The stylisation suggests how little contact with elephants the Europeans had; the formal representation of a castle on its back is probably derived from the pictures of elephants in the medieval bestiary (see p. 59).

This form of fighting platform is far removed from that traditionally used in India. Indeed the whole image has none of the grace and elegance of the ceremonial or state elephant, a thoroughly Indian motif shown on an ancient silver roundel (61). The state elephant was chosen with careful attention to certain characteristics which were thought to confirm the animal's royal and sacred origin. He had, for example, to have a very light grey skin colour described as white. This elephant of state was believed to be born of a cloud and compared with Airavāta, the mount of the king of the gods.

The elephant, the horse and even the pigeon have far more complicated associations than at first imagined, but their portraits display warmth and affection far beyond that shown for the creatures hunting and hunted. Familiarity may breed this response and so too does man's dependence. To the domesticated animals man attributes the more domestic human qualities.

Ilver coin of Antiochus III, eleucid king of Syria (246–227 :). Diameter 29 mm.

Ilver presentation coin of hristian V, King of Denmark D 1670–99, showing an dian elephant. Width 37 mm.

mbossed silver roundel with ders on elephant. Acquired at awalpindi, *c*. 2nd century AD. iameter 7·2 cm.

61

3. Animals in Thought and Religion

Men in many societies have used animals as symbols in their interpretation of their world. Some of the most striking examples of descriptions of the spiritual and material world in terms of animals are found in Africa, but even in this one continent there is no single formula. Each group of peoples have their own attitudes and beliefs with which certain animals are associated. In other parts of the globe quite different forms of explanation have been found.

To take Africa first, one particular study has, for example, illustrated three possible but different schemes. Among one group, the Nuer of the southern Sudan, the society of cattle was opposed to the domain of wild creatures. Man was paired with the ox as the most important creature of all, and the animals of the wild had little significance. By contrast the Lele in Zaire chose the animals who inhabited the forest to represent important aspects of life. The pangolin was taken by them to stand for the inner essence of man. The Fipa of Tanzania ignored the whole problem of wild and domestic; for them both were part of a process of intellectual control. This was realised at its fullest in the python. The control of this creature by man symbolised the most fundamental process of life by which the strange and unknown was brought into the light and order of human understanding.

The bronzes of Benin illustrate in art the way in which such systems of describing the universe can be expressed visually. These so-called bronzes, which are more accurately described as brasses, were made in the kingdom of

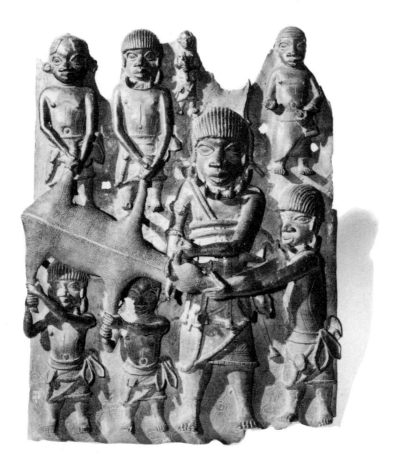

62
Brass plaque depicting the sacrifice of a cow, probably during the annual rites in honour of the king's ancestors. Benin, Nigeria, early 17th century AD. It is not known whether the plaques portray events, people, or simply stereotypes of court life. Height 51 cm.

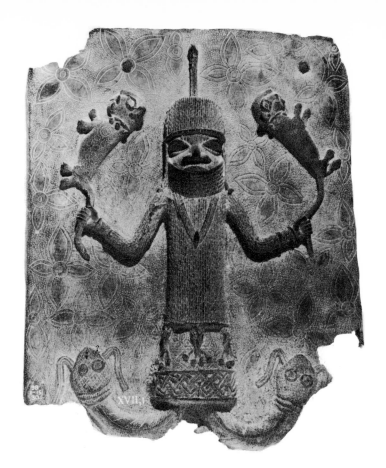

the Edo or Bini, which at one time formed an empire from Lagos in the west
to the Niger in the east. In the sixteenth and seventeenth centuries brass
plaques in which animals figure prominently decorated the palace of the
king, known as the *Oba*. The animals on Benin bronzes belong to three
groups: firstly those animals which man dominates, then a group which
though aggressive were taken as symbols of legitimate power, and finally
those which are hostile and represented abnormal power. The docile
vulnerable animals make up the first group: the mud-fish, antelope, cow,
pangolin, goat, ram and chicken. These animals man sacrificed and ate (62).
Towards all of them man was the aggressor and by this he expressed his
domination of a portion of the created universe. In the stance of the men
taking the cow to sacrifice this bearing of supremacy is shown.

A different power and a more dangerous one was symbolised by the
leopard, the elephant, python, crocodile and vulturine eagle. The leopard
was called the King of the Bush and was therefore the counterpart of the *Oba*
of Benin (63). According to a myth told by a renowned diviner or healer, the
leopard was chosen for kingship over the animals by God not only because
of its great power and beautiful skin, but also because of its good nature and
capacity to convene and direct an orderly peaceful meeting of animals. The
king alone was permitted to kill a leopard and this he did annually in sacrifice
at the rite which reaffirmed his own divinity and symbolised his ultimate
dominion over both natural and human life. The crocodile was also a symbol

of legitimate power as he was regarded as the policeman of Olokun, the King of the Sea and watery counterpart of the King of the Dry Land, again the King of Benin. Powerful rebel chiefs, on the other hand, were associated with the elephant. All these creatures, in their hostility, reversed the ideal relationship of man and animal. But their aggression was seen, not as random, but directed, like that of the king himself, by the forces of the supernatural world.

Fearful these powers were but not sinister. A medicine-cult staff, on the other hand, with its ambiguous silhouette (64) vividly conveys the injurious hostility of the creatures with abnormal power. These are the great grey heron, the owl, certain other birds (some of which were imaginary), the chameleon and particular species of snake: creatures associated with the night, with the power to transform, and with witchcraft and magic. They were seen as dangerous because they implied the dissolution of the boundary between man and animal. The ability to transform one's self into one of these night creatures was regarded as the height of supernatural power obtainable by man. The King of the Night, for example, (the morally inverted counterpart of the King of the Day, the King of Benin himself) transformed into the great grey heron. This ability was also possessed by witches and by the *obo*, the diviner or healer. The witches used their power for evil, sending out their life force in the guise of a hostile bird which would devour the victim who in turn had been transformed into a goat or antelope. The *obo,* on the other hand, would use the same power for good not evil. The wrought-iron staff (64) was one of the principal cult objects used by the *obo* in his transformation and control of this the third sphere.

Like the peoples of Benin, the Ashanti, who occupied the central area of Ghana, recognised important divisions in their world. The most significant boundary separated the village, the territory of the domesticated animals cows, goats, pigs, cats, dogs and sheep – from the bush, the domain of the wild – the leopard and the antelope. Between the two was an indeterminate zone on the fringe of the village used for refuse. This last was not unnaturally the haunt of the scavengers – the wild dog, the crow and the vulture.

Much of the influence of the Ashanti, who were one of the most successful powers in West Africa, depended on their control of gold mining. Small brass weights (65) used to weigh out gold dust were made in the shape of animals. Wide though the range of animal subjects is, the creatures of the bush alone are shown in these small castings. This use of animals of one domain only, it can be argued, cannot have happened by chance. The weights may have been associated with dangerous characteristics particularly with transformation, as by gold, money, or currency, things can be exchanged or changed into another. In other words the weights were associated with a substance, which could in real life dissolve the distinction between categories. A complete separation between the two categories was obviously important. Also the village life symbolised by the domestic animals was precious, the bush dangerous. So it is the creatures of the bush which appear on the weights. Within this one sphere further qualities were associated with particular animals. The leopard was fierce but beautiful and symbolised royal power; the elephant, bulky, blundering and strong represented the lesser chieftains. The antelope, the prey of the leopard, was

...ass weights for gold dust.
..shanti, Ghana. 18th and 19th
..ntury AD.

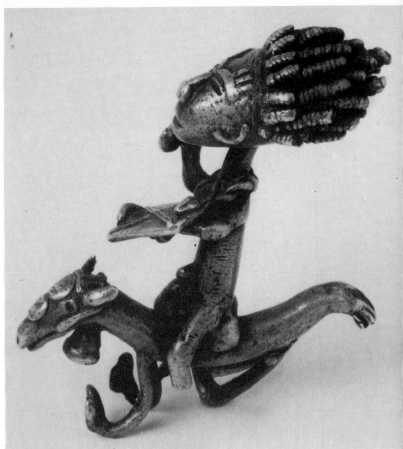

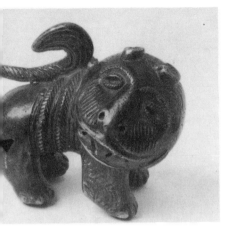

lion. Length 6·2 cm.

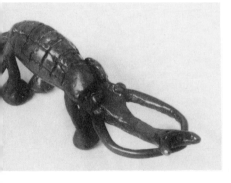

.n elephant. Length 7·7 cm.

b
A warrior on horseback.
Height 11·5 cm.

d
A scorpion. Length 6·2 cm.

the symbol of the intelligence of man which has to give way to the brutality of force. The subtleties of these characteristics were explained in proverbs in which the weak are pitted against the strong, the cunning against the stupid, the large against the small.

The Benin and Ashanti brasses or bronzes demonstrate that descriptions of the world can be built up in terms of animals, with different groups representing various spheres of activity of man. More difficult to express is the import of the fetish and the mask, which in Africa are two of the most common ways of using animal forms symbolically. The cultures in which

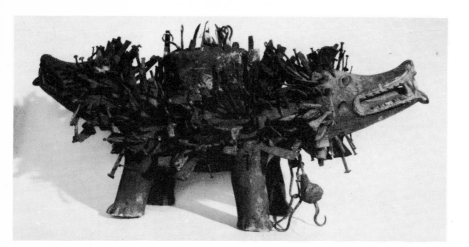

66
Two-headed dog; wood with nails and blades. Bakongo, Zaire. The Bakongo from the mouth of the Zaire River make several sorts of fetish or 'medicine' figures. This type is known as a *Konde*. It was regarded as a repository of ambiguous forces which could be manipulated by driving a nail into the object. Length 61 cm.

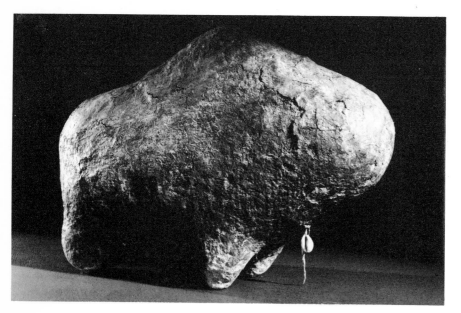

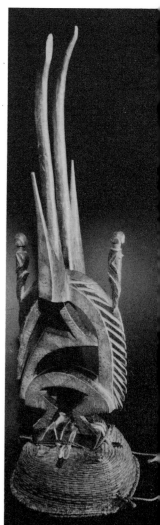

67
Altar in the form of a quadruped; indeterminate composition (said to include clay, beeswax and spit) on a framework of sticks and caked in dried blood. Bambara, Mali. Each of the Bambara initiatory cults in a village had altars or 'fetishes' incorporating materials of symbolic value, in which the power of the cult is located and on which blood sacrifices are made to generate and direct that power. Length 56 cm.

68
Headdress in the form of a roan antelope on the back of an aardvark; wood mounted on a basketry cap. Bambara, Mali. This particular mask is from the Bougouni district south of Bamako (the Bambara inhabit a wide area on both sides of the upper Niger) and in this region the antelope is invariably represented on the back of an aardvark, the burrowing of which is said by one authority to symbolise the way sunlight burrows into the earth to make crops grow. Height 65 cm.

they are found share some aspects of the same generalised view of the universe, that it is the conception of 'power' in the sense of ability or energy with, at a more specific level, a group of spirits who may activate such forces. This 'power' is ever-present, and it can be influenced by man by means of ritual. The fetish is one of the most evocative and mysterious ways of exercising this influence. Nails driven into a wooden double-headed dog (66) were used to manipulate these forces; the bristling irons give a vivid impression of their power. In particular the act of driving in a nail was a means to obtain the power which would enable a sick person to pass on his illness to an enemy or, less malevolently, was a simple act of thanks to acknowledge good fortune. In a very general sense a fetish is conceived as a repository of 'power'. It is activated by the addition of magical substances, blood and hair, and consecrated by a magical practitioner.

The Bakongo fetish is made explicitly in the form of a double-headed dog. Others represent leopards or humans. The *boli* or fetish of the Bambara peoples in Mali might be a buffalo or a hippopotamus (67). This particular *boli* is for the Kono society, the fourth in a series of six ranked cults in which Bambara men were initiated in order to acquire knowledge of ritual, myth, cosmology, metaphysics and moral values. All the associations or societies use *boli*. Among the societies of the Bambara the fifth is that of the Tyi Wara. Tyi Wara was a supernatural being whom, the myths relate, taught the Bambara the skills of agriculture. Tyi Wara literally means champion farmer. At first men became good and prosperous farmers, but when the harvest was good and the grain plentiful they wasted it and became less conscientious. Tyi Wara then despaired of his efforts and buried himself in the ground. When he had gone the men were anxious, so to appease him they created a fetish or *boli* in which his spirit could reside. The importance of any particular *boli* of this type is increased with age and with any supernatural phenomena in agriculture which are associated with it.

The power of Tyi Wara is also manifested in the elaborate headdresses carved by the Bambara (68). An antelope was the animal chosen to represent the powers of the Tyi Wara. They were worn at masquerades in the sixth of the initiation associations. The form of this mask with its towering horns is very beautiful. This, however, is not its most essential quality. The most important feature of all masks is that they provide a form in which spirits can make their appearances.

To each tribe or group of tribes, masks have a special significance, not only in the legends they record, but also in their power and function within the society. The mask of the Kalabari Ijo was concerned with the water spirits (69) for the basis of the Kalabari Ijo economy was fishing, and the success of any fishing expedition depended on the many water spirits inhabiting the river and creeks of the Niger delta, and their control of the movement of the shoals of fish. The water spirits are represented in masquerade form and their cult is a vehicle for the dancing which is the most developed Kalabari art. The mask itself is, as in this case, often worn horizontally and is not visible during the performance. It serves as the locus of the spirit during rites in the cult house where sacrifices are made to secure the beneficial activity of the spirit.

The graceful masks of the Mama people from the plateau of Nigeria represent the buffalo (70). This buffalo commemorates a legendary hero

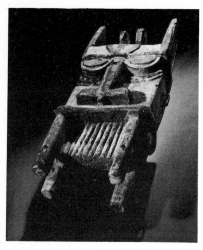

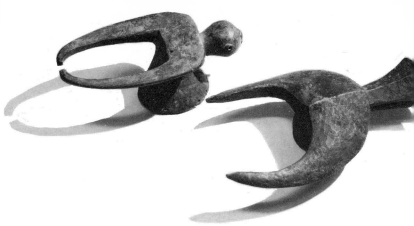

69
Wooden headdress combining human and hippopotamus features. Kalabari Ijo, Nigeria. Length 43·7 cm.

70
Two wooden headdresses each in the form of a buffalo head. From tribes in the Jos plateau region in Nigeria. Headdresses such as these are carved by several tribes including the Mama, the Rindri and the Kaleri, who inhabit the hills along the southern escarpment of the Jos plateau in central Nigeria. Length 46 cm, 37 cm.

whose power was so great that only a buffalo could represent him.

Thus masks are the residences of spirits at masquerades and adopt animal forms to represent the attributes of otherwise anthropomorphic spirits or legendary heroes. A world of the spirits symbolised by these animals provides an explanatory model of the world of nature and culture.

One of the most extraordinary types of sculpture which gathers up the forces of the universe, symbolised by animals, for the use of man in his daily life is the *ikenga* made by the Ibo peoples of south-eastern Nigeria (see colour plate II). These elaborate sculptures are shrines which a man sets up to the power of his right arm, the symbol of his ability or potential to achieve success in this life by his own efforts. They are carved on special occasions when, for example, the foundations of a house are laid. The help and advice of an *ikenga* is sought, and it is honoured with sacrifices of palm wine and kola nuts. Most *ikenga* were carved to represent a pair of animal horns, symbols of hunting trophies and of masculine prowess itself, and placed upon a stool, a symbol of rank.

Success in hunting was a universal need. A mask of a fish (see colour plate III) from Melanesia is connected with such success. The masks were worn during magical ceremonies to ensure a good catch. Some of the animals were of special significance to certain clans and such masks would probably be worn only by the members of the clan associated with the animal represented by the mask. The importance of animals as symbols of identity and as the source of actual livelihood are here closely linked.

A brilliantly painted bird (see colour plate IV) may likewise have such connections with a particular clan, but its significance is more elaborate than that of the mask. It was made in New Ireland, the eastern part of the Bismarck Archipelago, situated north-east of New Guinea. Religious ceremonies are of paramount importance in the lives of the people there, and *malanggan* carvings are the main and indispensable element of these ceremonies. They are primarily festivals in memory of dead relatives, but they also combine initiation rites for boys. The high point of the ceremonies is the display of carvings, figures, masks and open-work boards, made

'Humpen' or cylindrical drinking glass with enamelled decoration showing a bear attacked by hounds. Attributed to Bohemia, late 16th century. Although there is evidence that the technique of enamelling on glass may have been known in Europe as early as the 12th century, most early extant examples of European enamelled glass date from the mid-15th century and were made in Venice. By the end of the 16th century, the fashion became popular in other parts of Europe, especially Bohemia and Germany. Height 26·2 cm.

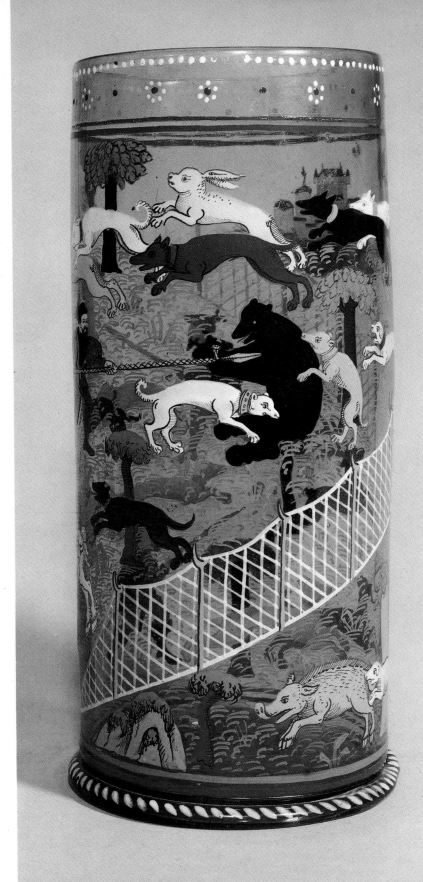

II
Wood tableau of human and
animal figures. Ibo, Nigeria.
This example is from the
Onitsha/Awka region of
northern Iboland, and the
typical form of the *ikenga* is
totally obscured by a riot of
figures of leopards, Europeans
on horseback, women with
children, rams, birds and
snakes, some of which may be
interpreted as symbols of
power and success. Height
14 cm.

III

Mask representing a fish, made of turtle shell and decorated with feathers, shells and seed pods. Torres Strait Islands, Melanesia, probably early 20th century. Animal masks were worn during ceremonies performed to ensure a good catch. Length 129·5 cm.

IV

Painted wood *malanggan* carving – a bird holding a double-headed snake. New Ireland, Melanesia, 19th century. *Malanggan* carvings are the focal point of ceremonies commemorating dead ancestors. The animals represented in the carvings are believed to have a special relationship with certain clans, or they may have a mythological significance. Width 46 cm.

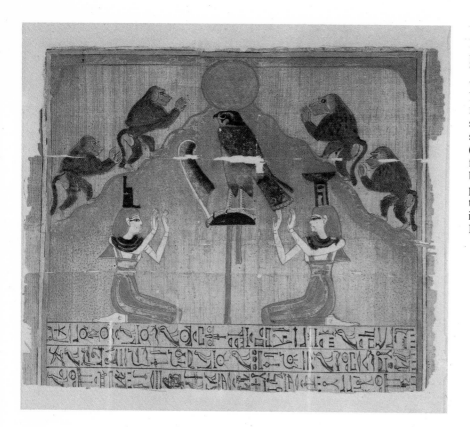

V

Book of the Dead. Part of the papyrus prepared for Pashedu 'foreman of the necropolis workmen'. Egyptian, Nineteenth Dynasty, *c.* 1250 BC. The adoration of the sun, shown as a falcon wearing the sun-disk by the goddesses Isis (left) and Nephthys (right) and four baboons. Probably drawn by a colleague of Pashedu, the papyrus is a fine example of the work of a skilled craftsman in the service of Pharoah. Length 53·5 cm.

VI

Three fabulous creatures painted on a drinking cup: a griffin, a siren and a sphinx. Made at Corinth. Greek, *c.* 600 BC. Height 11·1 cm.

especially for the purpose. The carvings may represent the dead ancestors, mythological figures or animals associated with certain clans. Preparations for the ceremonies take several years, and the festivities last for a few months after which the carvings are discarded or destroyed. The rights to carve certain patterns belong to individual families, and can be sold or given away.

Another bird sculpture of dramatic complexity is the hornbill (71) carved by the Iban people of Sarawak. The great sweep of the beak of this rhinoceros hornbill is counterbalanced by an intricate floral pattern in brilliant colouring. The wings and feet are less important because they are not distinctive in this species. The figure was placed on a pole at the Gawai Kenyalang festival which was traditionally prepared before a military or head-hunting expedition. This was to secure supernatural support, for the figure was an avatar of Sengalang Burong, one of the main spirits dominating Iban religion. In his dealings with human beings Sengalang Burong is manifested as the Brahminy kite, but for the Gawai Kenyalang festival he always appears in the hornbill. The complexity of the iconography is further illustrated by the possibility that a snake hanging from the bill is an allusion to the kite, for the kite eats snakes while the hornbill generally does not.

Across the Pacific on the north-west coast of America lived groups of Indians who also used the animals familiar in their world to represent or personify characters and scenes from their highly developed mythology. The whale, walrus, seal, sea otter, halibut, salmon and raven shared their habitat, and were used to express their spiritual world. The society was stratified, with the apex occupied by chiefs who claimed high rank through myths establishing the descent of the clan from supernatural beings who were often given an animal form. The claims by rival chiefs to this high status were reinforced by feasts known as *potlatches*. Such feasts might be prepared at

tylised rhinoceros hornbill, *Buceros rhinoceros*, with openwork floral design, carved in plai wood, painted black, white, red, green, yellow and representing the war-god Sengalang Burong. Iban ('Sea Dyak') workmanship from Sarawak, Borneo. This particular specimen was used at an important peacekeeping ceremony at Marudi (Claudetown) Baram District, in 1899, held to reconcile and pacify Kayan, Kenyah, Klemantan and Iban peoples. Length 104 cm.

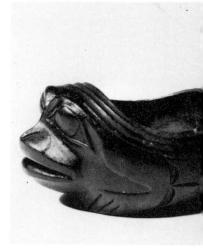

72
Wooden rattle, carved and
painted in the form of a raven.
Haida, Queen Charlotte
Islands, British Columbia, 19th
century AD. A shaman's rattle
used in ceremonies of healing.
The raven is an important
mythological being associated
with creation. Length 35 cm.

73
Wooden feast bowl carved in
the form of a frog. Haida,
Queen Charlotte Islands,
British Columbia, 19th century
AD. Such food bowls are still
impregnated with oil which
came from candlefish and from
sea mammals. It was consumed
in large quantities at feasts.
This conspicuous consumption
would help to demonstrate the
wealth of the chief. Length
18 cm.

the time when a new totem pole was raised. These totem poles, tree trunk
carved and painted with mythological scenes, usually represented the
genealogical data of the chief honoured. At the feasts masked dances were
performed. Shamans were important intermediaries in the communication
with these spirits and their wands and rattles were used in ceremonies of
healing (72).

The art of the Indians of the north-west is highly formalised. Every piece
of decoration was originally part of a design for an animal, bird or fish.
However, when the artist was faced with the problem of making a bowl in the
shape of an animal, such as a frog (73), he carved some parts in three
dimensions and some in two. By this system, parts of the body could be split
and placed along the sides of the bowl. This split image was then sometimes
transferred onto flat objects. The practice of taking portions of an animal
from its original context, and using it in a different position, encouraged the
stylisation of forms which has given this art an awe-inspiring severity.

So far we have seen that even in relatively simple societies the attitude of
men to their universe was extremely complex. Since animals were important
in their lives they were naturally taken to stand for powers greater than the
particular animals themselves. They were not generally the object of worship
but were used to represent spirits or symbolise different spheres or domains
within the world. They formed part of an explanation of a view of the world,
which was also expressed in myth and masquerade.

The outstanding example of an ancient civilisation in which animals were
associated with the various gods, is found in Egypt. The religious practices
gave rise to the belief, among people who came in contact with the
Egyptians, that they actually worshipped the animals themselves. The
Roman writer Juvenal remarked: 'One part worships the crocodile, another
goes in awe of the ibis which feeds on snakes, elsewhere there are shrines for
the golden statue of the sacred long-tailed monkey'. This was an excessively
simplified and indeed mistaken view, although for an outsider at this
comparatively late date there seemed ample evidence that the Egyptians
worshipped animals.

The association between animals and the gods originated in the

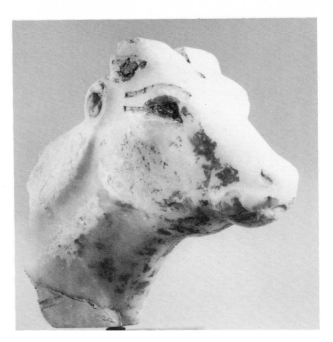

74
Alabaster head of a cow. From
Deir el-Bahri. Egyptian,
Eighteenth Dynasty, *c*. 1500
BC. Eyes and eyebrows were
originally inlaid and the head
was surmounted by horns and
a sun-disk. The cow was sacred
to Hathor, who was
represented as a woman with
cow's ears and horns, or as a
cow. The complete statue
probably decorated a side
chapel of a temple. Height
35·5 cm.

prehistoric period before 3100 BC, when many of the tribes inhabiting the
Nile Valley adopted an animal as a personal emblem. Such emblems then
survived in dynastic Egypt as the local deities of particular areas. Some of
these gods, like Re or Amun, grew more important and became worshipped
as major deities in a number of different areas, often as a result of political
developments. Thus Amun, originally a local god of Thebes in the south,
rose to prominence when a Theban family united the country under its rule
(*c*. 1567 BC). It was to these major gods that the king prayed in the great state
temples, while a vast army of priests acting as his deputies carried on the
daily rituals.

Many of these gods, whether locally or nationally worshipped, acquired a
human form in the dynastic period, although some retained the heads of
animals. Hathor might be recognised either as a woman with the ears and
horns of a cow, or as a cow (74). Bastet was represented as a woman with the
head of a cat. The Egyptian priests did not consider these animals as gods but
rather as representatives of various deities. The animals themselves,
therefore, were not normally the subject of worship. In all probability,
however, this distinction was lost upon the ordinary man who continued to
regard these sacred animals as having special powers.

Much of the theology related to these gods developed at a very early
period, but the Egyptians continued to amplify their beliefs creating a
complex system which, although perfectly satisfactory to them, appeared
confusing and often contradictory to the many foreigners with whom they
came into contact. The most vivid examples of such theology are the many
stories concerning the activities and appearances of the gods. Some were
probably created to explain various religious practices, the origin of which
had been forgotten; others explained occurrences in the natural world.

Re, the sun-god, was thought to ride in his boat across the sky, bearing the sun's disk from east to west. At night he travelled through the Underworld and his place was taken by Thoth who appeared to men as the moon. Re might show himself in several different forms. At sun-rise he was compared to the scarab-beetle who rolls its ball of dung before it. Thus Re was represented as a scarab-beetle raising the ball of the sun in the sky. At other times he might be shown as a falcon (see colour plate v). In very early times the falcon was thought of as a sky-god, since it was his practice to fly high in the sky while hunting, so he too was closely associated with the sun. Various other gods, such as Hathor, wore the sun- or moon-disk as part of their headdress, thus acquiring a universal, rather than a purely local, position.

The daily worship of such gods by the priests was never seen by the mass of the population, who were rarely allowed even as far as the first court of a temple. The statue of a god painted and robed was seen only at the time of his great festival, 'the coming forth of the god'. Then it would have been placed in a boat decorated at prow and stern with his emblem and carried on the shoulders of the priests. Thus the ordinary people rarely communicated directly with these major gods. Instead they turned to more homely deities whose functions and abilities they could understand. Magic played a large role in their beliefs for these minor gods were thought to have various powers to avert evil. One such god was Bes, one of the figures shown on ivory wands (75). With his terrifying appearance as a dwarf with the features of a lion, he frightened away evil spirits. He might also bang a drum and was sometimes shown fully armed. In company with a number of other minor gods he was concerned with the protection of the house and family.

Thoeris was a goddess represented as a pregnant hippopotamus (76). Like most powerful animals in Egypt the hippopotamus had a dual significance in its male and female aspects. The male was to be feared for his strength, yet if his favour was gained he might become a powerful protector. Thus the ivory from the tusks was made into magical wands and the female, Thoeris, holding in her hand a symbol of magical protection, was regarded as a kindly deity particularly concerned with women in childbirth.

75
Amuletic wand in hippo-potamus ivory, made for the Lady Sonbe. From Thebes, Egyptian, Twelfth Dynasty, *c.* 1900 BC. Such wands, incised with the figures of minor gods, were used for protection by the living against harmful creatures. They were sometimes placed near the bed of the owner. Both the material itself and the figures shown were regarded as having powerful magical properties which might be invoked by rubbing the wand. Length 36·5 cm.

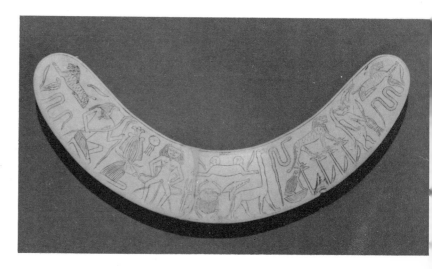

76

Book of the Dead. Part of the papyrus prepared for Nakht, 'royal scribe and military commander'. From Thebes, Egyptian, Nineteenth Dynasty, c. 1300 BC. In the funeral chamber Anubis shown as a jackal-headed god completes the mummification rites, and as a jackal seated upon the tomb guards the dead man. The two goddesses Nephthys and Isis kneel at the head and foot of the couch. At the corners sit the sons of Horus: Hapy, baboon-headed, Duamutef, jackal-headed, Imsety and Qebhsenuef shown here as human-headed. Thoth represented with an ibis head sits before Qebhsenuef. To the right is a figure of Nakht, his arms raised in adoration, and beyond the goddess Thoeris, shown as a pregnant hippopotamus. Length 66 cm.

Magic also played a large part in the beliefs concerning the Afterworld, which was peopled with potentially malignant gods and spirits who had to be defeated or placated before the dead man could proceed. Several texts were composed by the priests giving details of the geography of the Afterworld and the names of the various gods, as well as spells for the protection of the dead man: the *Book of Gates*, the *Book of What is in the Underworld*, the *Book of the Dead*. There were also other gods whose function was one of protection. One such major god was the jackal-headed Anubis, who was concerned primarily with mummification rites as patron of the embalmers (76). He watched over the necropolis and took part in the judgement of the dead in the Afterworld. Four minor deities, the sons of Horus, called Hapy, Imsety, Duamutef and Qebhsenuef, were given charge of the lungs, liver, stomach and intestines respectively, after these had been removed from the body. Their heads were commonly represented as the stoppers on the so-called 'canopic' jars holding these organs.

During the Late Period (after 700 BC) Egypt suffered a number of foreign invasions. In an effort to continue the traditions of the king's relationship with the gods, the foreign rulers developed a close interest in the official religion for political reasons. One clear result was the growth in popularity of animal cults in which the animals were regarded as particularly powerful as intermediaries, or even as living gods in themselves. Such cults appealed more particularly to the native Egyptian population as offering an immediate source of protection and help in troubled times.

Excavations at Saqqara, the desert area used as a cemetery for Memphis, the lower Egyptian capital, have revealed complex systems of underground galleries, within which were found the mummies of particular birds and animals. Especially important was the Apis bull, regarded during its lifetime

as a living god, the incarnation of the god Ptah of Memphis. The bull was chosen according to certain markings, including a white inverted triangle on the forehead (77). On death the Apis was identified with Osiris, ruler of the Underworld. Other mummified creatures found at Saqqara included the ibis and the baboon. By the fourth century BC the baboon was regarded as the living incarnation of Thoth, whereas the ibis (78) was thought of as being the soul of the god. Saqqara was by no means the only area where such burials took place. At other centres for the worship of Thoth ibises were specially bred and buried in catacombs.

Herodotus recorded that cats (79, 80), considered sacred to Bastet, were mummified and buried at Bubastis. He also noted that 'Anyone who deliberately kills one of these animals is punished by death; if an animal is killed accidentally the penalty is decided by the priests; but for killing an ibis or a hawk whether by intent or otherwise, the punishment is always death.'

In the eyes of their worshippers all these animal gods were capable of offering personal help. As an intermediary between him and the god a man might offer a mummified animal or a small bronze statue accompanied by a text giving his name and a prayer. Such donations took place in a small temple outside the catacombs and here the worshipper might ask for security, protection, long life or the promise of a life after death. It was these cults of animals in the Late Period that gave rise to the erroneous impression, particularly current among the Greeks, that the Egyptians worshipped animal gods.

Another of the great civilisations, the Indian, brought animals into its religious life. In the early Vedic religion of the Aryan tribes who invaded the Punjab from the north at the end of the second millennium BC, the powers of nature had been worshipped and thought of as having human attributes. This religion changed as it spread over the subcontinent, absorbing and developing local cults of which animals must often have been the object. Even Vedic texts contain animal myths and mention a lord of animals whose antecedents may go back to the civilisation of Harappa (2300–1700 BC) before the invasion of the Aryans. Outstanding animal representations, clearly symbolic, are the main feature of the earliest surviving official art of ancient India thought to have been carved by order of the Maurya emperor Aśoka (273–232 BC). From much the same time animal amulets appear, and the motifs decorating Buddhist shrines offer more evidence for the importance of animals in popular religion.

Hinduism, which developed from these beginnings, retained the separate worship of some animals, but in the main subordinated them to the gods of human form as their vehicles or mounts. Thus Brahmā and his consort Sarasvatī are associated with the goose, Durgā the Mother Goddess with the lion, Indra with the elephant, Śiva with the bull and the god of love with the parrot, though he also had as emblems a crocodilian monster and the fish. To these might be added associations like that of the goddess of prosperity, Lakṣmī, watered by elephants as symbols of fertilising rain and Viṣṇu in a creation myth lying in the primeval waters on the many-headed serpent of eternity, an ennobled representative of the ancient and widespread Indian regard for snakes. These associations, no doubt of complex origins, survive in modern devotion.

77
Statue of an Apis bull, Egyptian, Twenty-sixth Dynasty, *c.* 600 BC. The figure wears a sun-disk and uraeus, the striking cobra, between the horns. The distinctive forehead mark is inlaid in silver. On the back and loins is incised a ceremonial cloth and a winged scarab, a powerful protective symbol. Height 18 cm.

78
Bronze statue of an ibis. Egyptian, Late Period, after 600 BC. The ibis was considered sacred to Thoth, whose cult gained greater prominence at this period. Worshippers seeking material help offered mummified bodies of the bird or small statues to the god. This fine statue probably decorated a side chapel of a temple. Height 26·5 cm.

79
Bronze statue of a cat, Egyptian, Roman Period, after 30 BC. Incised on the throat, head and breast are two winged scarabs, and a *wadjet* eye, powerful protective symbols. The cat was sacred to Bastet, worshipped notably at Bubastis. Her cult gained greater prominence in the Late Period. The statue probably stood in the side chapel of a temple. Height 29 cm.

80
Mummy of a cat. From Abydos, Egyptian, Roman Period, after 30 BC. Large numbers of the animals were mummified and buried at the cult centres of the goddess Bastet as offerings to her. The pattern of bandaging is characteristic of this period. Height 46·5 cm.

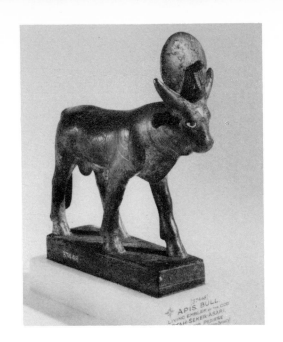

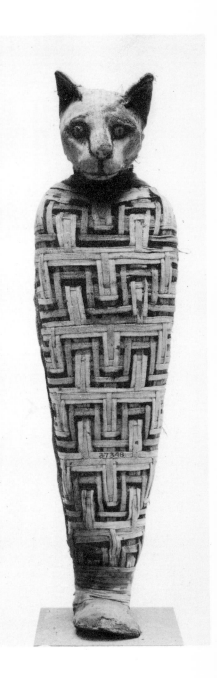

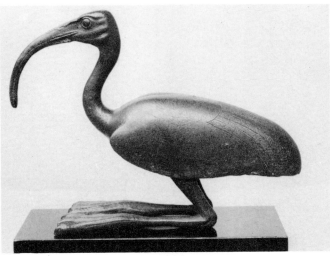

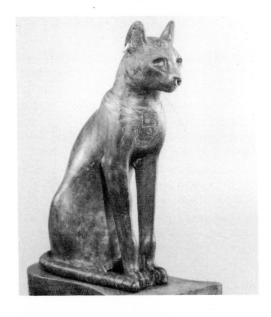

81
Varaha, the Boar Incarnation
of Viṣṇu. India, Pahari
school, Basholi style, Chamba.
c. AD 1740.
Gouache on paper. 28 × 21 cm.

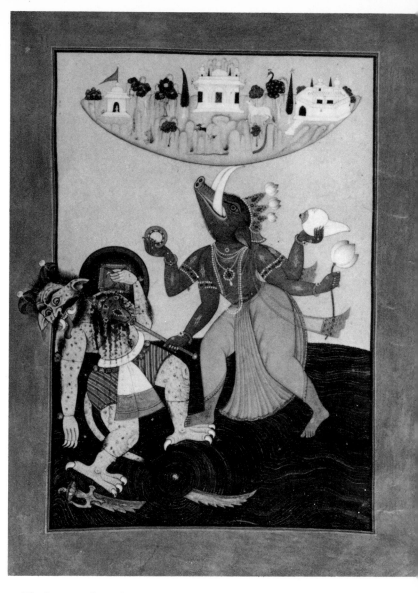

The incarnation of a god as an animal, to display a function or attribute of
the god, is a major feature of Hinduism. Such incarnations are particularly
associated with Viṣṇu the Preserver, who is said to adopt an appropriate
form whenever religion and the world are threatened. As a giant fish he
appears in the Indian flood-legend, guiding the ark and saving the scriptures;
as a tortoise he supports a mountain in a contest between gods and demons;
and as a boar he saves the earth by bringing her up from confinement
beneath the waters. This theme has inspired some notably powerful
sculptures and paintings (81).

In many cases, however, as the illustration shows, animal forms are mixed
with human and this combination is not confined to incarnations of Viṣṇu.
Viṣṇu's mount, the bird Garuḍa, enemy of snakes and an ancient symbol of
fire and the sun, is often represented as a bird only by his wings and a beaked
nose. Gaṇeśa, a stunted, corpulent figure with the head of an elephant (82)

32
Bronze figure of Gaṇeśa.
South India, 17th century AD.
The Hindu god Gaṇeśa is the
remover of obstacles who helps
his worshippers to the
attainment of their desires.
Appropriately he has the head
of an elephant, which can push
its way through the thickest
jungle, and rides on a rat,
which can enter the most secret
larder. Often he is shown
holding his right tusk, broken
off in a fight. Height 45·5 cm.

83
Bronze figure of the monkey
Hanumān. India, Deccan,
11th–12th century AD. Height
14·6 cm.

began as the creator of obstacles but became and remains a god of luck and wisdom, invoked to remove obstacles and bring success in the enterprises of life. Although no doubt originally an elephant god, his composite form was later felt to require explanation which a number of legends provide. The monkey Hanumān may be grouped here (83). In the great epic of the Rāmāyaṇa he was a warrior in the cause of Rāma, an heroic form of Viṣṇu. When Rāma's wife was abducted by a demon it was Hanumān who in a single leap crossed to the demon's island to bring her the comforting news that help was on its way. In the battles which followed he and his fellow monkeys performed great deeds of valour and strength. But the widespread cult of Hanumān in the villages certainly has deeper roots than the great popularity of this story would account for.

The cow, the animal sacred above all others in Hindu belief, is worshipped as a living creature and killing her is a sin. The reasons for this veneration, which had Vedic beginnings, are obscure but economic arguments provide some explanation. The earth itself is conceived as a cow; according to a myth all vegetation and therefore food derives from a primordial act of milking.

Many more examples might be given of the part animals play in Hinduism, nor indeed are they absent from the two other great historic religions of India. The twenty-four patriarchs of the Jain religion, which like Buddhism arose in the sixth century BC, have each a distinguishing animal emblem. In Buddhism the royal lion stands for the Buddha himself, who is called the lion of the Śākyas, the clan to which he belonged, and his doctrine is the lion's roar. In later Buddhism the lion (84) became the mount of Bodhisattvas or saviour deities and most notably of Mañjuśrī. As with all mounts, the lion carried the Bodhisattva and enabled him to be identified by his presence. So attractive did this animal appear in lessons of the religion that it acquired a special significance in Chinese Buddhism in the teaching of the monk Fa-tsang. The bold Chinese ink drawing (85) may represent the golden image of a lion which stood in the palace, and which Fa-tsang used to illustrate, in concrete terms, the doctrines of the Hua-yen school of Buddhism when he gave a famous lecture before the Emperor Wu Chao in AD 704. According to the Hua-yen school, all parts of the universe are caused by the same universal principle, and form a perfectly integrated whole, each part connected to all others. In Fa-tsang's illustration the various parts of the lion, down to the least hair, are identified with each other through the golden principle; each contains the whole golden lion. The lion and its separate parts, although they have different functions, are caused by the golden principle, which itself cannot exist without these phenomena.

Christianity forms a contrast with this and also with the other religions we have described. At one level many of the familiar types of symbol are seen: animals are used as attributes to identify religious figures such as the Four Evangelists, and they appear in allegorical stories to explain aspects of religious faith. There is, however, also the use of the animal symbol to express the spiritual qualities embodied in the life and teaching of Christ. The pacificity of the lamb and the purity of the dove are aspects which the religion taught men to seek. By adopting animals whose qualities were already familiar, the new message was given concrete form which could be represented pictorially and was therefore understandable to all. The animals

34
Carved ivory stand in the form
of a lion, said to be from the
Chos-ḥkhor-yang-rtse
monastery. The detail of mane
and eyes are remarkably
similar to the earlier Chinese
example. Tibet, 11th century
AD. Height 17·8 cm.

35
Lion, from Tun-huang, Kansu
province, China. T'ang
dynasty, 8th–9th century AD.
This drawing is one of many
paintings and documents
brought from a long-sealed
library at the Buddhist cave-
temple site of the Thousand
Buddhas at Tun-huang by Sir
Aurel Stein early this century.
The vigorous delineation of the
animal reveals the confidence
of the T'ang artist.
Ink drawing on paper. 29·8 ×
42·8 cm.

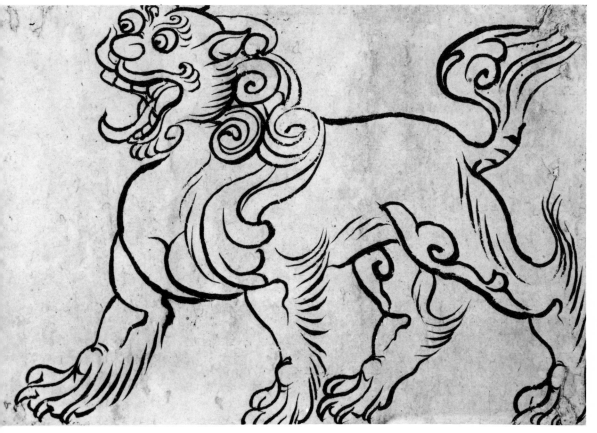

seen in this way were also used to explain the contradictions inherent in life, and to suggest their resolution not through argument but through imagery, as, for example, in the description of God's Holy Mountain: 'The wolf also shall dwell with the lamb, and the leopard shall lie down with the kid; and the calf and the young lion and the fatling together; and a little child shall lead them.' (Isaiah XI, 6.)

The main sources of Christian symbolism were the Old and New Testaments. In addition the history of the early Church played its part in the assimilation of other images from the classical and Asian civilisations. Although Christianity was declared one of the official religions of the Roman Empire in AD 313, it did not become the sole official religion until AD 380. Throughout most of the fourth century artists were working for both non-Christian and Christian patrons. The existing conventions of classical art therefore provided the inspiration for the illustration of biblical themes. Many subjects were taken over unchanged: the late-antique bucolic figure of the Good Shepherd called the *Kriophoros*, or ram carrier, was assimilated with the image of Christ as the good shepherd (John X, 1–16) and Christ's exhortation to his disciples 'Feed my sheep' (John XXI, 16–17). The figure of Kriophoros was derived from the god Hermes who was sometimes shown carrying a ram on his shoulders. The use of symbols which were ambiguous, or at least which bridged two worlds, was useful to the early Christians in times of persecution.

The *Agnus Dei*, or Lamb of God, is Jewish in origin, deriving from the Paschal Lamb, the lamb slain and eaten at the Jewish Passover (Exodus XII, 3–11). It was later applied to Christ, and because Passover and Easter occur at the same time, came to be associated with Easter. The *Agnus Dei* as the symbol of the redeemer, however, first appeared in the fourth century. This image of the lamb is taken from the title given to Christ by John the Baptist (John I, 29), and reinforced by its extensive use in Revelation. The qualities of innocence, purity and patience were attributed to the lamb and were set against the torments of the world and of death. The lamb is used in a large variety of settings in the art of the Middle Ages. It stands, for example, in the centre of a crosier head with a dragon, a figure of trouble and temptation, coiled around it. On this Flemish coin (86) the reference is more obscure, but the meaning is the same. The lamb holds a banner, a medieval heraldic device, which was probably first used in the twelfth century by the Knights Templar, one of the military orders in Palestine during the Crusades. This banner is the banner of victory and represents Christ's victory over death through resurrection.

All parts of the Bible were used as sources of animal symbols, the most important sections being Genesis and Revelation. From Revelation came the imagery of the extraordinary winged beasts used as the symbols of the Evangelists (see colour plate VII). These symbols were established in the fifth century but were not, at first, always attributed to particular Evangelists. The winged lion and the winged bull reproduce the winged creatures which are so prominent in Western Asia. Appropriately they originate not from Revelation alone, but are found in descriptions given by the prophet Ezekiel when he was exiled in Babylon, an area after all where such fabulous beasts formed part of the familiar artistic context:

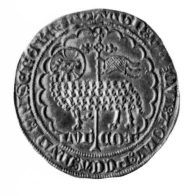

86
Gold coin of Louis de Mâle, Count of Flanders (AD 1346–84). Inscribed: *Agnus dei qui tollis peccata mundi miserare nobis.* (Lamb of God who takest away the sins of the world have mercy on us. John I.29.) This coin was called colloquially 'Mouton' and was copied from an identical coin issued by Jean II le Bon, King of France (1350–64). Diameter 30 mm.

Now it came to pass in the thirtieth year, in the fourth month, in the fifth day of the month, as I was among the captives by the river of Chebar, that the heavens were opened, and I saw visions of God.

Also out of the midst thereof came the likeness of four living creatures. And this was their appearance; they had the likeness of a man.

And every one had four faces, and every one had four wings.

And their feet were straight feet; and the sole of their feet was like the sole of a calf's foot: and they sparkled like the colour of burnished brass.

As for the likeness of their faces, they four had the face of a man, and the face of a lion, on the right side: and they four had the face of an ox on the left side; they four also had the face of an eagle.

Thus were their faces; and their wings were stretched upward; two wings of every one were joined one to another, and two covered their bodies.

(Ezekiel I, 5–7, 10–11)

This vision was then transformed in Revelation:

And the first beast was like a lion, and the second beast like a calf, and the third beast had a face as a man, and the fourth beast was like a flying eagle.

And the four beasts had each of them six wings about him; and they were full of eyes within.

(Revelation IV, 7–8)

The passage from Revelation occurs in the great visions of the Apocalypse where the four creatures do homage to the Lamb. The south Italian enamelled plaques (colour VII) have a more static quality than the whirlwind vision described in the text. A somewhat later manuscript from Iraq (87) has likewise lost this visionary quality. The figures of the Four Evangelists appear in the Islamic world drawn from the Old rather than the New Testament, and were then incorporated into Muslim accounts of the Ascension of Muḥammed. In medieval European theology their significance was elaborated in a different form. They came to be related to the four main events of Christ's life. The man or angel represented the Incarnation, the ox as a sacrificial beast represented the Crucifixion, the lion stood for the Resurrection and the eagle the Ascension.

The whole development of medieval symbolism was greatly complicated by the glosses and documentaries of the medieval scholars. The sermons of Honorius of Autun written between AD 1090 and 1120 are typical examples. They were composed of passages describing events in the life of Christ which were compared with sections from the Old Testament. Parallels with the habits of animals were then included to make the lessons more telling. But the sources of these stories about animals were not facts observed from nature but tales taken from writings such as the bestiary. This is the most important single source of medieval animal symbolism. It was an extraordinarily popular work based on a text known as the *Physiologus*. This text, which contains some of the observations made by Aristotle in the world of animals, was probably compiled by an Egyptian in a Christian ascetic community in the fourth or fifth century AD. It was written originally in Greek and translated into Ethiopian, Syrian, Armenian and Latin. The oldest surviving Latin examples date from the eighth and ninth centuries.

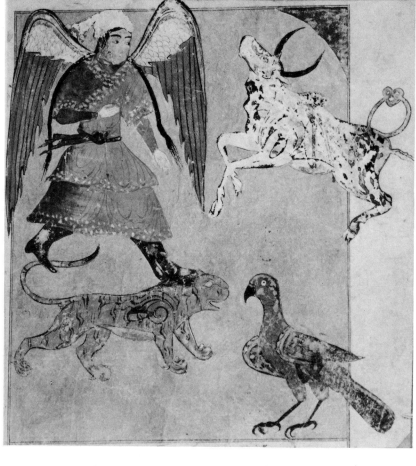

87
The emblems of the Four
Evangelists. Miniature from a
manuscript of Zakāriyya
Qazwīnī's ᶜ*Ajā'ib al-
Makhlūqāt* (The Wonders of
Creation, written in AD 1281
(AH 680)). Probably Iraq, 14th
century AD. The four figures
which relate to the Four
Evangelists were drawn from
the Old Testament or the
Midrash, if not from Muslim
tradition. Muslim accounts of
the Ascension of Muḥammad
(the Miᶜraj), in which they
appear, grew markedly in
popularity in the 14th century.
This doubtless explains their
inclusion in illustrations of *The
Wonders of Creation*. The
knotted tail of the humped ox
(zebu) is a reminiscence of the
constellation Taurus, and the
lion has mysteriously become a
tiger. The angel trampling it
has no symbolic significance.
Tempera on paper. 14 × 13 cm.

Even in its earliest form which described only thirty-nine animals, the text
included biblical references, folk-lore, some Aristotelian remarks, and moral
lessons to be drawn from this evidence. It was progressively expanded and
revised to include writings such as the *Hexaemeron* of St Ambrose from the
fourth century, and the *Etymologiae* or encyclopaedia of Isidore of Seville
compiled in the seventh century. Although many of the stories in the bestiary
are fabulous it was always regarded as a serious document on animals and
God's purpose as shown through them.

From the bestiary came most of the elaborate animal symbols which were
so widely used in art. The lion is still recognised today as a potent symbol of
the strength of Christ, but its significance as a symbol of the Resurrection
was derived from the descriptions in the bestiary which are now little known:

The third feature is this, that when a lioness gives birth to her cubs, she brings them
forth dead and lays them up lifeless, for three days – until their father, coming on the
third day, breathes on their faces and makes them alive.

Just so did the Father Omnipotent raise our Lord Jesus Christ from the dead on the
third day. Quotes Jacob 'He shall sleep like a lion and the lion's whelp shall be raised.'

This combination of folk-lore and faith explain the power attributed to the

sanctuary ring with its lion mask (88). It was a very practical embodiment of the powers of Christ. Any criminal seeking refuge could flee to the safety of the Church and was safe from the reach of the law once he gripped the ring of the sanctuary.

The importance of and the respect accorded to these sanctuary laws can be seen in the punishment of breaches of this right to protection. According to the Register of Robert Reade, Bishop of Chichester, for the year AD 1404–5, a thief who had escaped from prison in the Castle of Arundel was dragged away while grasping the ring of the cloister gates at Arundel College. His two captors later confessed and were sentenced to a pilgrimage to the shrine of St Richard of Arundel and to be scourged five times through the Church of Arundel. When they restored the thief to the Church, however, the penance concerning the scourgings was commuted, and instead they were to offer a candle at the High Altar the following Sunday.

The symbol of the pelican is only intelligible in the light of the description in the bestiary although it was already known from Psalm 102: 'I am like a pelican of the wilderness.' It was used as an allegory for the sacrifice of Christ and is always shown with its young in the nest pecking at its breast to feed them with its blood (89). In the bestiary text the pelican is described as having

88
Bronze sanctuary door ring with lion mask. From Brazen Head Farm, Essex. English, *c.* AD 1210. The lion as guardian endowed with the power to ward off evil occurred throughout antiquity. Although this example is known to have come from a secular building, most comparable examples occur on sanctuary doors. Diameter 27·3 cm.

89
'The Pelican in its piety'
illustrated in a Latin bestiary.
England, early 13th
century AD.
Body-colour on vellum
(detail). 27·9 × 17·2 cm.
British Library. Harley MS.
3244, f.54b.

great love for its young, but when they have begun to grow they turn and peck their parents in their faces. Then the parents strike and kill them. After three days the mother bird, overcome with grief and pity, pierces her side and sheds blood over her children to bring them to life. Allegorically, the bestiary compares the pelican with Christ who sacrificed his blood for mankind. Christ's blood from his pierced side, as on the Cross, flowed for man's salvation and eternal life. The pelican appears, therefore, above the cross in scenes of the Crucifixion, but was also popular on personal items such as seals, rings and brooches. The lamb, the lion, and even the pelican, have in this way entered the language as symbols whose connotations are familiar and evocative. There is no more moving appearance of the pelican than in King Lear (III, iv) as he realises the ingratitude of his daughters: 'Is it the fashion that discarded fathers should have thus little mercy on their flesh. Judicious punishment! 'twas this flesh begot those pelican daughters.'

4. Signs and Emblems

The use of animals as signs and emblems is a form of symbolism, but this usage is less complex than the religious symbolism just described. The signs of the zodiac which include animals and mythological creatures make up one such group of symbols; they are used to represent certain groups of stars and constellations. In one sense the animal or mythological being, for example the great bear or the serpent, is simply used to identify a constellation. As the zodiacal signs in particular were thought by astrologers to have an influence on the course of a man's life, they became associated with and were held to represent various qualities in men. Their function as symbols rather than as part of an astronomical system is further evident from the fact that the signs no longer correspond to the original constellations.

The groups of stars which lie in the region of the ecliptic, or band of sky through which the sun, moon and planets appear to move, were identified as twelve zodiacal creatures. The twelve signs were each considered to occupy $30°$ or $\frac{1}{12}$ of the great circle. The constellations, although not of course the $30°$ sections, are irregular in size. They are: Aries, the Ram; Taurus, the Bull; Gemini, the Twins; Leo, the Lion; Virgo, the Virgin; Libra, the Balance; Scorpio, the Scorpion; Sagittarius, the Archer; Capricorn, the Goat; Aquarius, the Water-bearer; Pisces, the Fish.

The source of some of these images, and also of the relevant astronomical observations, was Mesopotamia. In early times, however, the zodiacal divisions of the ecliptic, and the pictorial symbols by which they were later represented, were quite separate. The background to this development of the observation of the stars lay in the practice of the Babylonians, throughout their history, of taking decisions concerning many of the activities of their lives on the basis of omens. These were derived from such phenomena as the conformations of animal entrails, the movement of birds, and the collocations of planets and stars in the night sky. Records were kept of such occurrences and of the events which followed them, with a view to predicting future events from the recurrence of the same phenomena.

In this way bodies of recorded material were built up and steps were taken to systematise the information contained in them. Cuneiform documents giving lists of the names of stars and constellations, and other documents giving omens based on observations of the sky, are known from the first half of the second millennium BC onwards.

Many of the Babylonian equivalents of the names of constellations later used for the divisions of the zodiac occur in the star lists, and on a cuneiform tablet of about 500 BC the twelve names are listed in the order in which they are known today. It was not, however, until later, in the fourth century BC, that the zodiac, in the modern astrological sense, was established. Until that time the names were simply applied to constellations, but the innovation, introduced for accuracy of reference, was the division of the ecliptic into its twelve $30°$ sections. These sections were named after the twelve zodiacal constellations, and the progress of the sun, moon and planets could be charted by reference to them. This scheme was then of value for mathematical computation, but it is today known almost solely for its use by astrologers.

Three of the zodiacal symbols are known in other contexts of earlier date in Babylonia, and they were presumably taken over, perhaps in the

90
Impression from a green stone cylinder seal showing a worshipper coming before the seated deity Enki, who rests his foot on his creature the goat-fish. Babylonia, Sumerian, Third Dynasty of Ur, *c.* 2100 BC. Enki, or Ea, the god of sweet waters, is identified by the streams containing fish which flow from the vase in his hand. The goat-fish often occurs alone, representing Enki. Height 2·8 cm.

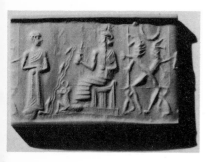

Hellenistic period, third to first centuries BC, and given new significance. Thus the symbol later used to represent Capricorn, the goat-fish, is attested already in the third millennium BC as an emblem of the god Enki, and is often used to represent him in subsequent periods (90). Again, a centaur-like being drawing a bow, which would appear to be the forerunner of the zodiacal sign Sagittarius, occurs frequently on seals of the Persian period, and is found on boundary stones of the late second millennium BC (91). Another, less distinctive, creature is the scorpion, which is also depicted on late second millennium boundary stones, and could have been a model for the Scorpio sign (92).

tail from a boundary stone owing a composite being rved in relief. He is in the rm of a bearded centaur awing a bow, and has a cond head, that of lion, cing backwards, and a cond tail, that of a scorpion. bylonian, Kassite, reign of eli-Shipak (1188–1174 BC). eight 51 cm.

etail from a boundary stone owing a scorpion carved in lief. Babylonia, Second ynasty of Isin, reign of arduk-nadin-ahhe 098–1081 BC). Height ·5 cm.

93
Silver coin of the Roman
emperor Augustus (27 BC – AD
14) showing Capricorn holding
'the horn of plenty'. The
surrounding laurel wreath
symbolises Augustus' victory
at Actium in 31 BC. Minted at
Ephesus in Ionia, Asia Minor.
Diameter 27 mm.
Reproduced × 1½.

Although these creatures shown on the Babylonian monuments may have
been taken over as zodiac signs in Hellenistic times, in fact the first
representations of them in this role in the classical Mediterranean world
occur on Roman coins (93). Capricorn shown on this coin was the birth sign
of the emperor Augustus. At the time of his birth (23 September 63 BC), the
moon was in the constellation of Capricorn although by the modern method
of casting horoscopes Augustus was born under the sign of Libra, as the sun
was in this constellation at his birth. The adoption of this symbol by
Augustus is the earliest use of such a device on a coin, and shows that the
conception of this zodiac sign was fully developed by that time and also
officially approved. On the coin Capricorn is shown carrying a cornucopia,
symbol of the wealth and prosperity which followed Augustus'
establishment of a stable government after nearly a century of civil war.

In order to understand the development of the signs of the zodiac in the
Middle Ages it is necessary to review earlier Greek astronomy and its
elaboration in Islamic countries. A catalogue of stars had been drawn up in
the fourth century BC by Eudoxos of Knidos. This catalogue was used by the
Hellenistic poet Aratos of Soli for a purely poetic description of the heavens
in his *Phainomena*. Such an approach dissatisfied the astronomer
Hipparchus (*fl.* 161–126 BC) who went on to perfect Eudoxos' catalogue.
Despite this, the process of mythologisation was carried on inexorably in
such writings as the poem by Eratosthenes (284–204 BC), the *Catasterism*.
He gave each constellation a mythological meaning; the Bull was linked to
the story of the rape of Europa and the Lion to the Nemean lion in the
labours of Herakles. The constellations were illustrated on globes, of which
a Roman copy known as the Farnese Globe was the earliest surviving
example, following Greek originals. These globes were made the subject of
the first illustrations in the books which then gave full-sized pictures of the
single constellations. These manuscripts, which combined astronomy and
mythology, are generally known as *Aratea* after Aratos. They were probably
already popular in the Roman period and we know them from copies by
Byzantine, Islamic, Carolingian and Anglo-Saxon illustrators, and from
later medieval translations of Islamic versions. Quṣayr 'Amra, an Ummayad
palace in the deserts of Jordan, has a domed ceiling painted as though it was
the surface of a globe and hence the constellations are, as it were, shown
inside out. Other versions of the classical model are seen in a Carolingian
manuscript (94) in which the text makes up the body of the figures and
animals. This manuscript, known as the 'Harley Aratus', gives Cicero's
translation of the *Phainomena* by Aratos below each figure.

The extent to which early medieval manuscripts follow each other is
demonstrated by comparing this figure of Aries with the one in a manuscript
written in England towards the middle of the eleventh century AD (95). It was
probably copied directly from the 'Harley Aratus' which is known to have
been in England at that date. Such faithful reproduction and loyalty to the
Phainomena is part of the unquestioning attitude of the early medieval
scholars. The symbols and their associations were valued and their
astronomical validity not doubted.

The scholars of the Arab world took a more critical attitude than their
Christian contemporaries. Although they were equally dependent on

classical texts they also made their own important contributions. The famous Arab astronomer al-Ṣūfī (AD 906–86) based his work on the writings of Ptolemy *c.* AD 138 who in his *Syntaxis*, known as the *Almagest*, continued Hipparchus' scholarly catalogue. Al-Ṣūfī's dependence on this classical tradition is demonstrated by the form of the illustration which shows the constellation as seen in the sky but also as shown on a globe (96). In his work *Illustrations of the Fixed Stars* he described each constellation separately giving a very full account. He added his own independent observations to information he had taken from Ptolemy. We know that al-Bīrūnī (AD 972/3–1048), a famous scholar from the area north of Iran, was familiar with al-Ṣūfī's work. His treatise is a compilation on the fundamentals of astronomy. This illustration of Scorpio (97) from a thirteenth-century manuscript is in the Islamic tradition of an outline drawing combined with heavy dots to show the stars. The delicacy of this type of drawing was greatly elaborated in the slightly later illustrations in the fourteenth-century manuscript of the *Illustrations of the Fixed Stars*.

By the fourteenth century some of the more accurate astronomical knowledge set out in these texts had reached western Europe through translations made in Sicily and Spain. The departure from the earlier classical texts, particularly the *Phainomena* of Aratos, coincided with a change in the style of illustration. The earlier forms of representation, which included classical detail widely copied in the idiom of the Carolingian or Anglo-Saxon artist, was gradually superseded by later medieval styles. The Leo and Capricorn in a fourteenth-century Bohemian manuscript (98) belong to the artistic traditions of their day. The lion, for example, may be compared with the form used in the same period as an heraldic device. This manuscript also emphasises the importance of Islamic astronomy in that it is a Latin translation of the *Introduction to Astrology* of Albumasār (Abū Maᶜshār Jaᶜfar ibn Muḥammad al-Balkhī (AD 786–885/6)).

n Arabic manuscript. *Illustrations of the Fixed Stars Kitāb Ṣuwar al-kawākib al-ṯābita*) showing the onstellation Leo, above as een on a globe and below as een in the sky. The author was ᴛe famous Arab astronomer, Abd al-Raḥmān ibn ᶜUmar al-ᵤfī, who died in AD 986 (AH 76). The present manuscript as copied in the 14th century ᴅ on paper in black *naskhī* ᶜript. 36 × 26 cm. British ibrary. Or. MS. 5323, f. 45b.

7 he zodiac constellation corpio from the treatise by al-ᴮīrūnī. Manuscript of the ᵉersian version of *al-Tafhīm li wā'il ṣināᶜat al-tanjīm*, a ʳeatise on the fundamentals of stronomy by the great olymath scholar, Abū ᴸayḥān al-Bīrūnī, AD 72/3–1048/9 (AH 362–440). his work has survived in both ᵉersian and Arabic versions. his manuscript of the *Tafhīm* ʳas made in Turkey (probably ᴷonya) and is dated AD 1286 AH 685). ᴸine and colour on paper. ᴮritish Library. Add. MS. 7697, 48a.

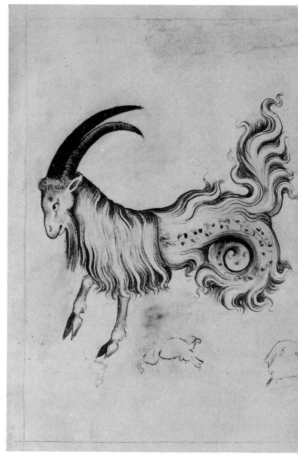

98

The constellations Leo, the Lion, and Capricorn, the Goat, from a Bohemian manuscript, 14th century AD. This manuscript includes extracts of the *Introduction to Astrology* of Albumasār (Abū Maᶜshar Ja ᶜfar ibn Muḥammad al-Balkhī, AD 786–885 (AH 169/70–272), translated into Latin by George Zothor Zaparus Fendulus. The main extracts are concerned with the 'paranatellons', or groups of stars north and south of the zodiac which rise at the same time as each decan 10° or one third of a zodiacal sign. Body-colour on vellum. 27 × 18·5 cm. British Library. Sloane MS. 3983, ff. 16b, 24a.

An important aspect of the Renaissance was the revival of magic and astrological lore. For example, in the fifteenth century Italian princes would not fight a battle unless the stars were favourable. Dürer's woodcuts of the *Celestial Globe* belong to this context (99). In this example, illustrating the Northern Hemisphere, he had reverted to both the composition and the style of the Farnese Globe already mentioned. Dürer's woodcut was entirely based on information provided for him by Johannes Stabius. Stabius had originally been a mathematician but from AD 1508 was closely connected with schemes undertaken for Emperor Maximilian I (AD 1459–1519). The print is dedicated by Stabius himself (not Dürer) to the Archbishop of Salzburg, Matthew Lang, who was Maximilian's closest minister. The debt to the classical and Arab astronomers is also faithfully recorded with the figures of Aratos, Ptolemy, Manilius, Azophi (al-Ṣūfī) at the corners. A coin struck later in the century (100) closely follows the scheme on Roman coins, and confirms that in the sixteenth century the interest in the pattern of the sky was as much astrological as astronomical.

Against these images, which are still well known in the West today, it is possible to set the creatures chosen in the Far East to symbolise the divisions

Imagines cœli Septentrionales cum duodecim imaginibus zodiaci.

Aratus Cilix

Ptolemeus Aegyptius

Azophi Arabus

Celestial globe –
Northern Hemisphere.
Albrecht Dürer (AD
1471–1528), German School.
Woodcut. 45·5 × 43·1 cm.

of the year. These were arranged according to a cycle evolved in China possibly as early as 1000 BC. It was based on sixty combinations out of the available 120 pairs formed by a set of twelve creatures and a set of the symbols known as stems. The cycle began with a combination of the first creature (the rat) with the first stem, each set continuing in a fixed order until sixty pairs had been formed. First the cycle was used for a period of sixty days, but by the beginning of the Christian era it had been adapted to a cycle of sixty years. Within it the twelve creatures recurred every twelve years. Parallel with the significance of a particular zodiac sign at the birth of an individual in the West, the animal of the year in which a person was born was thought to be of importance to his whole life. Charms were made illustrating these creatures (101). Certain personal items such as Japanese netsuke decorated with the animals, were popular with people born in the appropriate year (102).

There is a sense in which the signs of the zodiac can be seen as personal symbols. Heraldic emblems of individuals and of states take this type of personal symbolism a stage further. While the signs of the zodiac have been used to identify a man's own personal attributes to himself, heraldic emblems are above all used to identify a person or a state to others. The form of the device must therefore be instantly recognisable. The evolution of the forms of certain animals used as heraldic emblems has an unexpected history.

To find the source of the form of the lion rampant, for example, it is necessary to go back to ancient Mesopotamia. Not only the lion, but also at least two other creatures, the griffin and the eagle displayed, which became important heraldic devices, are found first on the cylinder seals of Sumer and Akkad in the third millennium BC. They also appear on decorative items

100
Silver presentation coin of Julius, Duke of Brunswick, AD 1576. This five thaler piece shows the signs of the zodiac and the planets. It probably had some astrological significance. Diameter 72 mm.

101
Bronze coin amulet from China, 17th century AD. It shows the twelve cyclical animals: Rat, Ox, Tiger, Hare, Dragon, Snake, Horse, Sheep, Monkey, Cock, Dog, Boar. Diameter 81 mm.

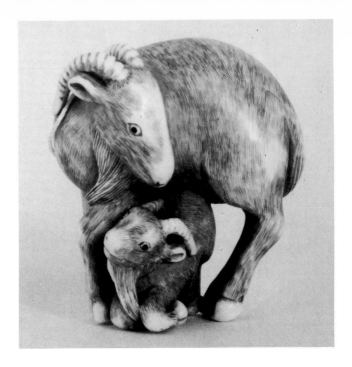

2
ory netsuke in form of a goat
d kid, the eyes inlaid.
nsigned, Kyoto school,
pan, early 19th century AD.
n example of a Kyoto-school
tsuke (retaining toggle) of
e popular naturalistic type.
ie goat is the Serow
apricornis sumatrensis.
eight 4·7 cm.

3
ragonite cylinder seal and
apression showing a hero and
o bull-men fighting lions and
lls. Sumerian, Early
ynastic period, *c*. 2600 BC.
eight 4·3 cm.

such as the shell decoration on the lyre from Ur (21). One feature which is important in the development of the 'heraldic' formula is the use of two opposed beasts, either confronted or addorsed. Frequently the two animals rear up either side of a tree. On some later classical examples this 'sacred tree' appears as a plant in a vase. Readily identifiable as a specific motif, which is instrumental in preserving and transmitting the use of confronted animals, is the hero holding two rearing lions by the neck (103). This same figure, as we shall see, occurs in much later centuries once again grappling with two confronted lions.

More immediately the design of opposed animals with or without a vertical division between them was taken, by means of trade or other contact, from Mesopotamia to the islands of the Aegean in the mid-second

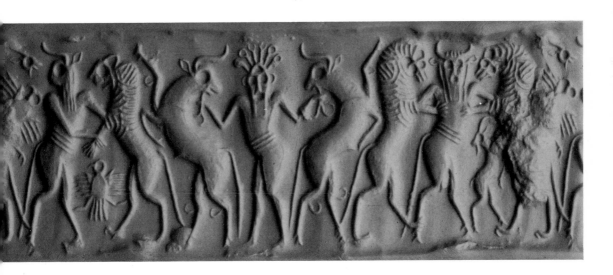

104

Impression from a rock-crystal sealstone showing two rearing goats. Late Minoan, *c.* 1450–1400 BC. Width 26 mm. Reproduced × 1½.

105

Impression from cornelian sealstone showing two lions. From Ialysos, Rhodes. Mycenaean, *c.* 1500–1400 BC. Width 20 mm.

106

Detail from the reverse of a wand of hippopotamus ivory showing an incised griffin. Egyptian, Twelfth Dynasty, *c.* 1900 BC. (For the whole wand see fig. 75 above.) Length 36·5 cm.

107

Handle for a bronze mirror of carved ivory with a warrior fighting a griffin. Found in Cyprus, *c.* 1200–1100 BC. (The reverse is illustrated in fig. 22.) Height 20·5 cm.

millennium BC. A sealstone from Crete (104) shows a pair of addorsed goa[t] rather more vivacious in style than the addorsed bulls on the lyre from U[r] (21). One from Rhodes illustrates the theme of confronted lions (105).

The griffin, like many winged creatures, was a peculiarly Mesopotamia[n] invention. In its earliest forms it had a lion's head, but by the secon[d] millennium BC it had developed its more usual shape, with a bird's head an[d] claws combined with a lion's body and wings. It had passed into Egypt (106[)] and also at a slightly later period was, like the confronted animals, found i[n] the Mediterranean world. The hero figure fighting a griffin, on a mirr[or] handle from Cyprus (107), can be interpreted as a use of one part of the mot[if] which usually shows a hero struggling with two creatures, one on either sid[e]. The griffin, and indeed the formula of the paired beasts, is familiar on muc[h] Greek pottery of the 'Orientalising phase', a period in which eastern moti[fs] were readily assimilated (see colour plate VI). After the sixth century BC bot[h] the paired animals and the griffin were much less prominent, although som[e] griffins are shown on vases as late as the fourth century BC. The 'heraldi[c]' creatures survived of course in Western Asia, as on a gold boss of th[e] Achaemenid period (108) and well through Sassanian (109) and Islam[ic] times.

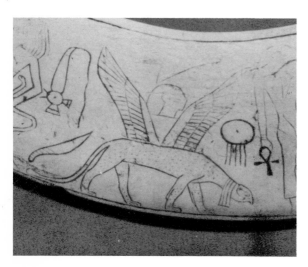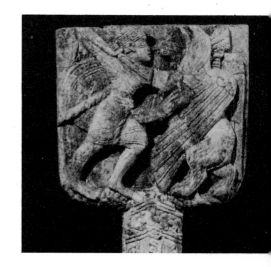

108
Circular plaque in gold with repoussé decoration showing an eagle with spread wings in concentric rings of cable, boss, and lotus designs. From the treasure of the Oxus, Iran. Achaemenid, 5th–4th century BC. Diameter 9·5 cm.

109
Bronze griffin-like monster in the form of a winged lion with the ears of a horse and the horns of a goat. Said to be from near the River Helmund, Afghanistan. Probably Sassanian, *c.* 4th century AD. Height 24·9 cm.

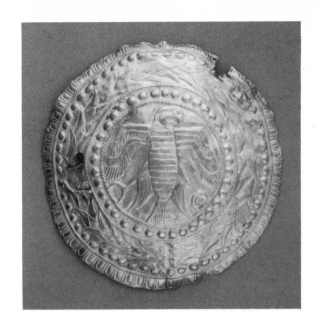

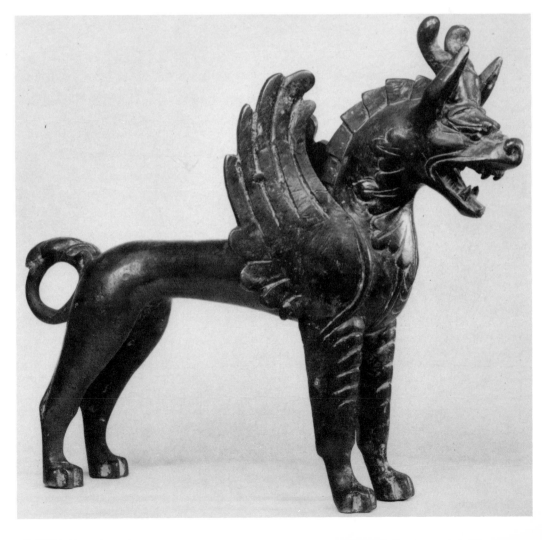

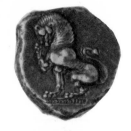

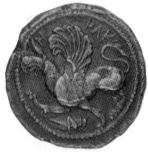

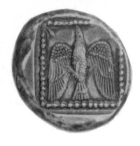

Their existence in classical Greece and Rome is less easy to trace. They are however, present on Greek coins (110) and the motif of two confronted lion was taken eastwards with Hellenistic influence as far as Gandhara in north west India (111). Other confronted animals, particularly goats, continued t be used in the Mediterranean area and can be seen on Roman engraved gem from the second century BC to the first century AD.

There are two possible sources for the various related 'heraldic' form which appear in northern Europe during the migration period. The ma between two beasts as seen, for example, on the Sutton Hoo purse is possibl derived from an eastern source. A pair of confronted griffins on either side c a vase containing a plant, incised on a Merovingian sarcophagus, is mor likely, on the other hand, to have been taken from a Roman example. Thu these motifs were already known in northern Europe before they wer reintroduced with the Byzantine textiles from the eighth century onwards As we have seen in the case of the lion hunt textile (31) designs on such silk favoured paired motifs. One significant example, which was said to hav been brought to Sens in France with the relics of St Victor *c.* AD 750, shows hero grasping two rearing lions recalling the early cylinder seal.

It is not known whether the confronted griffins on a walrus-ivory plaqu from England (112) were carved under the influence of such eastern moti used on Byzantine silks, or whether they represent a tradition alread current among the Germanic peoples. An ivory oliphant or horn fror southern Italy on the other hand, carved from an elephant's tusk in the tent or eleventh century AD, certainly represents the southern tradition (113). I reproduces the designs on the capitals of the churches of Apulia which ha adopted these motifs of paired lions, a griffin and an eagle among others from Byzantine silks.

In addition to its appearance as one of the paired motifs used fo decoration the griffin had also become a favourite subject in the bestiary tex An example in a beautifully illustrated bestiary *c.* AD 1200 shows the creatur

110
Three coins with animals in 'heraldic' style:

a
silver coin of Lycia with a lion, *c.* 475 BC. Diameter 20mm.

b
silver coin of Abdera in Thrace, with a griffin. The griffin of Abdera is borrowed from that on the coins of Teos in Ionia. The grasshopper is a mark of the engraver. *c.* 425 BC. Diameter 25 mm.

c
silver coin of Moagetas, king of Paphos in Cyprus, with an eagle displayed. *c.* 400 BC. Diameter 22 mm.

111
Two confronted lions carved in schist. Gandhara, 2nd–3rd century AD. Height 24·3 cm.

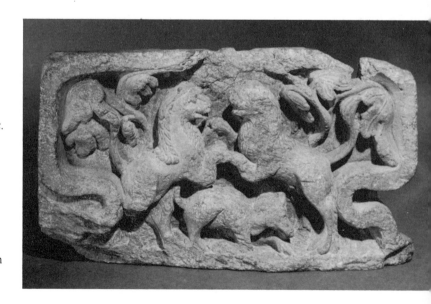

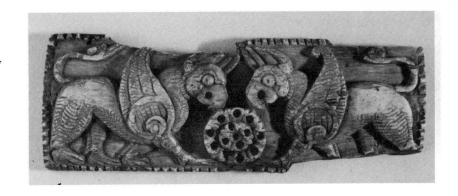

112
Plaque in walrus ivory with confronted griffins. Found at Old Sarum, Salisbury. English, late 11th century AD. Length 13·7 cm.

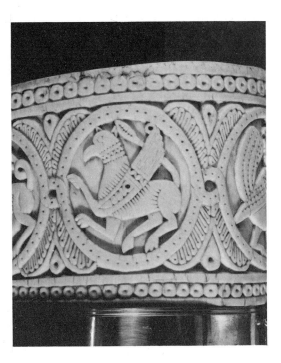

113
Details from an ivory oliphant or horn, carved from an elephant's tusk, showing a griffin, paired lions and an eagle displayed. South Italian, 10th–11th century AD. The motifs on this horn are taken from Byzantine textiles.

seruant.

CRipes uocatur. quod fit animal pennatū & quadrum

114

A griffin with a biting horse, from a Latin bestiary, England, c. AD 1200. This is one of the finest bestiaries produced in England in the late 12th or early 13th century AD, when the illuminated Latin bestiary was at the height of its popularity.
Body-colour on vellum. 30·7 × 23 cm. British Library. Harley MS. 4751, f. 7b.

in the graphic form in which it came to be used as a heraldic device (114). Although it appears as part of a tradition of manuscript illustration in which it was shown singly without an opposing griffin, the strict profile recalls the earlier paired griffins used as decoration. The backs of two Hispano-Moresque dishes are splendidly adorned with an eagle displayed and a lion rampant (115). These are examples of ornament and are not heraldic in purpose, but they both reflect the heraldic forms of the fifteenth century and are at the same time the descendants of the early sequence of examples we have discussed.

These three creatures in these specific forms became adopted as emblems in heraldry and on coinage. They were used because they were familiar and identifiable. The griffin, lion and eagle were particularly popular as they entered western tradition with the Greeks and were reintroduced in medieval art.

In the early days of coinage, however, they were only three of many animals used on Greek coins. Animals have been used in coinage since the first coins were struck in the Greek cities of Asia Minor in the late seventh

15
Two Spanish dishes of tin-glazed earthenware with gold 'lustre' decoration on the backs showing an eagle displayed and a lion rampant.
Above:
Valencia, *c.* AD 1420. On front, arms of Counts Ribagorza and Prades of the House of Aragon. Diameter 45·7 cm.
Below:
Valencia, mid-15th century. On front, sacred IHS monogram. Diameter 44·2 cm.

116
Electrum coin of the city of
Phocaea in Ionia, with a seal.
c. 550 BC. Diameter 20 mm.

century BC. They had been a favourite theme of numismatic art from the bull
and lion on the coins of Croesus, the fabulously wealthy king of Lydia
(560–546 BC). The animals on coins were there to identify who issued them.
Sometimes these animals were not just heraldic emblems, but symbolised the
political or religious acts or ideas of the coin's issuer.

Almost all the earliest coins of the Greeks in Asia Minor were marked with
pictures of animals which were the emblem of the merchant, rulers or states
who issued them. A seal was the emblem of the Greek city Phocaea in Ionia,
because of the similarity of its name (in Greek *phōcē*) to that of the city (116).
In choosing such an unfamiliar animal as their emblem the Phocaeans set a
difficult task for the artist who designed their coinage. The seal is drawn
according to the conventions of the Greek archaic style, with an enlarged eye
and stiff limbs, but at the same time the designer had a clear knowledge of its
actual appearance and drew an easily identifiable image of a seal.

With the spread of coinage during the following centuries animals on
coins proliferated throughout the Greek world. The eagle on the coin of Elis
(117) and the owl on the coin of Athens (118) were the emblems normally
used on the coins of these cities, but there was another reason for their use.
The people of Elis used an eagle because it was sacred to the Greek god Zeus,
and thus they proclaimed their control of his principal shrine at Olympia.
The Athenians used an owl because it was the companion of Athena, the
patron goddess of their city. These animals are religious symbols as well as
political emblems. It is possible that the issuers also wished to imply that they
possessed the attributes of the animal they chose as their emblem; the eagle's
strength and majesty, or the owl's wisdom.

Animals were still widely used by the later Greek kings and Roman
emperors, not so much as emblems but as symbols of the issuer's character or
actions. The coin of Demetrius, the Greek king of Bactria, in modern
Afghanistan (119), shows him wearing on his head the skin from the head of
an Indian elephant. A similar headdress has been worn by Alexander the
Great, and by placing it on his own head Demetrius identified himself with
his famous predecessor. The headdress proclaimed that both these kings
ruled over India, but it also symbolised their possession of the abilities of the
elephant, its great strength and the success it brought when used in battle.

A coin which celebrates the conquest of the kingdom of Egypt by the
Roman emperor Augustus (27 BC–AD 14), uses a crocodile as the symbol of
that kingdom (120). The animal is here used as an emblem and at the same
time illustrates Augustus' military and political success. Animals were,
however, fairly unusual on the coins of the Roman emperors and they never
appeared on the coins of their successors, the Byzantine emperors, which
depicted only portraits of the emperors and their families or religious images.

During the Middle Ages animals reappeared on coins as emblems. Their
appearance coincided with the growth of heraldry and the popularity of the
three creatures in their heraldic form already described. Again, however, the
animals could also carry a deeper symbolism. The lion on the coin of
Flanders (121) was the emblem of the dukes of Burgundy who ruled
Flanders. The design of the coin follows that of a French coin on which the
king of France was shown standing beneath a canopy, but here the king has
been replaced not by the portrait of the issuer, but by his heraldic emblem.

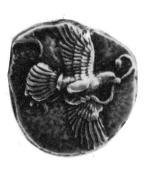

17
Silver coin of the city of Elis in
the Peloponnese in Greece,
with an eagle. Issued *c.* 400 BC.
Diameter 25 mm.

118
Silver coin of the city of
Athens, with an owl perched
on a vase within a wreath.
175 BC. Diameter 34 mm.

119
Silver coin of Demetrius,
Greek king of Bactria, showing
the king wearing an elephant
headdress. *c.* 200 BC. Diameter
33 mm.

20
Gold coin of Augustus,
Roman emperor, (27 BC – AD
4) showing a crocodile.
Diameter 21 mm.

121
Gold coin of Philip le Bon,
Duke of Burgundy, Count of
Flanders, (AD 1419–67), with a
lion seated under a canopy.
Diameter 30 mm.

122
Gold coin of James IV, King of
Scots, (AD 1488–1513) with a
unicorn reclining and holding
the arms of Scotland, a lion
rampant. Diameter 25 mm.

The lion represents not only the duke but also his lion-like attributes, majesty
and power. On Scottish coins (122) the heraldic device of the king, again a
lion, was shown on the shield it normally decorated, but a unicorn is also
shown as one of the heraldic supporters of the shield.

Heraldry is still the most important element of numismatic art. The purely
heraldic designs of most of the coins we use today are a witness to this. The
only change is the greater realism in the treatment of the subjects; the lion
now looks a little more like a lion. In the post-Renaissance period the finest

heraldic coin designs have been produced by Germany and its central European neighbours. The coins from Bohemia (123) and Henneberg in south Germany (124) are beautiful examples of the different ways in which the treatment of heraldic animals on coins had developed. The Bohemian coin has an elaborate design made up from purely conventional heraldic elements. The two-tailed lion of Bohemia is correctly placed on a shield, but set upon the breast of the crowned, double-headed eagle of the Holy Roman Empire which has been heavily stylised to make a frame for the Bohemian arms. The coin of the city of Henneberg uses the heraldic emblem of the city, a crowned hen drawn in a simple and natural fashion. The punning use of a hen as the badge of the city recalls the Greek coin of Phocaea (116).

This western preoccupation with animals as suitable emblems on coins has now spread throughout the whole world. In the late nineteenth century after two thousand years of coins without any image, the Chinese began to make

123
Gold coin of Leopold I, Holy Roman Emperor, as king of Bohemia AD 1669, showing a lion rampant, the arms of Bohemia, on the breast of the double-headed eagle of the Holy Roman Empire. Diameter 45 mm.

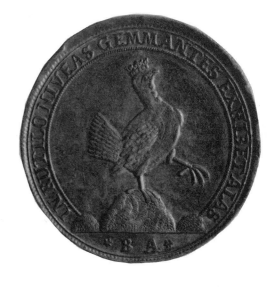

124
Silver coin of the city of Henneberg (south Germany), AD 1695, with a crowned hen standing on a rock. Diameter 42 mm.

125
Gold coin of the Chinese Empire, AD 1906, with a dragon among the clouds. Diameter 39 mm.

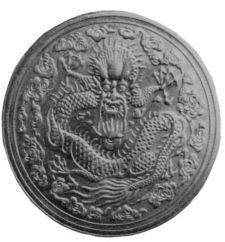

26
Bronze coin of Australia in the name of King George VI, AD 1938, with a leaping kangaroo. Diameter 30 mm.

27
Bronze coin of the Republic of Greece, AD 1831, with a phoenix rising from the flames. Diameter 35 mm.

coins in the European style (125). The creature they chose was the dragon, the symbol for many centuries of the emperor. Australia on the other hand, without a long history, adopted subjects from its own unique wildlife. The kangaroo (126), used with the emu as one of the heraldic supporters of the arms of Australia, is shown here in a realistic and dramatic picture of the creature drawn from nature. As we shall see in the last chapter, such objectivity in the depiction of animals is rare in the history of man's association with the animal world. Only in the last few years has the idea of depicting endangered species of animals on some coins to emphasise their vulnerability been a possible concept.

Although we know the need to save these animals is urgent, their representations on coins lack the impact of the totally imaginary phoenix on the Greek coin of 1831 (127). This coin, the first to be issued in Greece after its liberation in 1828 from Turkish rule, shows a phoenix rising from the flames. The allusion is once again to the bestiary. There was only ever one phoenix in the world and it lived in the East. After every five hundred years it gathered together precious spices and other perfumes and flew to the city of Heliopolis. There the priest spread twigs and brushwood on an altar on which the phoenix alighted. The bird lit a fire by scraping its beak on the altar and was consumed by the flames. After three days it rose up again into the sky, renewed and resplendent. In this form it was interpreted as a symbol of Christ's Resurrection. On the coin the phoenix symbolises not only the re-emergence of freedom and democracy in Greece but also the establishment of Christianity after the defeat of the Moslem Turks. Few will have remembered the source or details of the symbolism, but all instinctively recognised the irony in the use of this same phoenix by the Colonels of the Junta in Greece in recent years.

Coins demonstrate as clearly as any medium that the best symbols and signs depend on a complex series of associations as well as a readily recognisable image. Besides the phoenix the kangaroo is dramatic artistically, but less evocative as a symbol. To be an effective symbol an animal must be used to refer to some of the most important aspects of man's life, his position in a society or a state. They are a shorthand for ideas which are complicated or difficult to express in words.

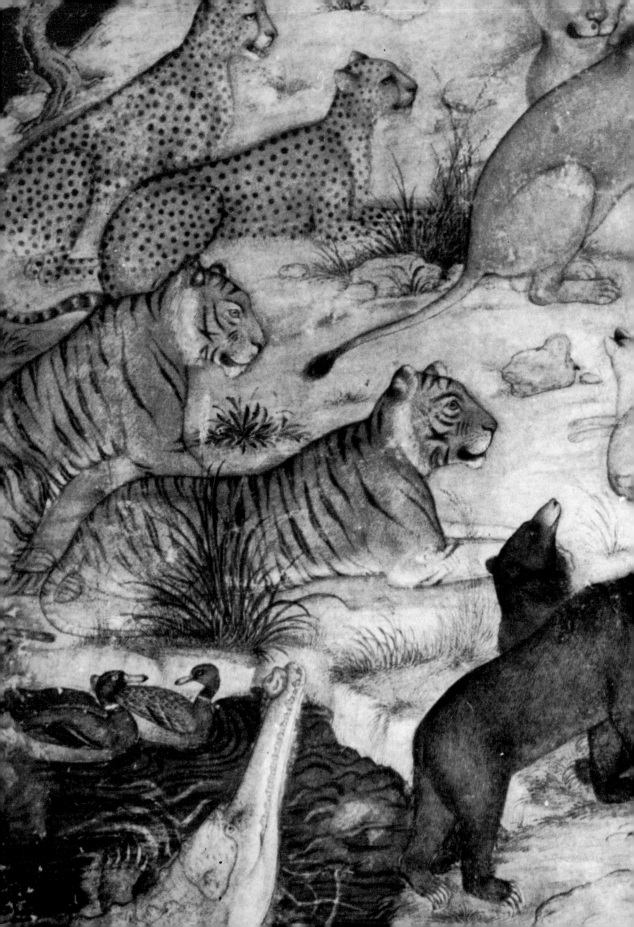

5. Stories and Fables

Animals take on many different roles in stories and fables. They are, as we have seen, used symbolically in some. In others they are there as real creatures, as in the stories of the Creation and the Flood. The animals in Greek myths, on the other hand, are often strange and imaginary, like Cerberus, the Chimaira, and the Hydra. However, they are part of the adventures and exploits of heroes and gods who have all too human qualities. To these groups can be added the fables in which animals are used to illustrate human foibles and folly.

The early illustrations of the Creation were dependent on classical examples. They followed mosaics which showed Orpheus and the animal kingdom. Some of their attraction probably depended on a bold display of a multitude of animals, and their close adherence to the earlier, non-Christian models. This exquisite cameo showing Noah receiving word from the angel of the Lord to lead his family out of the Ark was probably carved for the emperor Frederick II at his court in Sicily (128). It was later owned by Lorenzo de Medici. The subject allowed the artist to indulge his interest in a variety of animals.

Unlike the Creation and the Flood stories, which gave scope for the illustration of many animal types, other biblical stories were concerned with only one or two kinds of animal. The story of the Prodigal Son is such a tale. Its rendering on the tin-glazed dish is very specific, showing what might be

128
Detail from the Noah Cameo, made of onyx. Sicily or southern Italy, *c*. AD 1204–50. Frame probably French, of late 14th or early 15th century date. The three animals shown singly at the entrance to the ark are those mentioned in the Bible: the raven sent out by Noah which never returned, the dove that returned with an olive-leaf and the ox, representing the sacrifice Noah made to God. Length 5·3 cm.

village scene in northern Europe (129). The story is well known from the Gospels:

And when he had spent all, there arose a mighty famine in that land; and he began to be in want.

And he went and joined himself to a citizen of that country; and he sent him into his fields to feed swine.

And he would fain have filled his belly with the husks that the swine did eat: and no man gave unto him.

<div style="text-align: right">(Luke xv, 14–16)</div>

The pigs are used to emphasise the depths to which the second son had sunk by reason of his own profligacy and waste.

In the Greek myths, on the other hand, animals real and imaginary are used to illustrate not only human characteristics but also supernatural or god-like qualities. Such animals are not symbolic in the sense that the Lamb

131
Silver coin of Cyzicus in
Minor showing Herakle
the Nemean lion. *c.* 390
Diameter 21 mm.

132
Bronze plaquette with
Herakles and the Nemea
North Italy, early 16th c
AD. Attributed to 'Mode
prolific artist working in
15th or early 16th centur
who took his pseudonym
rivalry to a Mantuan art
who called himself 'Anti
Height 7·9 cm.

130
Bronze mirror case, decorated
with Herakles and the Nemean
lion, said to have been found
at Anaktorion. Greek 350–300
BC. Diameter 13·7 cm.

symbolises Christ but, like the swine in the story of the Prodigal Son, they are
complementary to the main character. Since the Renaissance these myth
have been current in European literature and art. Their origin and even the
most ancient texts in which they are found, are not easy to trace.

The most recent research shows that, as with so much of what we accept a
of Greek invention, the myths seem to have had Mesopotamian origins. The
stories of the Creation, the Flood, the sun god Helios or the earth goddess
Demeter bear a remarkable resemblance to their Mesopotamian
counterparts. The elements of the different myths are found in their most
ancient textual form in the *Odyssey* and the *Iliad* attributed to Homer, who
significantly lived in Asia Minor. They are also known from the *Theogony*
(or *Generation of the Gods*) by Hesiod. During the sixth century these myths
were more formally arranged in elaborate poems written to be sung to music
which culminated in the odes of Pindar composed in the fifth century to
celebrate victory at the Games. They received their fullest literary treatment
in the tragedies of Aeschylus and Sophocles and in the *Histories* of
Herodotus.

The myths about Herakles seem to have existed long before he is
mentioned by Homer and Pindar. He had an ambivalent status as both a god
and a hero. In addition to the famous twelve labours, he performed many
incidental labours and is described as the leader of an army in great military
expeditions. He illustrates the tension between nature and culture, and in no
myth is this more evident than the first labour in which he killed the Nemean
lion. This great lion, which had been laying waste the area around Mycenae,

was invulnerable to all weapons, so Herakles had to trap it and then squeeze it to death. The natural power of the beast required this brutal treatment. This element in Herakles' own character is symbolised by his wearing of the lion skin which he had taken from this lion. In both the classical representations, on the Greek mirror case (130) and the coin (131), this menacing meeting of two equal, natural forces is effectively achieved. The Renaissance plaquette is a much softer interpretation of the same combat (132). Such plaquettes, or small bas-reliefs, were deliberately based on antique gems, as well as contemporary engravings and sculptures. They were made from the last decades of the fifteenth century AD to render these major works of art accessible to far wider circles than the princely patrons. The vase painting of the Greeks, on the other hand, provides for a different style of representation. A scene of Herakles killing the Stymphalian birds has a deliberate kind of drama. The tension arises from the pattern of the birds within the frame allowed on the vase (133). These Stymphalian birds infested

133
Detail from a black-figured amphora showing Herakles killing the Stymphalian birds with sling-shot. Found at Vulci in Etruria, made at Athens *c.* 550 BC. Height 41·5 cm.

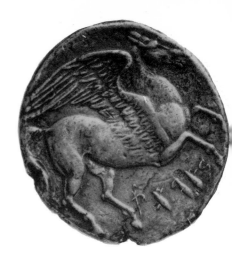

135

Silver coin of Carthage, north
Africa, showing Pegasos,
c. 265 BC. The winged horse in
this coin was copied from the
Greek coins of Syracuse in
Sicily which in turn had been
copied from the coins of
Corinth, the supposed home of
Pegasos. Diameter 37 mm.

134
Detail of the engraved design
of Pegasos on a bronze cista
(toilet-box). Etruscan *c.* 300 BC.
Height 48 cm.

a forest near Mycenae and were ferocious man-eating creatures with terrible
metallic feathers and claws.

Pegasos, the winged horse, was linked to two other great Greek heroes,
Bellerophon and Perseus, for Pegasos sprang from the body of Medusa, the
terrible creature with snakes for hair, when Perseus cut off her head. This
horse is described by Strabo in his *Geography*:

The summit of Acrocorinthus has a small temple of Aphrodite, and below the summit
is the Spring Peirene . . . and here they say, Pegasos, a winged horse which sprang
from the neck of the Gorgon Medusa, when her head was cut off, was caught drinking
by Bellerophon.

To enable him to harness this beast, Bellerophon was given a magical bridle
by the goddess Athena. The exquisite engraving on the Etruscan toilet-box
(cista) shows the moment when Bellerophon had caught Pegasos (134). The
grace of the winged horse obviously captured the imagination of the artist.
Indeed the image has proved so attractive that not only is it found on Greek
coins (135) and a Renaissance medal (136) but the same image now debased
is used today as a cliché for speed. In this instance the visual imagery of the
animal has given it an existence outside the myth to which it belongs. Not
only was it adopted wherever the myths of the classical world were
influential, as in Etruria and then in Renaissance Italy, but it is found as far
away as China, detached from its name, but a winged horse nonetheless.

Even minor creatures like the hippocamp are found in such different

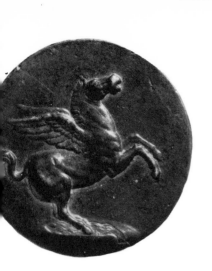

136
The reverse of a bronze portrait medal of Cardinal Petro Bembi showing Pegasos rearing, by Benvenuto Cellini of Florence (AD 1500–71) *c.* AD 1536. In his memoirs Cellini wrote that the horse had been ten times more difficult to engrave than the portrait on the obverse. Diameter 48 mm. Reproduced actual size.

137
Detail of the engraved design on the lid of a cista (toilet-box) showing a hippocamp ridden by a nereid (sea-nymph). Etruscan *c.* 300 BC.

139
Stone toilet-dish with a hippocamp. Gandhara, *c.* 1st century AD. Diameter 10·4 cm.

138
Silver coin of Byblos in Phoenicia with a hippocamp and galley, *c.* 430 BC. Diameter 25 mm.

countries as Italy and India. The hippocamp is the mount of Thetis, the mother of Achilles, and draws Poseidon's chariot. It is seen on many items such as the Etruscan cista (137), a coin from Byblos (138) and a toilet-box from Gandhara (139).

The hounds of the goddess Artemis have a different and more complicated series of associations. Shown on the medal (140) and the enamelled plaque (141) surrounding the goddess, these hounds are really the hounds of Actaeon. The story is a tragic one, for this boy saw by chance the goddess and her nymphs bathing, and so Artemis ordered that he should be torn to death by his own hounds. The hounds then became hers by an association of ideas. In these representations the much more complex series of events

140
The reverse of a bronze portrait medal of Hippolyta Gonzaga by Leone Leoni, Italy (AD 1509–90) showing Artemis with her hounds; behind is the three-headed dog of Hell, Cerberus, above her the crescent moon. Hippolyta was the daughter of Leone's patron, Ferdinand Gonzaga. Artemis was probably chosen to flatter Hippolyta for her chastity and as a reference to Hippolyta, Queen of the Amazons and wife of Theseus, who was a protegé of Artemis. Diameter 66 mm. Reproduced actual size.

141
Plaque, painted enamel on copper, showing Artemis with her hounds. Limoges, France, mid 16th century. Limoges, the leading centre of the craft of enamelling in France since the 12th century, developed to high artistic levels the new technique of *painted* enamels (i.e. applying successive layers of enamel with spatula or brush). The subjects were often adapted from engravings and the finest of these luxury items were commissioned by both the French court and patrician families abroad for their decorative appeal and technical skill. Diameter 29 cm.

relating to the life of Artemis, which seem to have been current before the story of Actaeon was developed, are ignored. Even the tragedy of Actaeon appears forgotten in these pictures of a carefree goddess.

Illustrations of Romulus and Remus make an interesting contrast, being the representation of a specific incident rather than of the general attributes of a god or goddess. The story of the twins fostered by a wolf appears in the legends concerning the foundation of Rome recounted in Livy's *History of Rome*. The early coin of the Roman Republic (142a) is thought to have been copied from a statue erected on the Capitoline Hill in 296 BC to commemorate this event. Representations of this symbolic event always follow the same scheme. One of the most precise of all is the copy of the Roman coin by the medallist Giovanni Cavino of Padua (142b). This theme

142a
Silver coin of the Roman Republic showing Romulus and Remus being suckled by the wolf, *c*. 265 BC. Diameter 20 mm.

142b
Tin medal by G. Cavino of Padua, Italy (AD 1500–70). Cavino's chief claim to fame was as a copier of ancient coins. Diameter 34 mm.

is also shown in exactly the same form on a pre-Roman coin from Carthage.

In all these stories the animals have supporting roles. They are used to throw human and often earthy characteristics into relief. Though frequently magical, they are not symbols of the supernatural. They are also quite distinct from the group of stories in which animals take on the role of men. These stories show animals a step closer to man. They concern not the universe as a whole but the play of human character in daily life, in society and in politics; they are very often satirical.

The best known of these animal fables make up the collection attributed to Aesop. Aesop is a shadowy figure said to have been a slave in Samos in the fifth century BC, and fables of this type seem to have existed at that time. They were collected together formally about 300 BC by Demetrius of Phaleron. The animals have the characters of humans, with all their wit and failings. The story of the fox and the grapes is one which has taken its place in the English vocabulary with the phrase 'sour grapes'; a fox, when he tried and failed to steal some grapes, called out 'Take them who will, the grapes are sour'. This is a short vignette of human character. More often the stories involve two animals or birds and are used to illustrate a moral, as in the story of the *Eagle and the Raven* (143):

He that is wel and sure garnyshed, yet by false counsayle may be betrayed, as Esope

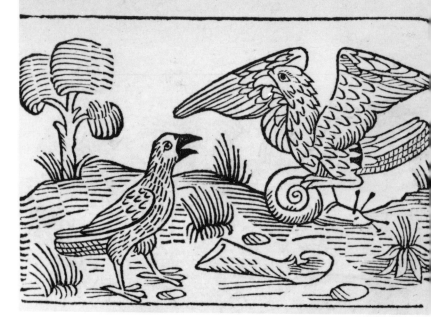

The viii fable is of the Egle whiche bare a nutte in his becke and of the rauen

143
The Eagle and the Raven
from: *The book of the subtÿl
historÿes and fables of Esope.*
Translation by Caxton
completed AD 1483. Printed
26 March AD 1484.
British Library.

telleth such a fable. An Egle was sometyme upon a tree, which held in his byl a nut
which he could not breake. The Raven came to him and sayd Thou shalt never breake
it, tyll thou flie as hie as thou can, and than let it fal upon the stones. And the Egle
began to fly and let fal the nut and thus he lost his nut. And thus many one hath bene
deceived through false counsel.
(*Fables of Esope*, after the Caxton edition of 1484. Imprinted at London by Henry
Wykes for John Waley)

The birds have human character and show the twists of human folly. All
these stories are short and have a single incident as a plot.

This combination of folk-tale and wit played out as satire through animals
reappeared in Europe in the later Middle Ages. Translations of Aesop and
Bīdpāy (to be discussed below) were known in Italy by the eleventh century.
They were useful models for the satires of Langland and Chaucer. The story
of Chaunteclear the cock, and Pertelot the hen in the *Nun's Priests' Tale*,
written after the peasant uprising of AD 1381, is a satire of human folly
containing references to the recent political troubles.

The ancestry of many fables is much more ancient than the collection
attributed to Aesop, and can be traced, in general terms at least, to ancient
Indian sources. Two Sanskrit classics *Pañcataritra* and *Mahābhārata* are
certainly the origin of the fables of Bīdpāy named after a legendary Indian
sage. These fables are best known in Persian versions, the *Kalīla wa Dimna*
and the *Anwār-i Suhaylī*. These two texts include similar tales in which
animals take roles on the stage of politics and morality. As with the Aesopian
fables a moral lesson for mankind is drawn from the incidents described. The
stories are often very complicated, with several minor plots within each

144
The *Sīmurgh*, king of the birds, with his army, which includes sandpipers, hoopoes, hawks, pheasants, crane, ibis, duck and green woodpeckers. From a manuscript of the *Anwār-i Suhaylī* by Ḥusayn Wāᶜiẓ Kāshifī (d. AD 1504–5/ AH 910), one of the Persian versions of the animal fables of Bīdpāy. This copy was produced for Prince Salīm, later Emperor Jahāngīr and bears two dates: 1604, 1610. Miniatures in Mughal style. Gouache on paper. 15·5 × 8 cm. British Library. Add. MS. 18579, f. 104a.

بچگانِ طبطوی را بازنهاد وغرضِ ازایراد این افسانه آنست
که هیچ دشمن را اگرچه بغایتِ حقیر باشد خوار نباید داشت
که از سوزنِ خورده قامت کادی آید که نیزهٔ در از قد در ان عاجز
فرو ماند و ذرهٔ اگرچه در هنظر اندک نماید هرچه باوی ملاقی کرد
بسوزد و حکما گفته اند دوستیِ هزار این بمقابله دشمنی یک

major one. Kalīla and Dimna, the main characters in one of the stories in
both versions, are two jackals; Dimna was determined to arouse fear and
suspicion between a lion and an ox, and to do so he used the story of the
sandpipers (144). This delightful and detailed miniature shows two
sandpipers who had foolishly built their nest by the sea, and had their nest
carried away by the *Jinn* (genie) who lived beneath the ocean. So they
complained to the other birds, and all the leaders of the birds took counsel
and appealed to their king, the *Sīmurgh* (or phoenix). The *Sīmurgh* is thus
shown with his army flying to the rescue. The *Jinn* was compelled to restore
the young birds, and so found to his cost that he could not afford to despise
even the humble sandpipers. Dimna was trying to demonstrate to the lion
that, strong though he was, he should not trust the ox. A double moral can be
drawn by those who read the story: first, the simple one that the strong
should not overlook the weak; and then the more profound one, that even
good causes can be used by people with doubtful motives for treacherous
purposes.

The victory of the weak against the strong is the theme of another very
amusing story. It is contained within the longer story of the dispute between
the owls and the crows for sovereignty of the birds. When the cranes were
about to choose the owl a crow flew by and advised them:

What motive could possibly induce you to make an owl your king, who is not only the
ugliest bird to look at but remarkable at the same time for his bad character and
profound ignorance united to a violent temper and a want of generous feeling,
besides this, his partial blindness, for he is at least unable to support the broad light of
day, and natural stupidity render him totally unfit for so distinguished a post; unless
you have secretly in view to declare him nominally your sovereign, reserving to
yourself the whole direction and administration of affairs, as the hare did when she
said that the moon was her sovereign.

Then follows the story of the elephants and the hares to illustrate the crow's
argument (145). Forced by drought to search for new watering-places, a herd
of elephants repaired to the 'Fountain of the Moon', a spring around which
some hares had made their home. Finding themselves repeatedly trampled
upon by the newcomers, the hares thought up an ingenious remedy. One
night a hare set off to see the elephants, posing as the Ambassador of the
Moon. Going to the top of a hill she called out to the king of the elephants
and said:

'The Moon has sent me to you; and if my language in obedience to my instructions
should appear objectionable, I must trust for my justification to the character in
which I appear.' The king of the elephants desiring to be further acquainted with the
object of her mission, she continued: 'He who, owing to a successful effort against a
weak enemy, is led to believe that his strength is irresistible, often pays dearly for his
presumption, in a contest with a more powerful opponent; and you, O king, relying
on your superiority over the other beasts, overlook the consequences of your temerity
in drinking at and polluting the Fountain of the Moon, who has directed me to
caution you against a repetition of this insult, threatening, in case of your
disobedience, not only to withdraw the light which she so graciously dispenses, but to
effect your destruction; and if you have any doubts about my mission, I will
accompany you to the Fountain, and convince you of the truth of it.'

145

The elephants and hares at the
spring called 'The Fountain of
the Moon'. From another
manuscript of the *Anwār-i
Suhaylī*, copied and illustrated
at Aḥmadābād in AD 1600–1,
with Mughal miniatures.
Gouache on paper. 16·5 × 13
cm. British Library. Or. MS.
6317, f. 114a.

So the king went with her to the fountain, and when directed to wash h
trunk in the pool, and humble himself he saw the reflection of the moo
quiver in the water. The hare persuaded him that this was a sign that t
moon was angry, so the elephant promised to mend his ways.

Such stories were a superb vehicle for the art of the miniature painters
the Mughal Court. ·One particularly spectacular example shows a cro
addressing a whole assembly of animals including again the *Sīmurgh* wi
the long streaming tail taken from Chinese models (see colour plate IX
Though it does not exactly fit the story from the *Kalīla wa Dimna* and *Anwā
i Suhaylī*, of the dispute between the owls and the crows, its theme is clear
related. The assembly might be a gathering of the ranks of men. It is
splendid composition with the multitude of animals echoing the shape of t
towering rock. Much more extraordinary and frightening is the painting
the *Rukh* attacking an elephant-like rhinoceros (146). The *Rukh* looks n
unlike the *Sīmurgh*, both being taken from the Chinese phoenix. This bird
not the bright monarch of the skies but a fierce creature causing hav
among elephants and birds, its long tail plumes like menacing flames. Whe
the previous miniature was crowded with animals in an orderly assembly th
one is filled with equal mastery to produce a surrealist nightmare. T
miniature probably illustrates the story in the *Thousand and One Nigh*
which tells how the *Rukh* feeds on rhinoceros and on the elephants which,
was said, the fierce rhinoceros caught on their horns. Although elephan
were familiar creatures, rhinoceros were much less well known, and t
strange tales about them gave rise to the myth of the unicorn in Islamic land
For this reason rhinoceros are shown in all sorts of forms including a rath
stout unicorn. The rhinoceros-unicorn was known as the *Karkaddan*. The
was in medieval Europe the same confusion about the identity of t
rhinoceros, where it was likewise interpreted as a unicorn. What is more t
same story about the rhinoceros attacking elephants with its horn is repeate
in the bestiary in relation to the unicorn: 'The unicorn often fights wi
elephants, and conquers them by wounding them in their belly.'

A marginal drawing in the fourteenth century 'Queen Mary's Psalte
shows a unicorn attacking an elephant. This is a much less alarming sce
than the Mughal miniature, yet they share a common source. For it is
Strabo (*c.* 63 BC–AD 21) that they and we owe the story that the rhinoceros
particularly inclined to contend with the elephant for a place of pastur
thrusting its forehead under the elephant's belly and ripping it up'.

As with many of the tales described in this chapter, this unlikely story ha
a long and colourful history.

46

he miniature which may be
ssociated with the Sindbād
ories in the *Thousand and
ne Nights* shows the *Rukh*
ttacking a rhinoceros here
epresented in the form of a
ntastic elephant. It was
ommonly believed that the
hinoceros would attack
ephants. India. Mughal
chool, late 17th century AD.
Gouache on paper. 13·5 ×
1·3 cm.

Animals are a favourite subject for ornament and decoration. Vessels in pottery or metal have been made in the shape of animals in most cultures and at many periods. Dishes and boxes have been decorated with animals of every type, and a choice among them has had to be made here. This chapter will mention a few examples of these types of ornament. The first part will describe several styles of ornament made up of different kinds of interlace and abstraction of animal forms. This type of ornament composed of sections of animal heads, limbs or eyes, repeated in imaginary compositions disintegrated or intertwined in patterns, is found in a number of areas. They are almost certainly not related. However, they share a common characteristic and that is an emphasis on the creation of decorated surfaces or of three-dimensional forms, in which the interest lies in the ingenuity of the abstraction rather than in references to realism. At first sight many decorated surfaces appear as incomprehensible if lively mazes of lines and ridges, but the eye is then led to follow the line in one direction and back again, and is thus able to draw animal forms out of this tangle of line and shape.

On a Chinese ritual bronze *c.* 1200 BC (147), made for offerings of food to the ancestors, the decoration was probably relevant to the ritual of the period and at the same time ornamental. Two eyes stare out from a frieze of feather-like hooks and scrolls. If it is compared with the small three-dimensional head of a ram, attached to the shoulder of the same bronze container, the interest of the disintegrated patterns in the first example is evident. For apart from the limitations of stylistic convention, the second detail is obviously an animal head, while the first leads the eye to explore the lines but not to comprehend the subject directly. The first example is in fact quite difficult to understand. Above the two eyes with their uncompromising round pupils are two curling horns, not unlike the shape of the ram's horns, but laid out flat and complicated by drawing the line of the horn round and round inside itself. A flange down the centre provides the nose, and below it three lines come to point. They have curled ends and are like a moustache or

147
Two details from a cast bronze ritual vessel. China, *c.* 1200 BC.
a
A mask with two eyes and feathery extensions, from the main body of the vessel.
b
A head of a ram on the shoulder of the vessel.

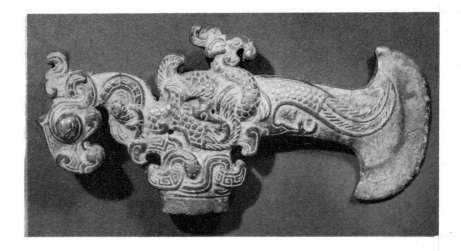

148
Bronze axe-head with
interlaced dragons and birds.
China, 6th century BC. Length
13·4 cm.

upper jaw. Away from the horns and eyes the pattern seems to dissolve the
face in rows of feathers. This is at the same time a split image. That is to say it
can be seen both as the front view of a mythological dragon-like creature
known as the *t'ao-t'ieh*, and as its two side views. Thus the eyes seen from the
front become two eyes in profile. Likewise the horns and the feathers are the
side views of the body, and what were the whiskers on the upper jaw are from
the side understood as the front claws. It is very difficult to hold both the
front view and the two side views simultaneously, and to recognise them as
one and the same creature, but like the split-image of designs from the north-
west coast of America (see p. 48) this is what they are. So difficult has it
generally been to understand this type of design that quite different animals
have been attributed to the front and side views of the one mythical creature.

The complicated methods used by the Chinese for casting bronze
stimulated the development of this type of ornament. Bronzes were cast in
pottery moulds made in several detachable sections. It was therefore difficult
to make elaborate shapes, but detailed surface decoration like the *t'ao-t'ieh*
mask could be stamped or incised in the clay very easily.

On later Chinese bronzes the designs of animals were equally complicated,
but much greater use was made of three-dimensional form and elaborate
surface texture. A Chinese axe-head of the sixth century BC (148) is a fantasy
of many animals. The main creature is a dragon with its head bent over in
profile at the back of the axe, and its body running through a maze of snakes
to end with a tail along the blade. A bird-like creature sits triumphantly in
the middle with its neck stretched around and up through the rear half of the
dragon. The design is difficult to understand at a glance. Instead the eye is
drawn to follow the different animal forms, and to disentangle them
gradually. This axe-head illustrates one of the high points of Chinese bronze
casting with its emphasis on complexity of animal decoration.

To the north-west and north of China a completely separate tradition
touched on the borders. That is the 'animal art' of the nomadic peoples
described in the first chapter. Among the nomadic peoples the head of a bird
of prey was a favourite decorative motif. In its early stages it is shown in three
dimensions with a semblance of realism, but by the fifth century BC it is found

in southern Russia, south Siberia and Mongolia in flatter, abstracted form. A golden bird's head found in the Oxus Treasure is an example of Scythian style work from the borders of Iran (149). It is a simplified version of the birds' heads already seen in the gold band of Ziwiye (4). The striated neck of the bird is reminiscent of the ibex horns common in this type of ornament which frequently become displaced from their proper associations. This is what happened on one of the two harness fittings in the shape of similar birds' heads from the Ordos area north-west of China (150). The left-hand bird is fairly easily recognisable as a bird although the different elements have been diminished or exaggerated. An elaborate curl represents the beak but it is quite staid compared with the right-hand bird's head. Here the original theme has disintegrated completely, and three striated ibex horns with open circular ends have been inserted with no relevance to the representational meaning of the design. The result is that the beak, the eye and the jaw or cheek are forced apart; the arrangement has become decorative and is no longer a simple bird's head. In this instance this last example would have been incomprehensible without the others.

This same tendency to change a relatively representational design into an abstract pattern is seen among other peoples. A group of coins of the Celts (151) show that their preference was for what we would see as ornament and pattern rather than realism. The Celtic peoples, living in the lands adjacent to the classical world, took classical coinage as their model. One of the most influential coins was the gold stater of Philip II of Macedon (151a). Two horses drawing a chariot with a driver are shown in exquisite, realistic detail. Even the perspective of the chariot is beautifully accommodated by the shape of the coin. It is almost impossible to believe that this was the ultimate prototype for the coin of the Ambiani in north-east France, *c.* 75 BC (151b). Yet all the details of the composition are still there. The chariot, now on the right-hand side instead of the left, and the charioteer are taken from the original. Empty space was abhorred and filled with stars and dots. The joints of the horse are greatly emphasised and the forms of the body exaggerated. This cannot be because the engraver had never seen a horse but must have arisen because he felt the need to articulate his design in a particular manner. It is splendidly independent of its classical model.

At this stage the design has lost its original form and achieves its effect

149
Gold ornament in the form of a stylised bird's head issuing from a serpentine body. From Iran, Oxus Treasure. Scythian, *c.* 5th–4th century BC. This object was found with the rest of the Oxus Treasure in Central Asia but it is probable that the hoard originated in Iran, and was deposited at the border of the Achaemenid Empire in time of trouble. Length 3·35 cm.

150
Two bronze ornaments in the shape of birds' heads. Ordos region, north-west China, 4th–3rd century BC. Length 2·8 cm.

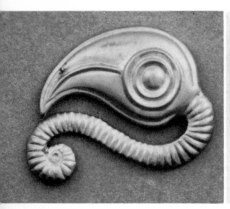
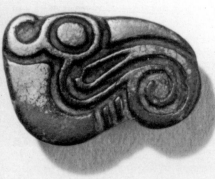
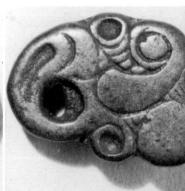

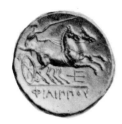

old coin of Philip II of
Macedon (359–336 BC) c. 335 BC.
Diameter 18 mm.

b
Gold coin of the Ambiani of
north Gaul, *c.* 75 BC. Diameter
27 mm.

c
Gold coin of the Catuvellauni,
Buckinghamshire, *c.* 35 BC.
This is the prototype for the
next coin. Diameter 19 mm.

old coin of Cunobelinus,
ng of the Catuvellauni *c.* AD
–40. Mint of Camulodunum
Colchester). Diameter 20 mm.

e
Gold coin of the Dobunni,
Gloucestershire, *c.* 30 AD.
Diameter 18 mm.

f
Base silver coin of Durotriges,
Dorset, *c.* 30 BC. Diameter
18 mm.

51
ix coins illustrating Celtic
daptations of the design on a
old stater of Philip II of
Macedon.

through its pattern rather than its content. But the retention of most of the
elements of the original cause it to lack a degree of coherence. However, a
coin issued a little later in Britain, although less vivid and lacking essential
details of the original, shows a design which is more tightly organised within
its own convention (151c). To achieve this coherence the wheel of the chariot
has been placed below the horse, not behind. In both these Celtic examples
the emphasis on pattern is an exciting transformation of the original.

The Celts were no mean engravers and did, at one stage, produce a much
more classical version of their own coins. The original forgotten, the coin of
Cunobelinus shows only the horse (151d). Although more realistic, the coin
still has a stylised rather than naturalistic approach. This interlude was brief,
and soon terminated by the Roman invasion. More remote Celtic groups in
the west of Britain retained by contrast the abstract quality of the earlier
versions on their own coinage (151e). Despite the dislocation of the parts of
the horse, the design of the coin of the Dobunni is beautifully organised. It
illustrates that the concern was for a satisfying pattern around which the eye
could move to compose and decompose the horse, and not for a single, easily
recognised, realistic horse. Some coins went further, understanding was

152
Gold pendant with three heads of birds of prey, set with garnets in cloisonné settings surrounded by bands of filigree-wire ornament. From Faversham, Kent. Anglo-Saxon, early 7th century AD. Diameter 3·5 cm.

153
Silver-gilt pommel with two interlaced animals biting one another's bodies. From Crundale Down, Kent. Anglo-Saxon, 7th century AD. Width 6·3 cm.

154
Carpet page from the Lindisfarne Gospels. Northumbria, *c.* AD 700. Body-colour on vellum. 34·1 × 24·5 cm. British Library. Cotton MS. Nero D, IV, f. 94b.

subordinated completely to design, and a series of dots and stripes resulte Round dots marking the joints of the horse are all that remain to remind of the original Celtic modifications of the gold stater on a base silver coin the Durotriges (151f).

Like the Celts the Germanic tribes, with some exceptions, rejected t conventions of naturalistic art of their contemporaries in the Mediterranea world. On metalwork and especially jewellery the forms they used we derived from animals and birds, but they were convoluted and twisted out all recognition, winding and intertwining amongst one another. One of t most important features of this type of decoration was the variety of surfa texture and colour used. The vivid polychrome effect of inlay in precio stones was one of the most brilliant styles. Inlay of garnets was employ with spectacular effects by the Anglo-Saxons as on the Faversham penda (152). Although this technique may have originally been adopted from sou Russian or eastern examples, together with this design of birds' heads, t Anglo-Saxons developed it to new heights. In addition to garnets, blue a green glass was used together with niello, a form of black inlay, and al white materials.

As important as this polychrome style was the use of various met finishes, particularly gilding and silvering, on chip-carved and striate surfaces. A sequence of styles embraced both the polychrome decoration ar the use of textured surfaces. The ribbon style in which animals we interlaced was characteristic of much Anglo-Saxon, Scandinavia Lombardic and Alamannic ornament in the late sixth and seventh centurie This followed what is regarded as the first style which consisted of a series creatures each stopping abruptly before the next; connected yet with barrier between each unbridged. The ribbon style was more fluid and is see in two forms: as a continuous abstract interlace of the long bodies creatures, and as a more restricted design in, for example, the two interwov animals on the Crundale Down sword pommel (153).

A more flowing and later version of the interlaced animals on the swo was probably the source of the style used for the interlaced animals in t four centre sections of one of the carpet pages (154) from the Lindisfar

155
Silver disc-brooch, with quadrupeds and snakes. Anglo-Saxon, 11th century AD. Found at Sutton, Isle of Ely, Cambridgeshire in 1694, with a hoard of silver coins of William the Conqueror. Although decorated in a unique manner, the style shows strong Viking influence. The animal in the bottom right-hand corner has two faces, one at the front with open mouth, a pointed snout and teeth, and one looking backwards with human mouth and pointed nose, which forms the ear of the main animal. The back is inscribed round the edge with a rhyming verse in Old English, translated: 'Aedvwen owns me, may the Lord own her. May the Lord curse the man who takes me from her, unless she gives me of her own free will.' Diameter 14·9–16·4 cm.

Gospels (folio 94b). This, one of the most important of all Englis[h] manuscripts, was written and decorated in Northumbria *c.* 700 AD. Th[e] portraits of the Four Evangelists included in the manuscript are based o[n] Italian prototypes, but the carpet pages, such as this one, combine Angl[o]-Saxon and Celtic features. In addition to the interlace the bright colours ca[n] be compared with the polychrome inlay on jewellery, as can the bird mot[if] around the borders of the page. The elaboration on the spiral design in th[e] four rectangular panels is, however, a Celtic motif.

From the eighth to the twelfth centuries AD the Vikings developed a serie[s] of distinctive styles in Scandinavia. An early Viking style of the eighth t[o] ninth centuries, seen for example in the Oseberg ship burial, shows as it[s] most characteristic feature interlaced beasts gripping and biting on[e] another. One of the later forms of Viking decoration of the eleventh centur[y] is known as the Ringerike style from a series of carved stones found in th[e] Ringerike district a few miles north of Oslo and in adjacent areas. On thes[e] stones the long interweaving tendrils of the acanthus, and of animal horn[s,] plumes and tails, are set against the heavy bodies of the animals themselve[s.] The Sutton, Isle of Ely, brooch is an English interpretation of this style bette[r] known from Scandinavia (155).

These animal styles were gradually penetrated by the conventions o[f] ornament current in the Mediterranean era. These included the paired o[r]

'heraldic' beasts already discussed, and the inhabited vine or acanthus scroll. The growing importance of Christianity and the symbolism associated with the religion, which saw the vine as representing Christ and His Church (John xv.1), may have encouraged its adoption. In Anglo-Saxon England in the century before the Norman Conquest, artists looked to the continent for inspiration. The complex borders of the 'Benedictional of St Æthelwold' illuminated in Winchester AD 974–84 illustrate the Anglo-Saxon treatment of the Carolingian acanthus. A pen-case from London of a somewhat later date shows a more restrained treatment, this time of an inhabited scroll (156). On the other hand a later carved Scandinavian tusk is extremely dense and taut (157).

By the thirteenth century even the relatively realistic animals enclosed in

156
Detail of an ivory pen-case showing two men shooting birds. From the City of London. Anglo-Saxon, 11th century AD. Birds and beasts among foliage decorate the sliding lid, while the broader end has a monster's mouth containing two dragons. The sides are carved with combats of men, animals and monsters, recalling the calendar pictures of the late-Saxon Winchester school of illumination.

157
Detail of a walrus tusk carved with foliate scrolls inhabited by beasts. Scandinavian, AD 1150–75. Original use unknown. Adapted as a reliquary in 14th century. Height 44·5 cm.

158
Detail of carved panel from
gittern showing a swineherd
knocking down acorns to feed
his pigs, English, *c.* AD
1285–1300. Apart from horns
and whistles, this is the only
medieval musical instrument to
survive. It was the popular
accompaniment for songs; in
Chaucer's *Canterbury Tales*,
the parish clerk serenaded the
carpenter's wife with a gittern,
with dire results to himself:
'The moone at night ful clear
and brighte schoon
And Absolon his giterne hath y
take.'

the scroll no longer satisfied, and lively genre scenes are seen both in
manuscripts and on decorative items such as the gittern (158). This gittern
was originally plucked but was altered to a bowed instrument, possibly in the
sixteenth century when it was owned by Queen Elizabeth's favourite, Robert
Dudley, Earl of Leicester, whose badge together with the Queen's arms is
engraved on the silver plate added to the peg-box. This detail shows a
swineherd with his swine beneath an acorn tree. Although each element is
represented with a considerable degree of naturalism, especially the leaves
and the acorns, the whole scene does not give an illusion of reality. It remains

primarily attractive as a scheme of decoration. It is likely that the craftsman worked from a pattern book rather than from personal observation.

In the Islamic world there were separate conventions of ornament. Animals were widely used on ceramics, and are also seen to great effect on inlaid metalwork. The animal scroll of the type used on this pen-case (159) had a relatively short life appearing first on Islamic metalwork in the late twelfth century AD. Its last dateable occurrence is on a brass pen-box made for the historian Abu'l-Fidā, the Ayyūbid ruler of Ḥamāh (AD 1310–32). Although shown in a precise geometrical arrangement, the animals on this pen-case are entirely recognisable and include a stag, a bear and a hare.

A different style of ornament is seen on an Egyptian bowl (160). The mass of fish, which are in fact set out geometrically in concentric circles, are so placed as to give the effect of appearing to move under water. These fish were possibly copied from imported Chinese porcelains carved with fish as an auspicious symbol. The calligraphic drawing of a cock (161) may also have a Chinese source in the form of sketches for embroidery. Such drawings no longer show any consciousness of the Chinese original and have achieved complete mastery of the adopted genre. At the same time the superimposition of four views shows a concern for experiment in the choice of natural position, and even an interest in the possibility of composite animals.

An Islamic form of animal ornament used in a Christian context in Spain is seen on a Hispano-Moresque dish (see colour plate VIII). This dish, although made in the kilns near Valencia under Christian supervision, is in the full tradition of Islamic pottery. There had been unbroken contact between Spain, Syria and Mesopotamia from the tenth to the fourteenth century AD. Lustreware painting, the application of metal pigments on an opaque glaze, was developed in Mesopotamia and widely used by the Arabs as a substitute for gold. Painted decoration in blue was also an Islamic tradition. Here it is used to great effect for the deer, which fills the main field of the dish as animals do on many Islamic pottery types. The motto around

160
Brass bowl inlaid with gold
and silver. The bottom of the
bowl has a design of four
concentric circles of fish round
a whirling rosette, swimming
respectively right, left, up and
down. Those few which remain
unrestored have finely chased
details. Mameluke Egypt. The
bowl bears an inscription in
the name of an emir of al-Nāṣir
Muḥammad (d. AD 1341/AH
741). Height 10·2 cm.

162
Black lacquer box decorated on the outside with Sika deer, stylised clouds, autumn grasses and the moon, in a variety of gold lacquer techniques with metal studs. Japan, late 17th century AD. The Japanese Sika deer, *Cervus nippon* have white spots in summer but none on their winter coat. Length 16·4 cm.

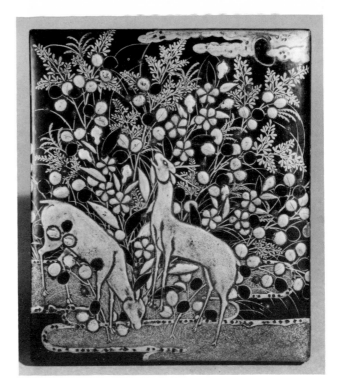

161
A game cock with its head in four different positions. Pre-Safawid Persia or Ottoman Turkey, late 16th – early 17th century AD. The painter's 'signature', Shāh Quli (?) may be a later ascription. 'Calligraphic' drawings, popular in Persia and at the Ottoman Court probably derived from Chinese sketches for embroidery or, later, blue and white porcelain, though they evolved, as here, into a decorative genre of their own. Brush drawing on paper. 10·2 × 15·8 cm.

the rim is Christian, although on some examples strange adaptations of Arabic are found. Painting in blue, this time under the glaze, was also adopted under Islamic influence in the Far East where the motif of the deer was and continued to be extremely popular.

An attractive example of Far Eastern decoration with deer as the subject is seen on a Japanese lacquer box (162). Lacquer, the sap of a tree, was widely used in China and Japan. It had the advantages that it could be coloured and used like a viscous protective paint, that it could be built up in layers to different levels, and that it could be carved, inlaid and gilded. The box is an example of the use of a number of complicated gold and black lacquer techniques and even includes metal studs. Complexity of manufacture does not mar the grace of the design of the Sika deer. Sprays of autumn grass and the moon complete what is a decorative rather than a naturalistic scene. Although the detail is concentrated on one side it shares with all the other types of decoration we have described the organisation and balance which is the mark of successful ornament. A sense of movement across a surface is one of the most important characteristics of ornament, and is to be contrasted with the illusion of volume and depth we associate with naturalistic drawing.

The other important characteristic of ornament is stylisation. This we have already encountered in the modification of animal forms shown on a surface, but it also influences three-dimensional ornaments, fittings and containers. The vessels in the shape of animals are legion. Any choice among them is totally arbitrary. As important and lively as any are the Moche pots

from Peru, among which is found again the theme of the deer (163). These pots are one of the few sources of information about the Moche civilisation which dominated the north coastal region of Peru *c.* 200–700 AD. The pot with a deer, for example, shows a hunter catching a deer painted on the side of the vessel. Although substantial buildings survive from this period in the Moche and Chicama valleys, nothing is known about the Moche people historically. These pots come from the elaborately furnished graves of the cemeteries of the ceremonial centres. There is a certain realism about the creatures but this does not extend to detail. A head and eyes may be modelled accurately as with the rodent, and then we accept the rest although it is barely sketched in.

In later times, in the Aztec empire of Mexico, animals were carved as substitutes for real ones. Effigies such as this monkey vessel (164) were possibly part of the tribute exacted by the Aztec emperor. We know that carvings of animals were placed in the royal menagerie when living specimens could not be obtained. At the time of the Spanish conquest in AD 1520 Emperor Moctezuma II dominated a large part of Mexico from its centre at Tenochtitlan in the Valley of Mexico. The tribute exacted from the many towns and villages took the form of fine craft work in stone, textiles and precious metals. The onyx monkey may have come from Huastec area of the Gulf Coast.

From the records made at the time of the Conquest we learn that such carvings were used as substitutes for real animals if a specimen of a particular animal could not be found:

The King kept ... all species and varieties of birds, animals, reptiles and snakes which were brought to him from every province ... and those which could not be obtained he caused to be depicted in gold and precious stones, likewise sea and freshwater fish. So no animal of the whole country was wanting here: they were either alive or figured in gold and gems. (Ixtlilxochitl, *Obras Históricas*, sixteenth century)

Such collections of animals illustrate an attitude which we will meet again in

163
Three earthenware stirrup-spouted vessels: one with a stag seated on top, another in the form of an otter eating a fish, another in the form of a rodent. North coast of Peru, Moche period, *c.* AD 200–700. Height 26 cm, 22 cm, 25 cm.

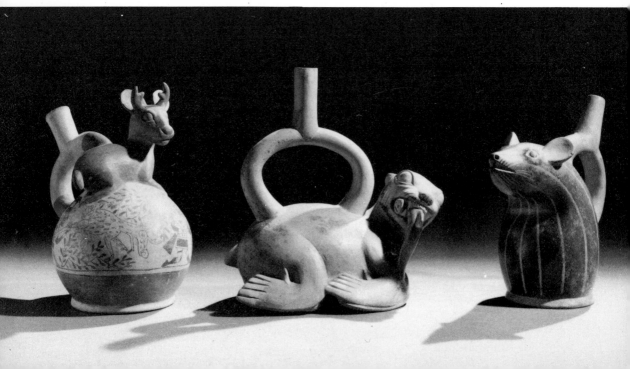

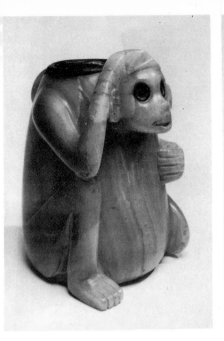

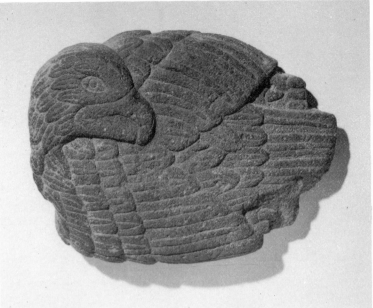

164
Mexican onyx vessel with a metal rim, in the form of a spider monkey. Probably from the Gulf of Mexico, Aztec period, *c.* AD 1300–1500. The red pigment in the eye sockets is probably recent. Height 23 cm.

165
Stone sculpture in the form of an eagle. Mexico, Aztec, *c.* AD 1300–1500. Length 27 cm.

166
Wooden ornament with bone inlay in the form of a feline figure with raised paws. Brazil, late 18th or early 19th century AD. Height 7·5 cm.

the next chapter, for it is part of a concern for animals as objects of interest in their own right. Nonetheless, although there was a fine aviary in the palace of Moctezuma II, the sculptures of birds of the time play with the pattern of the feathers (165) rather than reproduce the creatures from life:

Let us pass to the aviary. I cannot possibly ennumerate every kind of bird that was in it or describe its characteristics. There was everything from the royal eagle, smaller kinds of eagle, and then large birds, down to multi-coloured little birds, and those from which they take the fine green feathers they use in their featherwork There are other birds too which have feathers of five colours: green, red, white, yellow, and blue, but I do not know what they were called. At the proper season, they plucked the feathers of all these birds, which then grew again. All of them were bred in this aviary, and at hatching time the men and women who looked after them would place them on their eggs, and clean their nests, and feed them, giving each breed of bird its proper food.
(Bernal Díaz del Castillo, *History of the Conquest of New Spain*, sixteenth century)

The monkey, the eagle and the jaguar are creatures typical of Middle and South America and appear constantly in the art of that area. As ornamental as both the two preceding examples is the exquisite small carving of a feline or jaguar in wood (166). This shows in three-dimensions the characteristic features of ornament we have seen so often in two: the extreme, almost unrecognisable, stylisation; the balance of parts so that the eye is drawn to one section and then follows the line back again; the separation of the individual elements and their integration in a satisfying whole; and the difficulty of comprehension until each part has been explored.

Possibly one of the main reasons why animals are such a popular subject of complex decoration which involves disintegration, dissolution, convolution and interlace is that animals are so very familiar. The eye is thus able to make the separate pieces into a whole it recognises easily by matching each piece to known examples until the whole is comprehended.

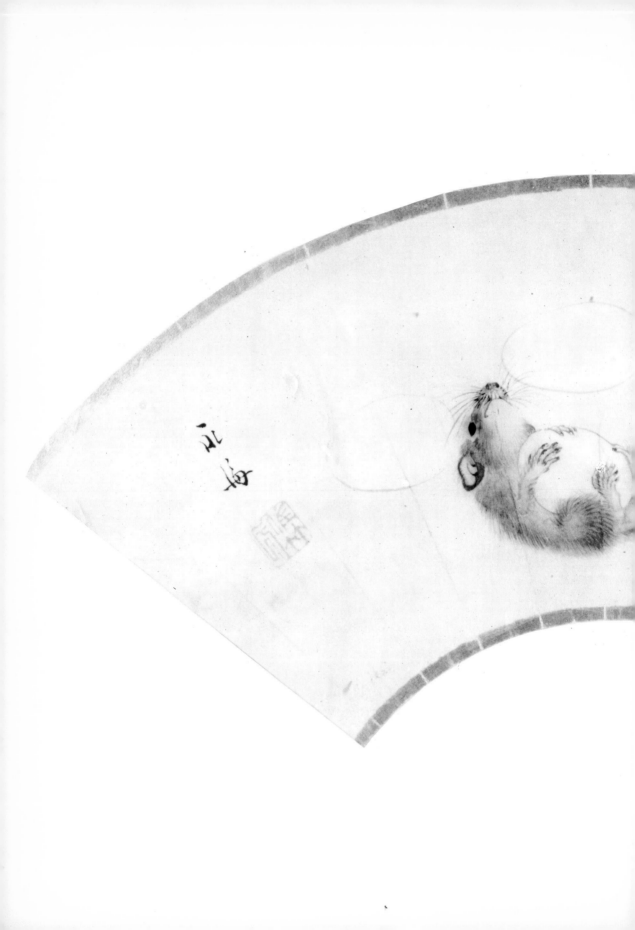

7. Animals Studied and Described

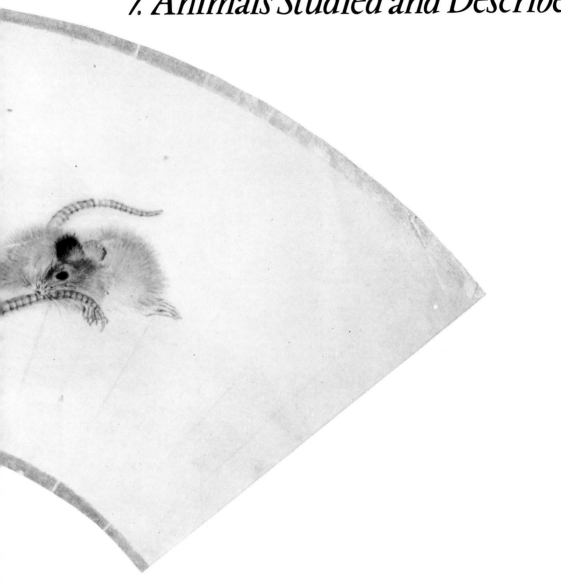

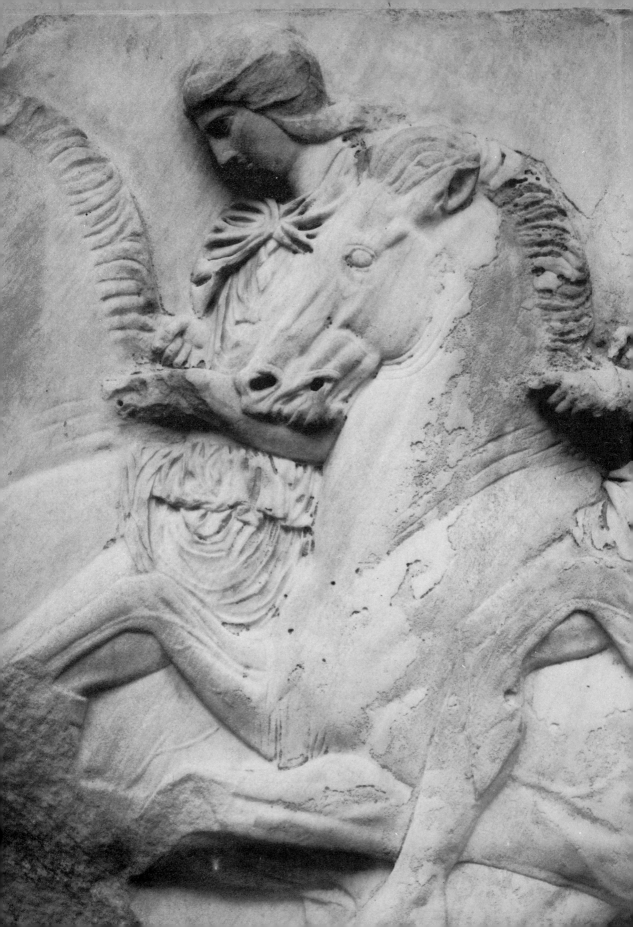

Today, we take for granted naturalistic studies of plants and animals. Such realism, based on accurate observation and the techniques of illusion, has been inherited from the Renaissance, and its revival of the achievements of the classical world. The previous chapters have demonstrated that realistic representation was not a general characteristic of the depiction of animals in art. The rare character of the phenomenon makes its appearance even more striking.

Some of the different reasons why animals have been the subject of art have been described in the previous chapters. These have rarely demanded a great degree of realism, but in most circumstances the animals had to be identifiable. The range of accuracy, however, could be and was very great. Lions on the Assyrian bas-reliefs appear faithfully drawn, the small bronzes of the nomadic hunters are much more schematic. As we have seen with themes such as the lion hunt or animals in combat, the same animals and compositions were frequently repeated and were transformed in the process. There was no attempt to match the animals in these motifs, whether cast in bronze or woven in silk, against reality. For that was not the point. The lion hunt was represented not to show a real scene but for its significance as a symbol of power or as a decorative design. Sometimes this use of stereotypes was important to reinforce the religious practices and traditions of a society, and so was an active constraint on innovation. This may in some circumstances have inhibited the development of realistic representation. Despite this there were in many societies occasions when animals were shown realistically. In ancient Egypt and Assyria, civilisations in which there were many conventions determining the nature of representation, some animals were accurately described in painting and sculpture. However, the most important development in the methods of naturalistic representation took place in Greece. This innovation is particularly important because, unlike the brief essays of earlier times, it marks the foundation of a tradition which had a long and sustained life throughout the classical period of Greece and Rome. It also made a fundamental contribution to the art of the Renaissance with its revival of classical forms. The archaic style, which incorporated some Egyptian conventions among others, had been dominant in Greek art before the fifth century. It is not fully understood why this was transformed by the gradual introduction of a naturalistic style for the representation of human beings and some animals. Several theories have been advanced. While none is widely accepted, what is certain is that the illusion of reality achieved by the Greeks was without parallel among other peoples in the ancient world.

The North Frieze of the Parthenon is as striking an example as any (167). The subject of the frieze is the procession to the Acropolis to escort a new robe for the olive-wood statue of Athena. This illustration, taken from the section of the cavalry, is skilfully carved to show horses in overlapping ranks. The sculpture is executed in shallow relief only, yet the impression of the horses ranged several deep, to say nothing of the realistic detail, is remarkable. The veins, sinews, and muscles of the horses are carefully suggested. To achieve this effect careful observation and an understanding of anatomy were essential, in addition to the mastery of the techniques of illusion including knowledge of proportion and foreshortening.

67
etail of a horse in the
anathenaic procession in
arble, from the North Frieze
the Parthenon. Greek, made
Athens during the third
uarter of the 5th century BC.
eight 102 cm. (North Frieze
ab XXXIX).

168a
Silver coin of Akragas in
Sicily, *c.* 425 BC. The coin
shows a fish of genus
Scorpaena, a crab of the genus
Carcinus, and a scallop shell of
the genus *Pecton*. It is
interesting to note that these
are all edible. Diameter 27 mm.

b
Silver coin of Dicaea in
Macedonia, showing an ox
with parasitic animals on its
back. *c.* 475 BC. Diameter
26 mm.

c
Silver coin of Messana in Sicily
with a running hare. The insect
below, a cicada, is an
engraver's symbol. *c.* 425 BC.
Diameter 26 mm.

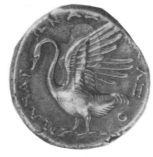

d
Silver coin of Clazomene,
Ionia, Asia Minor, with a
swan, the symbol of Apollo.
c. 350 BC. Swans were
particularly common in the
area. Diameter 24 mm.

e
Silver coin of Metapontu:
Italy, with a praying man
engraver's symbol, beside
ear of corn. *c.* 350 BC.
Diameter 21 mm.

f
Silver coin of the island of
Aegina, with a tortoise.
c. 340 BC. Diameter 21 mm.

g
Silver coin of Ephesus, Ionia,
Asia Minor, with the honey
bee sacred to Artemis.
c. 350 BC. The shrine of Artemis
at Ephesus was one of the
wonders of the ancient world.
Diameter 23 mm.

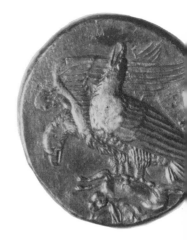

h
Silver coin of Akragas i
Sicily, with two eagles e
hare. *c.* 420 BC. Diamete
37 mm.

On a miniature scale the coins of the Greeks show this same skill. Many of the creatures are not depicted in sufficient detail for the species to be identified, but on them the hare, the swan and the ox are shown with life and conviction (168). Two of the coins illustrated are particularly interesting; a coin showing two eagles attacking a hare (168h); and one showing a fish, crab and scallop (168a). The first is remarkable not only for its composition and the sense of movement, but also for the dramatic intensity of the scene. The image refers to Aeschylus' tragedy *Agamemnon* in which the sight, by Agamemnon and Maecenas, of two eagles eating a hare was taken as an omen by the Greek army. The second coin makes no such reference but the creatures are identifiable as to genus if not to species, and are all edible.

Such realistic representation continued to be an important feature of all classical art and interest in depicting animals increased during the Hellenistic and Roman periods. A fine example is seen in the sculpture of the two greyhounds (43).

In the post-classical period this interest and skill was to a large degree lost. Important in this later period, however, was the substantial contribution which the Greeks had made to the natural sciences and to zoology in particular. It is impossible to examine medieval representations of animals without a brief mention of the work of Aristotle and the context to which he belonged. The earliest scientific work by the Greeks was undertaken in the fields of astronomy and mathematics by scientists in Ionia during the seventh and sixth centuries BC. This was followed in the fifth and fourth centuries by the investigation and even dissection of animals. Aristotle (384–322 BC) was the most important of all the scientists or philosophers writing about animals. His main treatises relating to zoology are the *Historia Animalium* and *De Partibus Animalium* but he wrote a number of other important works on similar subjects. He set out both a general scheme of the structure of the animal kingdom, and gave detailed observations of at least fifty species of animal.

During the Hellenistic period (third to first centuries BC), Aristotle's work remained of fundamental importance. His broad scientific approach was, however, gradually eclipsed, while his anecdotes about different animals were retained. Later classical writers expanded the sections on the supposed habits of animals with no recourse to direct observation. Political instability followed in the early centuries AD and men seeking guidance turned to the natural world for moral lessons. The *Physiologus*, which has already been discussed, was one of the texts written at this time which combined earlier classical zoological writings with such moral interpretations. In the centuries before the scientific revival of the twelfth century, the *Physiologus* was expanded to become the text or texts we know as the bestiary, incorporating the comments of early medieval scholars. The bestiary was particularly important for its exegesis of Christian symbolism already described in chapter III. Beautifully illustrated manuscripts were made, and were especially popular in England. Some of the least allegorical sections describe the domesticated animals (169).

The Greeks call 'bos' the ox by the name of *boaen* and the Latin call these creatures *triones* because they tread the Earth underfoot like the stars of that name. The

Hyrtus lasciuu animal est prurisu est seruens semp ad corru. cui oculi in trans
uersum ob libidinem aspiciunt. Ysi est noui trahit. Nam hyrti sunt oui
lox angli. scdm suetonium. cui nacta adeo calidissima est. ut ad amante
lapidem quem ni ignis ni serri valet domare materia. solus eu cruor dissoluat.
hedi ab edendo uocati. paruu enim pinguissimi sunt est saporis iocundi. Ysi
est edere inde est edulium uocat. De apro dicit dente trucis. et proc̄ cū dente.

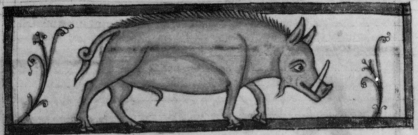

Apr a seritate uocat. ablata .r. litera est subrogata .p. un̄ apd gretos suatos .t.
seris dr. Omne enim quod serum est est immite abusiue est agreste uocamus.

uuencus dictus est iuuare in
capiendis usus homini in tra
colenda. ul quia apd gentil
les nouul semp ubicius iuuc
tus: immolabat. et numqz
taurus. Nam in uictimis
est etas considerabat. Tau
r̄ gretum nomen est sicut et
bos. Indicis taurus color ful
uus est. uolucris pnictate
pilus in contrium uersus
hiat omne qd capit. huic est
circumfuerunt cornua flexi

bilita qua uolunt. tergi duricia omne telum respuunt. tam immite seritate ut
capti animas prodant surore. De boue animali est exponitur apro.

Bouem greti boen dicunt. hunc latini bouem uocant eo qd tram terat. ysi
trionem. bouum in socus grimia pietas. nam alt altium inquirit. cu quo
ducere collo aratia gsueuit et frequenti mugitu pium testat affectum
si sorte deseerit. Boues impedieute pluuia: ad psepia se tenere nouerunt. Idē
u naturali sensu collegerunt mutacionem celi. soras spectant. est ultra psepia

122

kindness of oxen for their comrades is extraordinary, for each of them demands the company of that other one with whom he has been accustomed to draw the plough by the neck and, if by any chance the second one is absent, then the first one's kindly disposition is testified by frequent mooing.

When rain is impending, oxen know that they ought to keep themselves at home in their stables. Moreover, when they foresee by natural instinct a change for the better in the sky, they look out, carefully and stick their necks from the stalls, all gazing out at once, in order to show themselves willing to go forth.

Such accounts were still anecdotal, and by the twelfth century ceased to satisfy curiosity. Surprisingly the popularity of the bestiary had coincided with the first attempts to find new access to the writings of Aristotle by way of the Arabic texts. For it was in the Islamic lands that the scientific work of the Greeks was best preserved, and most constructively expanded. The *Manāfiʿ al-hayawān* (170), a work on the medicinal properties of animals, taken from the comments of Aristotle to which was added information from a treatise of the eleventh century, is a typical example. The illustrations in this manuscript are far from realistic. However, the rediscovery of Greek science preserved in such works in Arabic was to contribute towards a scientific revival in Europe. We have already noted the importance of Sicily in this context, and in particular the treatise of Frederick II on falconry, virtually the first handbook of ornithology to take account of Aristotle and go

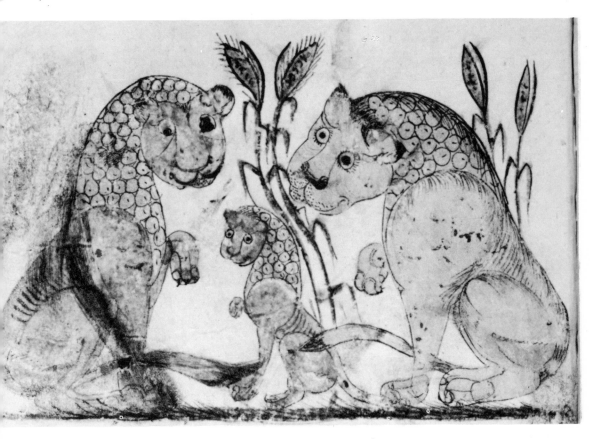

171
An African elephant, from the
'Liber Additamentorum' by
Matthew Paris (d. AD 1259).
England *c*. 1255. The 'Liber
Additamentorum' was a
collection of documents and
extracts dated *c*. 1244–59,
made by Matthew Paris firstly
as appendices to his 'Chronica
Majora', and later as a
separate book.
Line and wash on vellum. 33·3
× 23·5 cm. British Library.
Cotton MS. Nero DI, f. 169b.

172
An African elephant on the
reverse of a bronze medal by
Matteo de Pasti of Verona
(*c*. AD 1420–90). From a portrait
medal of Isolta (degli Atti) da
Rimini, wife of Sigismondo
Malatesta, lord of Rimini.
Dated 1456. The elephant is a
symbol of Sigismondo's
greatness and his magnanimity
towards lesser beings.
Diameter 84 mm.

beyond. In Frederick's service was Michael the Scot, one of a group of men working in Sicily and Spain, who translated scientific works. Michael the Scot's translation of some of Aristotle's works on zoology from the Arabic made them available to the West for the first time. Bartholomew the Englishman was familiar with Aristotle's *Historia Animalium* in the translation by Michael the Scot. He included material from it in the sections on animals in his encyclopedia *De Proprietatibus Rerum* written *c*. AD 1230, together with a wide range of anecdotes from other sources. Bartholomew was typical of his day in that he was not content only to quote from other authorities but added details from his own personal observation.

This new and more scientific interest in the animal world slowly made its influence felt in the way living creatures were represented. Though tradition among local artistic schools was usually slavishly followed in the depiction of animals in the bestiary, there are examples of the more enquiring attitude on the part of some artists and chroniclers. Matthew Paris, for example, was extremely interested in the elephant which had been brought back by Louis IX of France from Egypt after his crusade, and was given to Henry III of England in 1255. It was housed in the Tower and given a special elephant house. Matthew Paris recorded the gift in his main work, the 'Chronica Majora' and included an illustration. He was so interested in the beast that he even wrote a tract on the elephant in his own hand, some of which is inscribed on the present drawing (171). This drawing is in the bound volume known as the 'Liber Additamentorum', a collection of documents and extracts dated *c*. 1244–59. The drawing is expressly stated to be from life and the tract includes some direct observations particularly on the use of the trunk for getting food. In spite of his own enquiring outlook Matthew Paris and others were still heavily dependent on older tradition. From the bestiary, for example, he took the comic idea that since elephants were thought to have no joints they were unable to rise from a lying position and slept propped against trees. The hunters had thus only to saw through the supporting trees for the elephants to fall to the ground and to be rendered helpless. This belief that the elephants had no joints may account for the rather stuffed appearance of the elephant in this drawing.

In the same spirit he recorded in the 'Chronica Majora' for the year AD 1251:

At the turn of the year, at the season of fruits, certain wonderful birds never before seen in England, appeared, particularly in the orchards. They were little bigger than larks and ate the pips of apples and nothing else from apples.

This is an accurate description of the habits of the crossbill, and is much more precise and valuable than the illustrations and descriptions in the bestiary.

From this time, the borders of manuscripts began to illustrate some naturalistic scenes. Among the manuscripts with borders incorporating animals and plants one is quite outstanding. It is a treatise on the vices and virtues by one of the Cocharelli family in Genoa, written and illustrated in northern Italy at the end of the fourteenth century. One authority has argued that the extraordinarily accurate representations of elephants, camels, giraffes and also insects and shells illustrated in this manuscript were the

outcome of influence from southern Italy and Sicily, where, as we have seen the study of animals and birds was already well developed. It is also suggested that it was manuscripts such as this one which prepared the way for the sketch book now in the library at Bergamo attributed to Giovannino de' Grassi, (d. 1398) who worked for the court of the Visconti and the cathedral authorities of Milan, and for the similar one from which the leaf with the drawing of the cheetahs must have come (see colour plate x). Although such animals were probably drawn from life they were included in sketch books so that later they could be incorporated in larger compositions.

By the beginning of the fifteenth century naturalistic representation of animals was becoming more general. An important element in this development was the stimulus provided by the animals owned by the Renaissance princes of Italy. Hunting cheetahs were much prized and can be seen in the painting by Benozzo Gozzoli of *The Journey of the Magi* in the Medici Chapel. They were, however, only one of a number of exotic creatures which the monarchs of the fifteenth and sixteenth centuries obtained to enhance the prestige of their courts. The sketch books of Jacopo Bellini vividly record the lions which were kept in most Italian cities, and at the same period a group of lions was housed in the Tower of London. At Naples towards the end of the fifteenth century the visitor could see a zebra and a giraffe which were presented to King Ferrante by the Caliph of Baghdad. The competition between the different princes for the widest variety of animals in their menageries gave an impetus to the representation of the strange and wonderful creatures. For Renaissance princes not only wanted to own such animals, they also wanted them shown on the medals and in the paintings they commissioned. The elephant shown on the reverse of the portrait medal of Isolta da Rimini was intended to symbolise the power and magnanimity of Sigismondo Malatesta (172). It is so accurately recorded that the medallist Pasti must have worked from drawings made from a real creature. Three elephants also appear in one of Mantegna's paintings in the series now at Hampton Court entitled the *Triumph of Caesar*. One of the most famous of these elephants of Renaissance Italy was Hanno, sent as a gift by King Emmanuel of Portugal to Pope Leo X in 1514 when he sought the ratification by the Church for the Portuguese conquests in Africa and the Far East. Hanno caused much amusement when he was led in procession and sprayed the Church dignitaries with water. When he died in 1516 the Pope commissioned Raphael to design a suitable monument to him. This no longer survives but is recorded in a drawing in a sketch book by Francisco d'Ollandia, 1539–40.

The great voyages of the Portuguese in the fifteenth century down the coast of Africa, and the diplomatic and trading missions to the Levant were all productive of animals to satisfy the wealthy patrons in Italy. As yet there was no attempt to draw and record the animals in their own surroundings. This, as we shall see, was to come later. Instead animals were shown in European contexts to enrich paintings, just as in life they gave colour to the courts. For example Gentile Bellini, who had been sent by the Doge of Venice in 1479 to serve at the court of Sultan Mahomet II in Constantinople, included camels and giraffes in his painting *Preaching of St Mark in Alexandria*, which in fact shows them against a European background.

VII

Two copper-gilt plaques
decorated with a winged lion
and a winged ox in cloisonné
enamel, the symbols of the
Evangelists Mark and Luke.
Probably Italian *c.* AD 1175–
1200. Each, width 9·1 cm.

VIII

Tin-glazed earthenware dish,
lustred and painted in blue
with a deer and inscription in
Latin. Spanish, (Valencia), first
half 15th century AD.
Inscription round border
reads: 'SENTA-CATA-LINA-GUA-
RDA-NOS' ('St Catherine protect
us'). Diameter 39·1 cm.

IX The crow addressing the assembled animals. Illustration to a Persian
fable. India, Mughal school *c.* AD 1590. Gouache on paper. 27 × 19·4 cm.

wo cheetahs or hunting leopards. Lombardy *c.* AD
400. On the *verso* are two studies of an eastern goat
nd a ram. This drawing was formerly attributed to
ntonio Pisanello (before 1395–1455), but the existence
f a sketch-book of very similar drawings in the
iblioteca Communale at Bergamo suggests that the
resent study may originally have formed part of such
n album.

Brush and body-colours on parchment. 15·6 ×
1·5 cm.

I

ion on the prowl. Antoine-Louis Barye (AD 1796–
875), French School. Barye's watercolours were at one
me valued as highly as his sculptures. Both were based
n the exhaustive studies of live and dead animals which
e made over many years, mainly at the Jardin des
lantes in Paris. He would select, often long after, the
nes which he wanted to use in his watercolours and
ake tracings of them. These he would place in
andscapes which grew more featureless – immutable
eserts where topography and season had no place and
vhere the beast was supreme.

Watercolours and bodycolours with gum arabic; the
urface scraped out in places. 26·3 × 36·8 cm.

XII Tiger by a torrent, by Kishi Ganku (AD 1756–1838), Japan, *c*. AD 1795.
Although this work owes much to Chinese painting it is essentially Japanese
in feeling, especially in the stylistic tension between the finely detailed
treatment of the animal and the broader handling of its setting.
 Hanging scroll, ink and colours on silk. 169 × 114·3 cm.

t Iaer ons Heeren 1515 den eerften dach Mey, is den Coninck van Portugael tot Lifbona gebracht uyt In-
dien een aldufdanigen dier geheetē *Rinocherus*, ende is van coleure gelijck een fchiltpadde met ftercke fchelpen becleet, ende is vande
groote van eenen Oliphant, maer leeger van beenen, feer fterck er de weerachtich, ende heeft eenen fcherpen hoorn voor op fijnen neufe, dien wettet
hy als hy by eenige fteenen comt, dit dier is des Oliphants doodt-vyandt, ende den Oliphant ontfieget feere, want als dit dier den Oliphant aen comt, foo loopet hem metten hoorn
tuffchen de voorfte beenen, ende fcheurt hem alfoo den buyck op, ende doodt alfoo den Oliphant : Dit dier is alfoo gewapent dat hem den Oliphant niet mifdoen en can, oock iffet
feer fnel, lichtveerdich, ende daer by liftich, &c. Defen voorgeftelden *Rinocherus* wert van den voornoemden Coninck gefonden naer Hoochduytflant by den Keyfer *Maximilianus*,
ende vanden hoogh-geroemden *Albertum Durer* naer t'leven geconterfeyt alfmen hier fien mach.

1515
RHINOCERVS

73
Rhinoceros. Albrecht Dürer
AD 1471–1528). German
School, dated 1515. This
celebrated image long served as
the basis for illustrations of the
rhinoceros in works on travel
and natural history. It was the
first rhinoceros to arrive in
Europe in modern times.
Dürer never saw the animal
and based his image on a
sketch and descriptions.
Woodcut. 21·2 × 29·7 cm.

Dürer was working in the same tradition, but he took it much further,
showing great interest in the rhinoceros for its own sake. The rhinoceros was
itself a strange unfamiliar beast prized for its exotic character. Like Hanno
the elephant, this particular specimen had been intended as a present for
Pope Leo X from King Emmanuel of Portugal. The King of Portugal had
received it as a gift from the King of Cambodia. Along with many of his
contemporaries the King of Portugal was still imbued with medieval ideas.
He was consequently intrigued by stories of combats between the unicorn
and the elephant, recorded in the bestiary, and with the apparent
identification of the unicorn with the rhinoceros already mentioned. He had,
therefore, matched this rhinoceros against an elephant before he dispatched
it to the Pope. It was unfortunately drowned in a shipwreck before it reached
Rome. Dürer never saw the animal but records an extract from the letter he
must have received describing it and enclosing a sketch. This extract is
preserved on the drawing from which this woodcut was made (173):

On 8 May, in the year 1513, a big animal, which they call a *rhinoarate*, was brought

174
Head of a walrus. Albrecht
Dürer (AD 1471–1528),
German School, dated 1521. In
this study Dürer seized a rare
opportunity of studying a
walrus from life. As we are told
in the inscription the animal
had been caught off the
Flemish coast.
Pen and brown ink, tinted with
watercolours. 21·1 × 31·2 cm.

from India to Lisbon for the King of Portugal, and as it is such a curiosity, I must
send you its likeness It is well armed with a thick skin, and is very frolicsome and
in good condition. The animal is called *Rhinocero* in Greek and Latin and in Indian
Gomda.

(The date recorded in this inscription on the drawing is erroneous and the
rhinoceros actually reached Lisbon in 1515).

For Dürer to have made such a convincing portrait at secondhand the
original sketch must have been reasonably accurate. His own drawing and
woodcut are the outcome of his concern to explore and understand strange
animals and the many phenomena of nature. He combined an intense
personal vision of the world with the wish to discover the fundamental
principles of nature expressed, for example, in the rules of proportion.

His drawing of the walrus illustrates this well (174). He went to Zeeland in
December 1520, in the hope of seeing a stranded whale, but on this trip saw
the walrus which he described thus: 'The animal whose head I have drawn
here was taken in the Netherlandish Sea and was twelve Brabant ells long
and had four feet.' Although observed from life the vision of the animal was
so strange to him that he later used it as a study for a head of a dragon.

While Dürer, and Leonardo da Vinci before him, had been involved in
their own detailed studies of the human body and sometimes of animals,

scientists and naturalists had been compiling works on zoology based on observation and on dissection. So there developed a rather separate tradition of the representation of animals for scientific purposes. Among the most important travellers and zoologists were Pierre Belon (1517–65), Guillaume Rondelet (1507–66) and Conrad Gessner (1516–55). Belon made many of his own drawings which were brought together in a book in 1557. Gessner on the other hand took his illustrations from many sources and included drawings made from skins and even a version of Dürer's rhinoceros. These writers who were primarily concerned with European animals included some from the Middle East and Africa. By the later sixteenth century the animal life of the New World excited increasing interest. Although his work was not exhaustive, John White (fl. 1577–93), travelling to 'Virginia' with the expedition organised by Sir Walter Raleigh, as cartographer and draughtsman, produced some of the best early studies of the creatures of the New World (175). He made a systematic survey of the Indians and of the natural life of the region although many of his drawings have disappeared. Efforts such as White's culminated in the more comprehensive work of the painters Frans Post and Albert Eckhout under the patronage of Count Mauritz of Nassau in Dutch Brazil (1638–44).

In spite of the development of the scientific recording of animals, the element of the supernatural was often found directly linked with naturalistic records during the early years of the seventeenth century. These two elements had indeed been present in Dürer himself. Surprisingly alchemy with its use of magic had thrived alongside the development of the natural sciences, and men like Dr John Dee and Giordano Bruno explored the occult and the natural sciences as though they were one. Such men were fascinated by nature in all its forms and sought to penetrate to a reality which they believed lay behind it. Strange phenomena of all kinds were recorded in this

175
Common box tortoise. John White (fl. AD 1577–93), English School. In his voyages to North America he made systematic records of the inhabitants (of what is now North Carolina and Virginia) he encountered, as well as of the natural history and topography of the new lands. He is best known for his unusually scientific drawings of the Carolina Algonquian Indians – a tribe long extinct. Watercolours over black lead touched with white. 14·4 × 19·7 cm.

search. Men in general were fascinated by comets, stars and strange lights, which they believed to be portents. Kings and princes collected strange treasures, jewels, shells and ostrich eggs and encased them in precious mounts. Emperor Rudolph II (1552–1612) had a famous zoo and a fabulous *wünderkammer*.

A camel by Hendrick Goltzius and a whale by Jacob Matham illustrate these two interwoven elements in the seventeenth-century view of nature (176). The camel, no longer as strange as the rhinoceros in Dürer's day, had been faithfully observed and reproduced. The whale, though perhaps familiar at sea, on land became not just a curiosity but an omen or portent (177). The enormous size of the whale set against the puny figures of people emphasises the almost supernatural character of the beast. Matham probably never saw this whale as the engraving closely follows an earlier composition. Its interest for him must have been the strangeness and power of nature which it symbolised. These two contrasting qualities are expressed in a light-hearted manner in the studies of birds by Albert Flamen (178). His drawings combine relatively accurate representations of birds with landscapes which are romantic and unreal.

Rembrandt, one of the greatest artists of the northern Renaissance, drew animals only incidentally (179), but with astonishing conviction he suggested the character of the elephant by means of an untraditional and

176
Camel. Hendrick Goltzius (AD 1558–1617), Dutch School. Goltzius made several studies of this camel, apparently brought to Holland as a curiosity. The present drawing probably dates from before October 1590 when Goltzius left Haarlem for a lengthy stay in Italy.
Red and black chalk on cream-coloured paper. 29·8 × 41·6 cm.

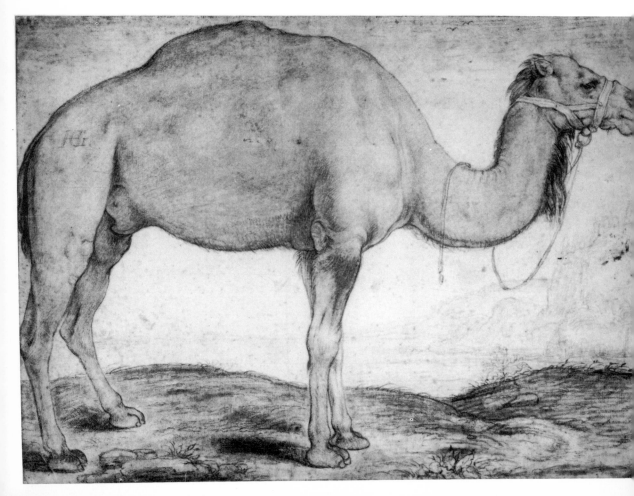

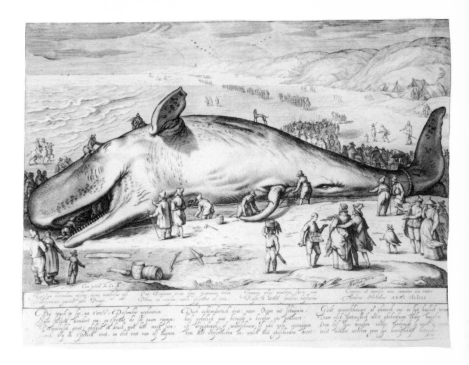

177
Sperm whale on a beach. Jacob Matham (AD 1571–1631), Dutch School. A number of sperm whales were found on the Dutch coast around the end of the 16th century. The stranding of one of these giant creatures was believed at the time to portend evil. This specimen, according to the inscription, appeared in 1601. Matham seems to have based the engraving on earlier prints rather than first-hand knowledge of the whale. Engraving. 31 × 43 cm.

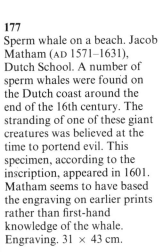

178
Pelican. Albert Flamen (fl. AD 1648–69), Flemish School. Though Flemish by birth, and possibly a native of Bruges, Flamen spent his most active years in Paris. He may have been taught by Jacques Callot (1592–1635) and is best known for his drawings and engravings of animals. Pen and grey ink and grey wash with watercolours. 13·2 × 20·6 cm.

unusually free technique. He was only one of the many Dutch artists who drew animals. The other country which developed a flourishing school of animal artists was England. The tradition was a long one and began with Francis Barlow (1626–1704), whose work shows considerable Dutch influence. During his lifetime he was well known as a painter and illustrator. In 1656 John Evelyn wrote of him as 'The famous painter of

179
An Indian elephant.
Rembrandt van Rijn
(AD 1606–69), Dutch School.
Detailed studies of animals by
Rembrandt are comparatively
few. The present drawing,
which may be compared with a
similar sheet dated 1637 in the
Albertina, Vienna, is executed
in the master's boldest style. A
travelling circus may have
provided Rembrandt with the
opportunity of studying this
and other animals.
Black chalk. 17·8 × 25·6 cm.

180

Birds in a garden. Francis
Barlow (AD 1626(?)–1704),
English School. On the left, a
peacock with four peahens. In
the centre an ostrich, and on
the right a cassowary, with two
pheasants between them. There
are also two swallows.
Barlow's representations of
animals, for which he is best
known, were often based on
his own careful observation of
nature.
Pen and brown ink, with grey
wash; indented for transfer.
21·2 × 31·3 cm.

181
Six studies of a lemur. George
Stubbs (AD 1724–1806),
English School. Inscribed
Lemur murinus, probably by
Sir Joseph Banks (1743–1820),
who bequeathed this drawing
with his collection and library
to the British Museum. He was
a celebrated botanist and
zoologist, and knew Stubbs
personally. The lemur is the
Lesser Mouse Lemur,
Microcebus murinus.
Pencil. 19·7 × 32 cm.

Fowle, Beasts and Birds'. Barlow's work was evidently much appreciated
and he enjoyed the patronage and friendship of a number of eminent men,
including the then Duke of Devonshire, to whom he dedicated the second
and third editions of his Aesop's fables. In the present drawing (180) he has
placed the birds on a terrace of a grand house, such as would have been
familiar to his patrons.

Stubbs, the greatest of English animal artists, was also patronised by the
great men of his day. Both in Stubbs's work and in his life the influence of
the scientific outlook of his time is clear. He was one of the first English
artists to examine animals scientifically. The studies of the lemur shown in a
number of positions to illustrate its form and movement, are excellent
examples of such work (181). In the same way, he studied animals in the
menagerie of the Tower of London. The connection with Sir Joseph Banks
who owned this sheet introduces another element. Sir Joseph Banks had
sailed on the *Endeavour* with Captain Cook on his first voyage (1768–71)
accompanied by his own staff of artists. They provided him with an
enormously important collection of botanical and zoological specimens
and drawings, many of which are preserved in the Natural History
Museum today. His staff were in the line of succession from John White
and Albert Eckhout. Stubbs, who was commissioned by Banks to make
drawings from animal skins from abroad, shared to some degree in this
tradition.

The most important influence on his work was the general activity in the
zoological sciences of his time. He lived during the period when there was

growing curiosity as to the nature of zoological species. Linnaeus (1707–78) was the great pioneer in the classification of species, and at the same time the Comte de Buffon (1707–88) made important advances in the study of comparative anatomy. Stubbs had always been fascinated by anatomical studies. Born in Liverpool he moved to York and, inspired by the publication of *Tables of the Skeleton and Muscles of the Human Body* by Albinius in 1749, he embarked on the dissection of a horse. This exercise was the first step towards his remarkable publication of *The Anatomy of the Horse* (182). Stubbs was not working from an entirely veterinary or

82

The Anatomy of the Horse. George Stubbs (AD 1724–1806), English School. Published in 1766, *The Anatomy of the Horse* marks a major step forward in the anatomical study of animals. Stubbs's skill both as draughtsman and engraver (and evidently as dissector) was ideally suited to a project of this kind. In the preface he tells us: 'All the figures in it are drawn from nature, for which purpose I dissected a great number of horses; at the same time, I have consulted most of the treatises of reputation on the general subject of anatomy.' Etching. 38 × 47·8 cm (platemark).

anatomical point of view. Although he expressed the hope that the work would be useful to 'Farriers and Horse Doctors', in fact his *Anatomy* omitted vital features, including the blood supply and the nervous system. Its importance lay in the use he made of it himself. For these studies were behind all his magnificent paintings of horses.

Two traditions which had been closely linked since the Renaissance can now be distinguished: the study of animals, often painstaking and detailed, with the intention of using this information in larger artistic compositions; and the drawing of animals intended primarily as zoological records. Stubbs's life and work illustrate both attitudes, but his greatest contribution was as an artist rather than as an anatomical draughtsman. The later French artist Barye (1796–1875) shared Stubbs's preoccupation with anatomical accuracy. He made many studies of animals at the Jardin des Plantes in Paris. Like Stubbs he later used these as the basis for his watercolours and sculptures. In his drawings the animals (see colour plate XI) figure prominently while the landscapes are generalised but romantic. Although a fine draughtsman Jemima Blackburn represents the second tradition (183). Her work appears to be a record of creatures studied from the life, but even in this drawing the scientific information and an artistic presentation are pleasingly combined.

It is illuminating to compare these European studies of animals with the depiction of animals, birds and insects in the Far East, and to consider the impact of European conventions on this separate tradition. China and Japan are one area of the world in which a long tradition of the painting of animals flourished quite independently of Europe. From the Han dynasty (206 BC – AD 220), birds and animals appear incidentally in Chinese art. They were a subject of a whole genre of paintings from the T'ang dynasty (AD 618–906) onwards, which in turn influenced the painters of Japan. Although in paintings of all periods the creatures are often disarmingly lifelike (184), one of the most important qualities of Far Eastern animal painting from the late Sung period (AD 960–1279) was its decorative character. Sometimes the animals were accurately observed, but more often not. Features of one bird or animal were combined with those of another. The decorative character of much of this painting is demonstrated by the status which the artists who painted animal and plant subjects enjoyed. After the Sung period they were, particularly in China, less highly regarded than artists who painted landscape.

To our eyes the most obvious characteristic of such animal and plant studies is their calligraphic quality. Far Eastern painting and woodblock printing was influenced by the indigenous techniques of writing in ink with a soft and supple brush on highly absorbent paper. The movements for writing characters were used for painting. For these technical reasons the qualities of writing were transferred to painting, and so also to woodblock printing. Chinese and Japanese woodblocks illustrate this quality particularly well (185). The movement of writing with a brush is translated into the implied movement of the birds and of the snake on a double page from a book illustrated by Utamaro (186). This sense of sequential composition, which is to be followed as in reading, even in such small studies, creates an impression of movement and life.

183

Eyed lizard. Jemima Blackburn (AD 1823–1909), English School. Only one volume of drawings by Jemima Blackburn was issued during her lifetime, *Birds drawn from Nature*, published in Edinburgh in 1862. The present study is a characteristic example of her work at its most decorative.
Pencil and watercolours. 14·2 × 19·8 cm.

184

Rats with eggs. Satake Eikai (AD 1802–74), Japan, Edo period.
Fan-painting in ink and light colours on paper treated with mica and gold leaf. Overall length 49 cm.

喜上眉稍

姑蘇丁亮先製

138

85

*M*agpies with peach and plum
*b*ossom. Ting Liang-hsien.
*C*hina, Ming dynasty, early
*1*7th century AD. Kiangsu
*p*rovince, Soochow prefecture.
*P*rinting from multiple colour
*w*oodblocks was at its height in
*C*hina in the early 17th century
*a*nd Soochow was pre-eminent
*i*n this art.
*W*oodblock print. Ink and
*c*olours on paper. 35·2 ×
*2*8·3 cm.

186

A snake and lizard. Kitagawa
Utamaro (AD 1753–1806),
Japan, AD 1788. Opening from
the woodblock album *Ehon
Mushi Erabi*. By 1788
Utamaro's powers were
mature and the *Ehon Mushi
Erabi* (Insect Book), published
in two volumes, marks his
emergence from the spell of
such masters as Shunsho,
Shigemasa, and Kiyonaga. The
album is a remarkable example
of woodblock technique,
power of design and intense
observation of nature, the last
a relatively new feature in
Japanese art. This copy was
owned by Sir Joseph Banks,
which is a tribute to its
zoological interest.
Woodblock book. Each
illustration 21 × 16·2 cm,
each page 26·7 × 17·6 cm.

187
Kingfisher with separate
details of wings and tail. Copy
by Tōmin, from Kanō Tanyū's
sketchbook dated AD 1660.
Japan, late 18th century. One
of a series of copies of sketches
of birds by Tanyū, many of
which show an interest in
details of anatomy and
plumage, then a novel attitude
in Japan. The bird, the Greater
Pied Kingfisher *Ceryle
lugubris*, is accurately drawn.
Ink, colour and body-white on
paper. 27·5 × 40·5 cm.

Although the Utamaro woodblock print gives a more generally realistic
impression than the drawing of the 'eye-lizard' by Jemima Blackburn
accuracy of detail takes second place to the decorative effect. The same poin
can be made about the Chinese woodblock print of the birds. This wa
brought back from Japan in 1692 or 1693 by a German doctor name
Kaempfer, and subsequently acquired by Hans Sloane whose collection wa
part of the foundation of the British Museum. Through such prints, as we
as painted lacquers which were also popular, the theme of birds on branche
or insects among flowers became known in Europe. As with the studies of th
lizards, it can be seen that European drawings of birds on branches ar
generally more accurate than their Far Eastern counterparts but often sho
less sense of movement.

The contrast between the two traditions can also be observed b
examining the effect of the introduction of European anatomical studies int
Japan in the seventeenth century (187). This later copy of the study of
kingfisher appears totally alien beside the Far Eastern examples alread
discussed. With contact with Europeans in the seventeenth century, th
Japanese of their own accord increasingly adopted and adapted some of th

European modes of representation of animals. A number of artists devoted time to studying particular creatures following them to their natural habitat. A long handscroll illustrating turtles is the result of such observation (188). The artist Asai Tonan made extensive studies of the habits and behaviour of turtles, but at the same time he used the skilful brushwork traditional in the Far East. Other artists used skins and specimens, as in Europe, to provide information for larger compositions. A magnificent painting of a tiger by Ganku shows the animal in precise detail, while the landscape is painted in a more traditional and impressionistic manner (see colour plate XII). The lowering tiger is, if looked at closely, a skin painted in exceptional detail rather than a real creature of muscle and bone.

Although they had continued to work in their own idiom, such Japanese artists had consciously adapted some European attitudes in their depiction of animals. The influence of European ideas, particularly those transmitted by members of the Honourable East India Company, had a different effect in China and India. These men were encouraged to take an interest in the wild life of the regions to which they were posted. Thus John Reeves (1774–1856) for example, posted in Canton as Inspector of Teas, commissioned a large series of drawings which are now in the Natural History Museum. These were much more accurate than the stock drawings produced by the Chinese in general for less serious customers. The Company also employed its own naturalists to draw and record animals and plants. As a further step towards the encouragement of research into natural history the Company set up an 'Institution for Promoting the Natural History of India' with a menagerie and aviary at Barrackpore. This lasted only a relatively short time, but illustrates the degree of interest shown by the Company. The artists who drew the animals and birds were normally Indians employed either by private individuals or by the Company to assist the naturalists. Unlike the

188
Turtles. By Asai Tonan (AD 1706–82), Japan, Edo period. Tonan was a physician as well as an artist and worked in Kyoto, the birthplace later in the 18th century of the Maruyama/Shijō School, which first made observation from nature a necessary part of artistic training. Tonan's scientific interests clearly led him to study the habits of turtles, which could be found in many ponds, especially in temples. His lifelike approach expressed in a free and flowing brush line, shows him to have been a true precursor of the Maruyama/Shijō School. Handscroll painting in ink and colours on paper. Height 28·3 cm.

89

young vulture. Drawn for
ɪe East India Company,
ɪowing the Egyptian vulture,
ɪeophron percnopterus. The
ɪlture ranges as far east as
ɔrth-west India.
ʹatercolours on paper. 54·2
 40·6 cm.

Japanese artists discussed above, the Indians and the Chinese were here working directly for Europeans.

Originally the style used by the Indian artists was derived from the later developments of the Mughal school. Natural history had never been the main subject of Mughal painting, but from time to time various patrons had shown a keen interest in it. Paintings in this tradition were too elaborate, decorative and expensive for the British. More important the British were afraid that accuracy would be subordinated to the demands of artistic convention. So the Indian artists made adjustments. They took to using English watercolours with the customary admixture of Chinese white, and painted on European paper provided by their employers. The artists carefully followed the style of English illustrated books, as this magnificent painting of a young vulture shows (189). The models for such bird drawings are to be found in the illustrations in George Edwards's *A Natural History of Birds* (1743–51) and John Latham's *A General Synopsis of Birds* (1787–1802). Although the Indian artists retained some of their own personal idiosyncracies they adopted a generally European approach and technique.

Careful observation which is necessary to all such faithful studies of animals was the outcome of several different factors: an interest in nature in general; the scientific examination of particular creatures; a wish to record the strange and exotic animals of the different parts of the world. This latter pursuit had, as we have seen, first brought Europeans to describe the animals and plants of Africa, America and the Far East. In turn the same interest was adopted in these other continents. The European conventions of representation and the attitudes which sustained them were thus taken far beyond the confines of Europe. An objective interest in animals is now widely accepted, and detailed and accurate studies are made of them. The species of animals have been recorded, drawn and thus gradually understood. But the representations of animals described in this chapter, which are part of this process of understanding, are only one of many forms of the depiction of animals. Animals as seen in the art of the world as a whole are as varied as the imagination of man.

British Museum and British Library Reference Numbers for the Plates

COLOUR PLATES

I MLA 1903.6–18.1
II Ethno 1954.Af.23.522, given by the Trustees of the Wellcome Historical Medical Museum
III Ethno 1926–95
IV Ethno 84.7–28.15, given by the Duke of Bedford in 1884
V EA 9955
VI GRA 1958.7–21.1
VII MLA 58.6–1.1,2
VIII MLA BL 1900
IX OA 1920.9–17.05
X PD 1895.12–14.94
XI PD 1968.2–10.27
XII OA Japanese painting no. Add 79

MONOCHROME PLATES

1 PRBA Christy Coll., given by H. Christy
2 PRBA Peccadeau de l'Isle Coll.
3a Ethno 1941 Am.1.4b, given by Mrs H. G. Beasley
3b Ethno 1954 W. Am.5.1079, given by the Trustees of the Wellcome Historical Medical Museum
4 WAA 134383–4
5 WAA 135851
6a WAA 123269
6b WAA 123270
7 WAA 132619
8 PRBA W.G. 2261, given by J. Pierpont-Morgan
9a OA 1950.11–7.215
9b OA 67.12–13.7
9c OA 1911.4–7.2
9d OA 1973.7–26.30
9e OA 67.12–13.11
9f OA 1910.7–13.15
10 WAA 48285
11 OA 1950.11–17.157
12 OA 1947.7–12.386
13a GRA 1824.4–98.8 Bronze
13b GRA 1814.7–4.965 Bronze
14 WAA 136789
15 PRBA 1939.5–1.14
16 PRBA 56.12–22.1
17 PRBA 1864.5–1.8, 9, 10
18 CM Sir A. J. Evans 1919.2–13.593
19 MLA 1912.6–10.3
20 OA 1950.11–16.2
21 WAA 121198A
22 GRA 1897.4–1.872
23 GRA 1873.8–20.385
24 WAA 134965
25a CM PCG I 87
25b CM BMC 38
26 OA 1973.7–26.90, Seligman Bequest
27 OA 1953.2–14.01, gift of Sir Edward Marsh
28 WAA 124534
29 CM BMC 114
30 MLA EC 252
31 EA 17173
32 EA 20790/2
33 GRA 1897.4–1.996
34 GRA 1859.4–2.102
35 MLA EC 415, 418, 420
36 MLA forthcoming Catalogue of Medieval Tiles nos. 9113–9120
37 CM George III Naples 2
38 MLA Ivory Catalogue 377
39 OA 1948.12–11.09
40 OA 1920.9–17.0316
41 OA 1953.2–14.02, bequeathed by Sir Edward Marsh through the NACF
42 OA 1936.4–11.023
43 GRA 1805.7–3.8
44 OA 1924.4–23.1
45 OA 78.12–30.753 Henderson Bequest
46 WAA 132092
47 EA 52947
49 EA 1387
48 EA 37978
50 EA 37982
51 GRA 1910.6–20.20
52 GRA 1842.7–28.785
53 GRA 1964.12–21.1, 1973.3–1.1
54 GRA 1904.7–3.1
55 OA 1948.12–11.014, bequest of Sir Bernard Eckstein
56 OA 1942.1–24.01, bought with the aid of the NACF
57 CM 1970.5–14.212
58 CM BMC 61
59 CM PCG V A B
60 CM 1845.11–13.21
61 OA 1937.3–19.5
62 Ethno 1913.12–11.11, presented by the Foreign Office
63 Ethno 1898.1–15.30, presented by the Foreign Office
64 Ethno 1954.Af.23.353 given by the Trustee the Wellcome Historical Medical Museum
65a Ethno 1947.Af.13.123 bequeathed by Cap R. P. Wild
65b Ethno 1949.Af.8.1
65c Ethno 1956.Af.27.162 given by Mrs Webst Plass
65d Ethno 1949.Af.8.6
66 Ethno 1905.5–25.6
67 Ethno 1972.Af.53.1
68 Ethno 1956.Af.27.7, g by Mrs Webster Pla
69 Ethno 1950.Af.45.216 bequeathed by P. Amaury Talbot
70 Ethno 1954.Af.23.135 Ethno 1972.Af.26.2 given by the Trustee the Wellcome Historical Medical Museum
71 Ethno 1905.818, Dr Charles Hose collection, given to Christy Coll. 1905
72 Ethno 1972.Am.13.10, given by Mrs A. W. Fuller
73 Ethno 1933.3–15.36, bequeathed by W. L. Loat
74 EA 42179, given by the Egypt Exploration Fund
75 EA 18175
76 EA 10471/20
77 EA 37448
78 EA 64095
79 EA 64391, given by R. John Gayer-Anders and Mary Stout
80 EA 37348, given by the Egypt Exploration Fund
81 OA 1966.7–25.01, Bro Sewell Fund
82 OA 1895.3–24.2
83 OA 1878.11–1.339, giv by Major General Augustus Meyrick
84 OA 1955.4–21.1, given P. T. Brooke Sewell I
85 OA 1919.1–1.0169
86 CM 1847.11–17.203
87 OA 1948.12–11.03, bequeathed by Sir Bernard Eckstein

88 MLA 1909.6–5.1
89 Harley MS 3244, f.54b
90 WAA 103232
91 WAA 90829
92 WAA 90840
93 CM BMC 696
94 Harley MS 647, f.2b
95 Cotton MS Tiberius BV
 part 1, f.32b
96 MS Or 5323, f.45b
97 Add 7697, f.48a
98 Sloane MS 3983, ff.16b
 and 24a
99 PD 1895.1–22.734, given
 by W. Mitchell Esq
100 CM 1840.10–10.14
101 CM 1882.7–4.14
102 OA F770, given by
 Sir A. W. Franks
103 WAA 89538
104 GRA 1923.4–1.3
105 GRA 1872.3–15.1
106 EA 18175
107 GRA 1897.4–1.872
108 WAA 123926, bequeathed
 by Sir A. W. Franks
109 WAA 123267
110a CM PCG II A 36
110b CM BMC 2
110c CM PCG II A 46
111 OA 1904.12–17.2
112 MLA Ivory Cat. 36
113 MLA 1923.12–5.3
114 Harley MS 4751, f.7b
115 MLA 78.12–30.333 (*left*),
 MLA 54.6–3.2
116 CM PCG I A 10
117 CM PCG II B 41
118 CM PCG V B 16
119 CM PCG V A 17
120 CM PCR 323
121 CM 1909.10–6.48
122 CM Grueber 73
123 CM 1861.12–3.1
124 CM SSB 57–44
125 CM BMC 66
126 CM Melbourne Mint
 1938.10–6.7
127 CM Clarke Thornhill
 1935.4–1.10419
128 MLA 90.9–1.15
129 MLA English Pottery
 Cat. E.153
130 GRA 1904.7–8.1
131 CM PCG III A 15
132 MLA 1915.12–16.17
133 GRA 1843.11–3.40
134 GRA 1884.6–14.33
135 CM PCG V C 29
136 CM M 198
137 GRA 1884.6–14.33
138 CM PCG Addenda 7
139 OA 1937.3–19.3
140 CM George III Fle D 44
141 MLA 91.9–5.13

142a CM BMC 28
142b CM M 0135
143 C.11.c.17
144 Add 18579, f.104a
145 MS Or 6317, f.114a
146 OA 1920.9–17.0126
147 OA 1973.7–26.13
148 OA 1936.11–18.32
149 WAA 123940, bequeathed
 by Sir A. W. Franks
150 OA 1950.11–17.53, 33
151a CM PCG II B 19
151b CM Evans 1919.2–13.18
151c CM Evans 1919.2–13.107
151d CM Evans 1912.2–13.353
151e CM T.C.P. 13. N. 1.
151f CM Barrett
 1935.11–17.78
152 MLA 1145.70, Gibbs
 Bequest
153 MLA 94.11–3.1
154 Cotton MS Nero D, IV,
 f. 94b
155 MLA 1951.10–11.1
156 MLA 70.8–11.1
157 MLA 1959.12–2.1
158 MLA 1963.10–2.1,
 purchased with the aid
 of the Pilgrims Trust
 and the NACF
159 OA 91.6–23.5
160 OA 78.12–30.686
 Henderson Bequest
161 OA 1930.11–12.04
162 OA 1974.5–13.9, given by
 Sir Harry and Lady
 Garner
163 Ethno 1909.12–18.65, 62,
 64, given by H. van den
 Bergh through NACF
164 Ethno 1969.Am.2.1, given
 by Miss M. Pepys
165 Ethno 8624, Christy
 Collection
166 Ethno 4103, Christy
 Collection
167 GRA 1816.6–10.43,
 North Frieze slab
 XXXIX
168a CM BMC 59
168b CM 1939.5–13.1
168c CM 1928.1–20.38
168d CM PCG III A 33
168e CM Lloyd 1946.1–1.335
168f CM PCG III B 39
168g CM Zitelli 1929.4–5.5
168h CM Lloyd 1946.4–1.817
169 Harley MS 3244, f.47a
170 Or MS 2784, f.208b
171 Cotton MS Nero D I,
 f.169 b
172 CM George III Var. Pr. 8
173 PD 1895.1–22.74
174 PD 5261–167 Sloane
 bequest

175 PD 1906.5–9.1 (68)
176 PD 1875.4–10.557
177 PD 1846.5–9.273
178 PD 1836.8–11.257
 Sheepshanks collection
179 PD Gg.2–259, the Rev. C.
 M. Cracherode bequest
180 PD 1920.4–20.19
181 PD 1914.5–20.304. Banks
 bequest
182 PD 1914.2–28.3013
183 PD 1911.4–26.36, given
 by the Trustees of
 Professor Hugh
 Blackburn
184 OA Japanese painting
 no. 2121
185 OA 1906.11–28.9
186 OA 1915.8–23.068
187 OA Japanese painting
 no. 2705
188 OA Japanese painting
 no. 2580
189 OA 1956.2–11.02

Bibliography

Åkerström-Hougen, G. 'The Calendar and Hunting Mosaics of the Villa of the Falconer in Argos', *Acta Instituti Atheniensis Regni Sueciae, Series in 40, XXIII.* Stockholm, 1974.

Allen, D. 'Some Contrasts in Gaulish and British Coins', in *Celtic Art in Ancient Europe, Five Protohistoric Centuries.* Eds. Paul-Marie Duval and Christopher Hawkes. London, 1976.

Ameisenowa, Z. 'Animal-headed gods, evangelists, saints and righteous men', *Journal of the Warburg and Courtauld Institutes,* vol XII (1949).

Archer, M. *Natural History Drawings in the India Office Library.* London, 1962.

Armstrong, E. A. *The Folklore of Birds.* London, 1958.

Arnold, T. W. *Painting in Islam.* Oxford, 1928.

Atkinson, F. M. (trans) *Asiatic Mythology.* London, 1932.

Backhouse, J., Barr, J., and Foot, M. (eds.) *William Caxton.* Exhibition held at the British Library. London, 1976.

Bakka, E. 'On the beginning of Salin's Style I in England', *Bergen Universitetet Årbok,* 1958.

Barfield, L. *Northern Italy before Rome.* London, 1971.

Basham, A. L. *The Wonder that was India.* London, 1954.

Ben-Amos, P. 'Men and animals in Benin Art', *Man,* 1976.

Benesch, O. *The Drawings of Rembrandt.* London, 1954–7.

Benson, E. P. *The Mochica.* London, 1972.

Bernoulli, C. 'Stierprotomen und ihre Rätsel', *Festschrift für Hans Swarzenski.* Berlin, 1973.

Bisi, A. M. *Il Grifone.* Rome, 1965.

Blake, J. (ed.) *Europeans in West Africa, 1450–1560.* London, 1942.

Blunt, A. *Art and Architecture in France 1500–1700.* London, 1953.

Boardman, J. *The Greeks Overseas.* London, 1964.

Boardman, J. *Pre-Classical, from Crete to Archaic Greece.* London, 1967.

Boas, M. *The Scientific Renaissance, 1450–1630.* London, 1962.

Bodenheimer, F. S. *Animal Life in Palestine.* Jerusalem, 1935.

Bodrogi, T. *Oceanian Art.* Budapest, 1959.

Boudet, J. *Man and Beast, A Visual History.* London, 1964.

Bradbury, R. E. 'Ezomo's *Ikegobo* and the Benin cult of the Hand', *Man,* 1961.

Brailsford, J. W. *Later Prehistoric Antiquities of the British Isles.* London, 1953.

Brailsford, J. W. 'The Polden Hill Hoard, Somerset', *Proceedings of the Prehistoric Society,* 41, 1975.

Breuil, H. 'Prétendus manches de poignard sculptées de l'âge du Renne', *L'Anthropologie,* 16, 1905.

Brion, M. *Animals in Art.* London, 1959.

British Museum. *Introductory Guide to the Egyptian Collections in the British Museum.*

British Museum. *Catalogue of Modern Chinese Coins.* (In preparation).

British Museum. *Catalogue of Indian Coins.* London, 1884–1936. (In preparation).

British Museum. *Catalogue of Roman Coins.* London, 1910–62.

British Museum. *Catalogue of Greek Coins.* London, 1873–1927.

Brodrick, A. H. (ed.) *Animals in Archaeology.* London, 1972.

Brown, W. L. *The Etruscan Lion.* Oxford, 1960.

Bruce-Mitford, R. L. S. 'The Sutton-Hoo Ship Burial: Comments and General Interpretation', *Aspects of Anglo-Saxon Archaeology.* London, 1974.

Buhler, A., Barrow, T. and Mountford, C. P. *Oceania and Australia: the art of the South Seas.* London, 1962.

Buxton, J. 'Animal Identity and Human Peril: some Mandari Images', *Man,* 1968.

Cabrol, F. *Dictionnaire d'Archéologie Chrétienne et de Liturgie.* Paris, 1903–53.

Cambridge Anthropological Expedition to Torres Straits, Reports, 6 vols. Cambridge, 1901–35.

Carson, R. A. G. *Coins: Ancient, Medieval & Modern.* London, 1970.

Carson, R. A. G. *Principal Coins of the Romans.* (In preparation).

Chelkowski, P. J. (ed.) *Studies in Art and Literature of the Near East.* New York, 1974.

Clutton-Brock, J. 'The historical background to the domestication of animals', *International Zoo Year Book,* vol 16. London, 1976.

Coe, R. T. *Sacred circles: two thousand years of North American Indian Art.* An exhibition held at the Hayward Gallery London, October 1976–January 1977.

Cole, F. J. *A History of Comparative Anatomy from Aristotle to the 18th century.* London, 1944.

Cole, F. J. 'The History of Albrecht Dürer's Rhinoceros in Zoological Literature', in *Science, Medicine and History,* ed. E. Ashwood-Underwood, vol I, 1953.

Colnaghi, P. & D. *Animal drawings through three centuries,* (collection of Sir Bruce Ingram. Exhibition held at P. & D. Colnaghi & Co. Ltd. London, 1953.

Coombs, D. 'Bronze Age weapon hoards in Britain', *Archaeologia Atlantica,* 1:I, 1975.

Cox, J. C. *The Royal Forests of England.* London, 1905.

Croft-Murray, E. (ed.) *The Art of Drawing.* Exhibition held at the British Museum. London, 1972.

Croft-Murray, E. and Hulton, P. *Catalogue of British Drawings,* vol I 16th and 17th centuries. London, 1960.

Dalton, O. M. *Catalogue of the Early Christian Antiquities in the British Museum.* London, 1901.

Dalton, O. M. *Catalogue of the Ivory Carvings of the Christian Era in the British Museum.* London, 1909.

Dalton, O. M. *Catalogue of Finger-Rings in the British Museum.* London, 1912.

D'Azevedo, W. L. 'Mask Makers and Myth in Western Liberia' in *Primitive Art and Society,* ed. Anthony Forge. London, 1973.

Dennys, R. *The Heraldic Imagination.* London, 1975.

Dent, A. & Goodall, D. M. *The Foals of Epona.* London, 1962.

Dolenz, H. 'Nachtrag zum Bericht über das späturnenfelderzeitliche Bronzemesser aus Rosenheim, Kärnten', *Archaeologia Austriaca* 44, 1968.

Douglas, M. 'Animals in Lele religious symbolism', *Africa,* 1957.

Douglas, M. *Purity and Danger. An analysis of concepts of pollution and taboo.* London, 1966.

Douglas, M. (ed.) *Rules and Meanings.* London, 1976.

Eames, E. S. *Catalogue of Medieval Tiles in the British Museum.* (In preparation).

Egerton, J. *George Stubbs, anatomist and animal painter.* An exhibition at the Tate Gallery. London, 1976.

Egger, F. 'Frosch und Kröte bei den alten Agyptern', *Ethnologische und Geographische Gesellschaft Basel* vol 4, 1935.

Elliot, J. H. *The Old World and the New 1492–1650.* Cambridge, 1970.

Epstein, H. *Domestic Animals of China.* Commonwealth Agricultural Bureaux. England, 1969.

Ettinghausen, R. 'Studies in Muslim Iconography. The Unicorn', *Freer Gallery of Art Occasional Papers,* vol I. Washington, 1951.

Ettinghausen, R. *From Byzantium to Sasanian Iran and the Islamic World.* Leiden, 1972.

Evans, R. J. W. *Rudolf II and his world. A study in Intellectual History 1576–1612.* London, 1973.

Evison, V. I. *Fifth Century Invasions South of the Thames.* London, 1965.

Evison, V. I. 'Quoit Brooch Style Buckles', *Antiquaries Journal,* 1968.

Fagg, W. *Divine kingship in Africa.* London, 1970.

Fagg, W. *The Tribal Image.* London, 1970.

Fagg, W. *Eskimo Art in the British Museum.* London, 1972.

Firth, R. 'Twins, Birds, and Vegetables: Problems of identification in primitive religious thought', *Man,* 1966.

Forbes, R. J. *Studies in Ancient Technology,* vol II. Leiden, 1965.

Foster, J. *Bronze Boar Figurines in Iron Age and Roman Britain,* British Archaeological Reports 39, 1977.

Franks, A. W. Note in *Proceedings of the Society of Antiquaries of London,* 2nd ser. III, 1864–67.

Fraser, D. & Cole, H. M. *African Art and Leadership.* Wisconsin, 1972.

Freeman, J. D. 'A Note on the Gawai Kenyalang, or Hornbill Ritual of the Iban of Sarawak' in *The Birds of Borneo,* ed. B. E. Smythies. Edinburgh, 1960.

French, C. C. *A History of horseman-ship.* London, 1970.

Geertz, C. 'Deep play: notes on the Balinese cockfight', *Daedalus,* Winter, 1972.

George, W. *Animals and Maps.* London, 1969.

Gimbutas, M. *Bronze Age Cultures in Central and Eastern Europe.* The Hague, 1965.

Goldscheider, C. A. & Petter, F. (eds.) *L'Animal de Lascaux a Picasso.* An Exhibition held at the Museum National d'Histoire Naturelle. Paris, 1976/77.

Gough, M. *The Early Christians.* London, 1961.

Greenwell, W. 'On some rare forms of Bronze Weapons and Implements', *Archaeologia* 58:1, 1902.

Grierson, P. *Numismatics,* London, 1975.

Guiart, J. *The Arts of the South Pacific,* London, 1964.

Hahnloser, H. R. 'Urkunden zur Bedeutung des Türrings', *Festschrift für Erich Meyer.* Hamburg, 1957.

Hands, R. *English Hawking and Hunting in the 'Boke of St Albans'.* Oxford, 1975.

Head, B. V. *Principal Coins of the Greeks.* London, 1959 (new edition).

Hencken, H. *Tarquinia and Etruscan origins.* London, 1968.

Henderson, I. *The Picts.* London, 1967.

Hobson, R. L. *Catalogue of English Pottery in the British Museum.* London, 1903.

Holmqvist, W. *Germanic Art during the first millennium AD.* Stockholm, 1955.

Honour, H. *The European Vision of America.* Cleveland, 1975.

Horton, R. 'The Kalabari world view: An outline and interpretation', *Africa,* vol 32, 1962.

Horton, R. 'The Kalabari Ekine Society: A borderland of religion and art', *Africa,* 1963.

Hulton, P. and Quinn, D. B. *The American Drawings of John White.* London and Chapel Hill, 1964.

Hundt, H-J. 'Über Tüllenhaken und -gabeln', *Germania* 31, 1953.

Imperato, P. J. 'The Dance of the Tyi Wara', *African Arts,* 1970.

Jenkins, G. K. *Ancient Greek Coins.* London, 1972.

Jensen, E. *The Iban and their Religion.* Oxford, 1974.

Jockenhövel, A. von 'Fleischhaken von den Britischen Inseln', *Archaologisches Korrespondenzblatt* 4:4, 1974.

Johns, C. M. 'A Roman Bronze Statuette of Epona', *British Museum Quarterly* 36, 1971.

Jones, D. & Michell, G. (eds.) *The Arts of Islam.* Exhibition held at the Hayward Gallery. London, 1976.

Kay-Robinson, D. *Animals in Art.* London, 1976.

Kirk, G. S. *The Nature of Greek Myths.* London, 1974.

Kirschbaum, E. (ed.) *Lexikon der Christlichen Ikonographie,* 8 vols, 1968–76.

Klauser, T. (ed.) *Reallexikon für Antike und Christentum.* Stuttgart, 1950 onwards.

Klingender, F. *Animals in Art and Thought, to the end of the Middle Ages.* London, 1971.

Knatchbull, W. (trans) *Kalila and Dimna, or the fables of Bidpai.* Oxford, 1819.

Kromer, K. *Hallstatt.* Vienna, 1963.

Kubler, G. *The Art and Architecture of Ancient America.* London, 1962.

Kurz, O. 'Lion-masks with rings in the West and in the East', *Scripta Hierosolymitana.* Jerusalem, 1972.

Langton, N. *The Cat in Ancient Egypt.* Cambridge, 1940.

Lartet, E. & Christy, H. *Reliquiae Aquitanicae.* London, 1875.

László, G. *Études Archéologiques sur l'Histoire de la Société des Avars.* Budapest, 1955.

László, G. *Steppenvölker und Germanen.* Munich, 1970.

Lavin, I. 'The Hunting Mosaics of Antioch and their sources', *Dumbarton Oaks Papers,* vol 17, 1963.

Leroi-Gourhan, A. *The Art of Prehistoric Man in Western Europe.* London, 1968.

Levey, M. *High Renaissance.* London, 1975.

Lévi-Strauss, C. *Totemism.* London, 1963.

Lévi-Strauss, C. *The Savage Mind.* London, 1966.

Linton, R., and Wingert, P. S. *Arts of the South Seas.* New York, 1946.

Lloyd, A. *Herodotus Book II,* Commentary 1–98. Leiden, 1976.

Lloyd, J. B. *African Animals in Renaissance Literature and Art.* Oxford, 1971.

Löfgren, O. *Ambrosian fragments of an illuminated manuscript containing the zoology of Al-Gāḥiẓ.* Uppsala, 1946.

Lysaght, A. M. (ed.) *Joseph Banks in Newfoundland and Labrador, 1766: his diary, manuscripts and collections.* London, 1971.

McLeod, M. D. *Asante art and hierarchies of values.* (Unpublished paper).

Megaw, J. V. S. *Art of the European Iron Age.* New York, 1970.

Mellaast, J. *The Neolithic in the Near East.* London, 1975.

Menzel, B. *Goldgewichte aus Ghana.* Berlin, 1968.

Mercier, L. *La Parure des Cavaliers et l'insigne des preux.* Paris, 1924.

Merhart, G. von 'Studien über einige Gattungen von Bronzegefässen', *Festschrift des Römisch-Germanischen Zentralmuseums Mainz,* II, 1952.

Miall, L. C. *The Early Naturalists, their lives and work. (1530–1789).* London, 1912.

Moorey, P. R. S. *Ancient Bronzes from Luristan.* London, 1974.

Nasr, S. H. *Islamic Science*. London, 1976.

Ottenberg, S. 'Humorous Masks and Serious Politics among Afikpo Ibo', *African Art amd Leadership*, eds. D. Fraser and H. M. Cole. Wisconsin, 1972.

Pacht, O. 'Early Italian Nature Studies and the Early Calendar Landscape', *Journal of the Warburg & Courtauld Institutes*, vol XIII, 1950.

Painter, K. S. Note: 'A Bronze Ox-Head from Somerset', *Antiquaries Journal* 43, 1963.

Pallottino, M. *The Etruscans*. London, 1975.

Panofsky, E. and Saxl, F. 'Classical Mythology in Mediaeval Art', *Metropolitan Museum Studies*, IV, 1933.

Paton, D. *Animals of Ancient Egypt*. Princeton, 1925.

Piggott, S. *Ancient Europe from the Beginnings of Agriculture to Classical Antiquity*. Edinburgh, 1965.

Pinder-Wilson, R. H. *Paintings from the Muslim Courts of India*. An exhibition held at the British Museum. London, 1976.

Popham, A. E. and Pouncey, P. *Italian Drawings in the British Museum. The Fourteenth and Fifteenth centuries*. London, 1950.

Powdermaker, H. *Life in Lesu: the study of a Melanesian society in New Ireland*. London, 1933.

Powell, T. G. E. *The Celts*. London, 1967.

Ray, J. *The Archive of Hor*. London, 1976.

Reinach, S. 'La Sculpture en Europe avant les influences Gréco-Romaines', *L'Anthropologie* 7, 1896.

Reitinger, J. *Oberösterreich in Ur – und Frühgeschichtlicher Zeit*. Linz, 1969.

Reznicek, E. K. J. *Die Zeichnungen von Hendrick Goltzius*. Utrecht, 1961.

Roes, A. 'Un bronze d'Asie Mineure au Musée Britannique', *Syria*, 1950.

Ross, A. *Pagan Celtic Britain*. London, 1967.

Rücker, E. *Maria Sibylla Merian 1647–1717*. Exhibition held at the Germanisches Nationalmuseum. Nuremberg, 1967.

Salin, B. *Die Altgermanische Tierornamentik*, 2nd ed. Stockholm, 1935.

Sarton, G. *A History of Science: Ancient Science through the Golden Age of Greece*. London, 1953.

Sarton, G. *A History of Science: Hellenistic Science and culture in the last three centuries BC*. Cambridge, Mass., 1959.

Schiltz, V (ed.) *Or des Scythes; tresors des musées soviétiques*. Exhibition held at the Grand Palais. Paris, 1975.

Schmitt, O. (ed.) *Reallexikon für Deutschen Kunstgeschichte*. Stuttgart, 1937 onwards.

Schüle, W. 'Die Meseta Kulturen der Iberischen Halbinsel', *Madrider Forschungen*, 9, 1969.

Scullard, H. H. *The Elephant in the Greek and Roman World*. London, 1974.

Sen, A. *Animal Motifs in Ancient Indian Art*. Calcutta, 1972.

Sillar, F. C. and Meyler, R. M. *Elephants Ancient and Modern*. London, 1968.

Singer, C. *A Short History of Scientific Ideas to 1900*. London, 1962.

Siroto, L. 'Gon: A mask used in competition for leadership among the Bakwele', *African Art and Leadership*, eds. D. Fraser and H. M. Cole. Wisconsin, 1972.

Smith, B. 'European Vision and the South Pacific', *Journal of the Warburg and Courtauld Institutes*, vol XIII, 1950.

Smith, R. A. *Stone Age Guide*, 3rd ed. London, 1926.

Sourdel-Thomine, J. and Spuler, B. (eds.) *Propyläen Kunstgeschichte, Islam*. Berlin, 1973.

Spiegel, H. 'Some aspects of New Ireland malanggan carvings', *Archaeology and Physical Anthropology in Oceania*, vol 8, 1973.

Sprockhoff, E. 'Nordische Bronzezeit und frühes Griechentum', *Jahrbuch des Römisch-Germanischen Zentralmuseums Mainz*, I, 1954.

Stern, H. P. *Birds, Beasts, Blossoms, Bugs, the Nature of Japan*. New York, 1976.

Stevenson, R. B. K. 'Sculpture in Scotland in the 6th–9th Centuries AD', *Kolloqium uber Spätantike und Frühmittelalterliche Skulptur*. Heidelberg, 1970.

Steward, J. H. (ed.) *The Handbook of South American Indians*, vol 3. Washington, 1948.

Sulimirski, T. *The Sarmatians*. London, 1970.

Talbot, Rice, D. (ed.) *The Dark Ages*. London, 1965.

Tambiah, S. J. 'Animals are good to think and good to prohibit', *Ethnology*, 1969.

Taylor, B. *Stubbs*. London, 1971.

Titley, N. M. and Waley, P. 'An Illustrated Persian Text of Kalīla and Dimna dated 707/1307–8', *The British Library Journal*, vol I, no I, 1975.

Tonnochy, A. B. *Catalogue of British Seal-Dies in the British Museum*. London, 1952.

Toynbee, J. M. C. *Animals in Roman Life and Art*. London, 1973.

Trew, C. G. *From Dawn to Eclipse, the story of the Horse*. London, 1939.

Trump, D. *Central and Southern Italy before Rome*. London, 1966.

Turner, G. H. 'Select Pleas of the Forest', *Selden Society*, vol 13, 1899.

Ucko, P. J. *The Domestication and Exploitation of Plants and Animals*. London, 1971.

Vey, H. & Osten, G. von der *Painting and Sculpture in Germany and the Netherlands: 1500–1600*. London, 1969.

Volbach, W. F. *Early Decorative Textiles*. London, 1969.

Walters, H. B. *Catalogue of the Roman Pottery in the Department of Antiquities, British Museum*. London, 1908.

Wellesz, E. 'An early Al-Sūfi Manuscript in the Bodleian Library in Oxford. A Study in Islamic Constellation Images', *Ars Orientalis* III, 1959.

White, C. *Dürer: the artist and his drawings*. London, 1971.

White, T. H. *The Book of Beasts*. (A translation from a Latin Bestiary of the 12th century). London, 1969.

Whitehead, P. J. P. and Edwards, P. I. *Chinese Natural History Drawings, from the Reeves Collection*. London, 1974.

Wilkinson, J. V. S. *The lights of Canopus Anvār i Suhaylī*. London, 1929.

Willey, G. R. *An Introduction to American Archaeology*, vols I & II, Englefield Cliffs, 1966 & 1971.

Williams, D. *Icon and Image. A study of sacred and secular forms of African classical art*. London, 1974.

Willis, R. G. *Man and Beast*. London, 1974.

Wilson, D. M. *Catalogue of Anglo-Saxon Ornamental Metalwork 700–1100 in the British Museum*. London, 1964.

Wilson, D. M. *The Vikings and their Origins, Scandinavia in the First Millennium*. London, 1970.

Wilson, D. M. *The Anglo-Saxons*. London, 1971.

Wilson, D. M. and Klindt-Jensen, O. *Viking Art*. London, 1966.

Winkler, F. *Die Zeichnungen Albrect Dürers*. Berlin, 1936.

Wittkower, R. 'Marvels of the East. A study in the History of Monsters', *Journal of the Warburg and Courtauld Institutes*, vol V. London, 1942.

Wood, C. A. and Fyfe, F. M. *The Art of Falconry: the 'De Arte Venandi cum Avibus' of Frederick II*. Oxford, 1943.

Zeuner, F. E. *A History of Domesticated Animals*. London, 1963.

Left column partial entries: